ANIMATION AND AMERICA

Animation and America

PAUL WELLS

Rutgers University Press
New Brunswick, New Jersey

First published in the United States 2002
by Rutgers University Press, New Brunswick, New Jersey

First published in Great Britain 2002
by Edinburgh University Press Ltd
22 George Square
Edinburgh EH8 9LF,UK
http://www.eup.ed.ac.uk

Library of Congress Cataloging-in-Publication Data and British Library
Cataloging-in-Publication Data are available on request.

ISBN 0 8135-3159-4 (cloth)
ISBN 0 8135-3160-8 (paper)

Printed in Great Britain

Contents

Acknowledgements — vi

Introduction: Abdicating All Mental Law — 1

1 Animation and Modernism — 19

2 The Disney Effect — 38

3 Synaesthetics, Subversion, Television — 60

4 New Disney, Old Stories? — 102

5 New Animation *Auteurs* — 126

6 United States of the Art — 151

Filmography — 172

Bibliography — 178

Index — 182

Acknowledgements

I would like to thank my colleagues at both De Montfort University and the University of Teesside for their support and encouragement through the long duration of this project.

My particular thanks go to Philip Davies, George McKay and Nicola Carr for their extraordinary tolerance and support, and to the staff of EUP for their help and creativity.

As always, this book is dedicated to my wife, Joanne, our two children, Freddie and Lola, but on this occasion I would also like to offer thanks and appreciation to John Powell and Christopher Frayling for the belief they placed in me, and the opportunity they gave me.

Abdicating All Mental Law

'I'm History; No, I'm mythology; I don't care what I am – I'm free !!'
– The Genie in Disney's *Aladdin*

Arguably, America has produced four major indigenous art forms. The Western (in film and fiction); jazz; the Broadway musical and the animated cartoon. The cartoon has borrowed liberally from the former, and indeed embraced all other forms in the arts; its inclusiveness part of its distinctive vocabulary. Fundamentally, though, animation in the United States has been characterised by a desire to express *difference* and *otherness*, and as Stefan Kanfer has recently noted, it is one of the few major art forms 'that has been able to widen its audience as it experimented and grew'.[1] From the cartoon to the computer-animated film it has engaged with the contradictory conditions of American mores, reflected the anxieties within American culture, and offered insight into the mytho-political, and indeed, mytho-poetic zeitgeist of a nation. The critical positioning of animated films as merely populist texts, however, has long proved to be inhibiting in properly acknowledging its omnipresent significance as a potentially radical art form and a culturally determined language of high social significance. The following discussion seeks to re-position the animated film in America within a range of critical frameworks which demonstrate the freedoms of its vocabulary and the complexity of its meanings.

Mark Langer has usefully summarised the trajectory of animation criticism, identifying how animation has laboured to achieve a degree of cultural capital, achieving its current, more favourable status through the efforts of 'animatophiles' over the last thirty years. Participants include 'animation company owners and employees, animation scholars, devoted fans and obsessive consumers of animation and its ancilliary products',[2] who have encouraged an engagement with the specialised particularities

of the form, and its specific rewards. Even in a contemporary period when animation enjoys increased critical attention, however, the idea that a 'cartoon' can support aesthetic and cultural analysis, and demonstrate valid positions about social preoccupations is often met with doubt and incredulity. Virtually all critical accounts have an overt or implied 'justification'of why it is crucial to address and analyse animated films. In some way this may be accounted for by the sense that the great era of animation in United States from the late 1920s to the early post-war period is in itself perceived to be the summation of the form's achievements.³ Anything, thereafter, it is implied, merely lacks quality or credibility, and is effectively a pale shadow of the former affectivities of such films. It is certainly the case that it was in this period that animation received most critical attention, though this must be immediately qualified by the fact that what this essentially means is that the pre-eminence of the Disney studio and its output became synonymous with animation in a way that virtually marginalised any address of other work. Gregory Waller has observed that Disney not only received creditable attention in academic and art-related periodicals like the *Journal of Aesthetics* and *Art Criticism* but also enjoyed wider dissemination in general-interest and cosmopolitan magazines like *The New Yorker*, as well as the established news and entertainment industry publications. Tellingly, he notes that in 1942, Manny Farber 'offered the first and only appreciative assessment of Leon Schlesinger's Merrie Melodies unit at Warners published during this entire decade'.⁴ In a sense this dominance has to a certain degree remained, but the more important point is how this critical paradigm which rightly elevated the work of the Disney studio to the status of 'art' while acknowledging its reassuring populist and ideological credentials, also managed to marginalise for many years the work of other pioneers in the field and the achievements in other areas of cartoon animation. The recognition of Disney's achievement was to create a hierarchical effect in the field which inevitably demoted the significance of other forms. With the passing of the 'Golden era' came the rise of television and the concomitant fall of critical interest in animation as both an important art-form and critical idiom. Arguably, animation as an industry only survived in the United States because of its albeit 'reduced' presence on television, and further, that in sustaining its presence ultimately facilitated its revival in the 1980s and 1990s. It is clear that animation did have a period of apparently less artistically significant work in what may be termed the 'post-theatrical' hiatus, but, curiously, this did enable particular

forms of pragmatic experimentation to take place, and the socio-cultural function of animation to be re-determined.

Interestingly, the 'art' of animation has been valorised in the 1990s by the production of individual animation cels configured as valuable paintings. The world wide web promotes gallery after gallery of cel-animated art; some specialising in cels drawn from contemporary films; others speaking of rare works from the Golden era. Animation's relationship to the principles and effects of 'Fine Art' is, of course, crucial in evaluating its aesthetic agendas, but it is also intrinsically related to its sociological value and meaning. Undeniably, the enduring cultural kudos of traditional painting practices has been co-opted by gallery owners and art critics alike in order to prioritise its artistic bases and principles, but while raising the profile of animation as an art work at one level, it has done much to distract from properly recognising the distinctive aesthetic language and vocabulary of animation, and its place as a socio-cultural document of its time. There remains little recognition that the very aesthetic values in Disney's work in the 1930s and 1940s championed by eminent figures like Philippe Lamour, Jean Charlot and Elie Faure, which fully acknowledged how aesthetic approaches privileged certain ideas and issues, are those which inform the current address of animation as an art. Simply, a market has emerged for particular images from well loved films, and little analysis has attended this phenomenon which embraces individual images in their own right beyond the familiarity and appeal of their source. Crucially, though, the key issue remains that to merely designate one frame as the 'art' of the animated film is to resist the recognition of animation as a language of moving images characterised by codes and conventions unique to its execution. Another aspiration of this discussion, therefore, is to recover the more formal critical perspectives which properly define the status of animation as a form, and apply them beyond the Disney canon into the whole realm of animated film in the United States.

These perspectives which endorse the primacy of animation as a specific and unique form of creative expression sit at an extreme from its position within the academic practice of Film Studies; its perceived role as merely 'children's entertainment'; and its previously marginalised function as a television 'schedule filler'. In the contemporary era, however, this is changing. The overall boom in the production of animated feature films – Disney now competing with Dreamworks SKG – and the creation of animated sit-coms – *The Simpsons, King of the Hill, South*

Park and so on, have altered both the cultural climate for, and the cultural cachet related to animation. Similarly, the emergence of niche children's channels, and dedicated broadcast outlets like the Cartoon Network, have necessitated a re-evaluation of the place of cartoons and animated films in aesthetic and commercial terms. The development of Nickelodeon, the Disney Channel and the Fox Network competing head-to-head against the majors, ABC, CBS and NBC, in the children's market has led to a contradictory position for animation within the realms of the political and creative economy available through broadcasters. On the one hand, this degree of competition has necessitated significantly reduced licence fees and production budgets for new work, and forced small- to medium-sized production companies to agree new pre-sales and distribution agreements in order to maintain their company status and a competitive position in a buoyant and ever changing marketplace. On the other hand, this has meant an increased prominence for animation in a number of broadcast contexts, creating an eclectic mix on all broadcast channels of 'classic' cartoons from the 1930s to the 1950s; previous 'home produced' television animation; imported series from other countries, (most notably Japan, but increasingly Britain has a foothold in overseas markets with programmes like *Noddy*, *Maisy*, *Kipper* and *Bob the Builder*); and new work, produced in recent times, on much reduced investment.[5]

The Hanna Barbera back catalogue, for example, and a range of Warner Bros. *Looney Tunes* and *Merrie Melodies* have found their place on the Cartoon Network, seeking its original audience of 'baby boomers', and now, their children. Original series like *Jonny Quest* have been up-dated as *The Real Adventures of Jonny Quest* in order to accommodate computer-generated animation and 'modernise' the science fictional premise of the series. Fully computer-generated series, like *Starship Troopers*, *Max Steel* and *Beast Creatures*, contemporise this aesthetic further, echoing the graphic space and violent confrontational thematics of many computer games and their virtual environments. The often neglected *Reboot*, made in the United States by British artists, was a pioneer in this area by setting its narrative within a computer environment, aping Disney's feature film, *Tron* (1982). The popularity of mainstream Japanese feature animé is also reflected in the presence of *Pokémon*, *Digimon* and *Dragonball Z* in the schedules, and may be traced in many elements of contemporary American cartoons. Ironically, many 'American' cartoons have often been made in Japanese, Korean and Taiwanese production houses.

These factors have made a significant impact in relation to the idea that animation could embrace and facilitate serious issues and agendas. Previously, the predominantly comic discourses of the most popular animated films have also been viewed as antithetical to any notions of seriousness. This has been misleading in a number of ways, most notably in maintaining a historically determined, and hugely misinformed, view which ultimately confuses seriousness with solemnity, and comedy with 'escapism', rather than relevance. While it is the case that some forms of comic address do not seek to be didactic or have purpose or intent in making statements, the very language of comedy, like animation, is an intrinsically alternative one, speaking to a revisionist engagement with the 'taken-for-granted'. In the American context, it is especially the case that animation in all its forms, not merely those played for laughs, has served to operate as a distorting and re-positioning parallel genre both to established live-action film and television texts (and their predominantly conservative codes of representation), but more importantly, to society in general. Ironically, its status as a peripheral form, or more precisely a form which does not carry with it connotations of earnest sociological engagement, has legitimised what might be characterised by what former *Monty Python* animator Terry Gilliam has called 'wonderful acts of smuggling' in regard to representing or expressing different view-points, ideas and emotional states.[6]

Animation – simplistically, the art of making films frame-by-frame – serves to question and challenge the received knowledges which govern the physical laws and normative socio cultural orthodoxies of the 'real world'. Roger Cardinal suggests that at its most radical, 'the whole idea of the animated film is to suppress the categories of normal perception', and ultimately, to 'annihilate the very conditions of rationality'.[7] This is not merely the view of the detached aesthetic or cultural theoretician, however, but one which drove the imperatives of the animators at Warner Bros.' 'Termite Terrace', the nickname given to the old studio buildings inhabited by Tex Avery, Chuck Jones and their colleagues. Donald Crafton notes that this was a distinctiveness always understood by the animators-turned-scribes of the in-house bulletin, 'The Exposure Sheet'. Appositely, story-writer Michael Maltese writes,

Set aside your indignations,
And regard the machinations
Of the animation industry with awe;

Nowhere else in all the nation,
Will you find a near relation
To this abdication of all mental law.[8]

This is an especially crucial observation when attempting to evaluate
how the very language of animation is deployed in the service of ideolo-
gically charged material, or merely re-determines the consensual para-
digms of everyday existence in any one cultural or national formation.
The highly rationalised, some would argue 'naturalised', agendas played
out through the majority of American televisual or cinematic texts, still
often endorsing the values and characteristics of cultural populism,
become subject to re-definition. Crudely, for example, at one level, *The
Simpsons* is merely a variant on the American sit-com tradition, includ-
ing the dominant stereotype of the white, blue-collar buffoon, and the
resolution of dysfunctional aspects of family life, but its very status as an
animation asks an audience to re-perceive supposedly everyday issues,
themes and knowledge. The management of many texts in the United
States in order to secure narrative, moral and commercial coherence is
undermined when the animated text itself refuses management, annihil-
ating the codings of the kinds of social existence predominant in soaps,
sit-coms and generic dramas. Ironically, a text like *The Simpsons* demon-
strates a more limited degree of challenge than other animated texts but
within the limits of generic expectation in which it works it revises a
number of predominant paradigms which have come to define aspects of
America and 'Americanness'. There is a long tradition of this kind of
subversion which stretches back to the animated 'stag' film *Buried
Treasure* (1928), featuring the animated penis, Eveready Harton; the titil-
lating Betty Boop cartoons of the 1930s – *Silly Scandals* (1931), *Boop Oop
A Doop* (1932), *Chess Nuts* (1932), and *Betty Boop's Penthouse* (1933); the
John Magnusson and Jeff Hale animation of a Lenny Bruce routine,
Thank You Mask Man (1968); Ralph Bakshi's *Fritz the Cat* (1972) and
Coonskin (1975); and the work of contemporary iconoclasts like Bill
Plympton and John Kricfalusi.[9]

Beyond the intrinsic de-construction of a more literal conception of the
image offered by animation, there are its qualities as a vocabulary that
both illustrate and define the execution and consequences of 'movement'
in its widest terms. Stanley Cavell has usefully delineated animation as a
model in which the viewer is presented with 'drafts of the world's

animism' and the essential 'circulation or metamorphosis out of and into the human organism'.[10] This constitutes animation as a mode of expression which both re-defines the material world and captures the oscillation between interior and exterior states, thus engaging with matters both of (aesthetic, spiritual and intellectual) consciousness and the reception of a pragmatic (socio-cultural) 'reality'. Consequently, this results in an ontological equivalence in the animated text which recognises the co-existent parity of perceived orthodoxies in representing the literal world and the expression of dream states, memory and the fragmentary practice of 'thought' itself. As Czechoslovakian surrealist animator Jan Svankmajer has observed, this serves to disturb 'the utilitarian habits of the audience, to unsettle them, [sometimes] for subversive purposes'.[11] It is clear that the vocabulary of animation challenges the notion of passive acceptance through the sustained creation of a self-evidently artificial, constantly evolving but pertinent aesthetic of pictorial mediation. At once, and at any time, the animated form is both a depiction and an interpretation, collapsing the sense of differentiation between the literal and the imagined. As Hugh Kenner has noted when discussing the tension between violence and sentimentality in Chuck Jones' films, and most particularly, *Bully for Bugs* (1953), 'despite everything its script inflicts on a bull we sure never think [it is] real ... [but] that's a tricky concept. For if we don't think of a bull the cartoon gets trivial, whereas thinking of a beast in pain expels us from the cartoon world. But that is not a beast, therefore not in pain; it's a wondrous arrangement of lines and color [sic] and movement'.[12] Consequently, the cartoon becomes inherently metaphysical because it is playing out creative ideas which are extrapolated from, and interpretive of, observational and representational codings. This invariably results in expression which moves beyond the recognisable limits of the material world in order to comment upon them. If nothing else the American cartoon tradition alone has re-determined how the parameters of 'law and order' may be interpreted psychologically, politically and geographically.

Attempts to grapple with these issues have often superficially floundered on the basis of viewing animation only as a mode of 'fantasy', or as a language which works as an approximation of the less stable but seemingly cogent image systems which have been determined within the practices of fine art – most notably, surrealism, impressionism and expressionism. Crudely, of the main cartoon studios, it was Disney that most embraced impressionism (though this is couched within a

predominantly realist aesthetic); Warner Brothers, the dynamics of the surreal, especially in the cartoons of Tex Avery and Bob Clampett; and the Fleischer Brothers, the use of expressionism, in a way that comes to define the notion of a 'cartoon noir'. This will be explored further through the analysis of texts, but here it is interesting to note that Hermann Warm, designer on the German expressionist classic, *The Cabinet of Dr Caligari* (1919), and a key figure in the Berlin Sturm group promoting expressionism in all art forms, suggested that 'films must be drawings brought to life',[13] while earlier in 1916, director Paul Wegener unconsciously anticipates the evolution and importance of the animated film when he says, 'I can imagine a kind of cinema which would use nothing but moving surfaces, against which there would impinge events that would still participate in the natural world but transcend the lines and volumes of the natural'.[14] Lotte Reiniger, the creator of cut-out silhouette animation, for example, drew directly upon these inspirations in the development of her work,[15] but such debate was not unusual in cultures both in Europe and the United States, which were developing the whole concept of 'film art'. It is a debate, however, that even within the contemporary era, which while still having validity, runs up against the perception of film largely as a mass entertainment medium *per se*, and the clogging proliferation and cultural saturation of popular and academic film criticism. Even within this context, however, it remains the case that animation still requires championing as a 'film art' in its own right. The challenge in 'animation' is to recognise its presence, achievement and uniqueness as a film form, but invariably this issue is coloured by the return to a view of animation as an inexact method and aesthetic, and an anxiety about the perception of the form as one which may be accepted and recognised as the facilitator of progress in the visual arts. A premise it is *actually* achieving on its own terms and within the currencies of new Hollywood production. Again, as Waller has noted of the Classic Disney era, this desire to properly place animation in its most appropriate critical and creative culture has resulted in unhelpful divisions because on the one hand some writers like Jean Charlot readily elevated animation, acknowledging its seemingly highbrow credentials, while others like Dorothy Grafly rooted animation in a 'folk' tradition which resisted the obscurities and aspirations of modern art.[16] Even within the parameters of the latter, though, important aspects remain which speak to ideas and issues beyond the cultural mainstream. As Erwin Panofsky noted of early cartoons in 1934:

They retain the most important folkloristic elements – sadism, porno-graphy, the humor engendered by both, and moral justice – almost without dilution and often fuse these elements into a variation on the primitive and inexhaustible David-and-Goliath motif, the triumph of the seemingly weak over the seemingly strong; and their fantastic independence of the natural laws gives them the power to integrate space with time to such perfection that the spatial and temporal experiences of sight and hearing come to be almost incontrovertible.[17]

These achievements in themselves define 'difference' as a mode of expression which collapses the expectations of cinematic photo-realism, narrational orthodoxy and determinist representation into a form of cinema predicated on a more primal and unconscious expression which recalls and encourages the most progressive of creative impulses. It is my own contention, therefore, that animation is a child of the modernist principle, and is concerned with the consistently evolving premises of 'modernity' even within the contentious terrain of the post-modern era and the populist agendas of American culture. At every point of social, cultural and artistic development, animation has expressed the continu-ing tension between a medium in which innovation and creativity can continually take place while aligning with, and depicting the most human of needs, desires, thoughts and feelings. Consequently, it is per-haps inevitable that animation in America must be understood as the bastard child of its own avant garde, insinuating itself into spaces available to it at the moments of significant change within America's emergent culture. Animation, then, in the United States is not fantasist, but the language of projection and sublimation, played out in both populist contexts and creative 'arthouses' which did not recognise or describe themselves as such. As Robert McKee has noted from a highly pragmatic perspective in promoting the deep structures of story-telling in screenwriting, 'there is no necessary contradiction between art and popular success, nor a necessary connection between art and Art film'.[18]

One need only remark upon Disney's own self-consciousness about, and suspicion of, 'culture' to recognise that the mixture of humility and aesthetic ignorance which characterised his response was a resistance to foregrounding the status he perceived in 'art' and its apparent remove from the entertainment he wanted to provide for the average American.[19] Of course, this is also closely related to the idea of Disney's model of creating animation through an industrial and commercial process which

readily denied the specific artistic credibilities of individual creators and was predicated upon the 'branding' of the animated film in his own name. To demote the aesthetic in order to promote the spectacle in animation does much, however, to misrepresent its actual achievement, and the ideological and philosophic engine at its heart. Understanding this has divided critics and commentators throughout the century of animated film from America, and the debates which have characterised its evolution as a form have persistently engaged with this issue.

In general, criticism of the animated film is often predicated on its distinctiveness as an embodiment of 'pure cinema', and, most particularly, intrinsically related to what Disney had achieved by the 1930s, than in its more prototypic or various forms. This has configured animation in opposition to 'realism' instead of being recognised as an artistic interrogation of 'the real'. More often, more populist, if detailed and highly informed journalistic profiles of Disney himself or his studio have become a vehicle by which a particular kind of 'mainstreaming' has occurred, little challenged by more leftist critiques of the 'sweatshop' principle of industrial animation. Only among film art critics and practitioners did some assessment of meaning and effect in the animated film enter the debate, which soon gave way to analyses of issues of taste and creativity.[20] What is clear, though largely unacknowledged, however, is the fact that animation credibly supported and sustained this breadth and depth of interest and criticism. The animated film clearly said something different about American culture, and said it in a different voice. In many senses its emergence was grounded in what had become typically American grand narratives – pioneers creating a language of expression which explored new frontiers; apparently ordinary people applying their artisanal skills to achieve fulfilment as individuals and as progressive working communities; succeeding within the harsh conditions of industrial capitalism and the new machine age; expressing the desire for a liberal democratic consensus that embraced utopian values and ideals. At the very same time as animation spoke to these principles, however, it insisted upon its intrinsic difference and appeal, which ironically was concerned with unconsciously and unknowingly playing out the differential and progressive concerns of an avant-garde perspective. Crucially, as Stephen Dwoskin has noted, 'Even in the cartoon or dramatic animated film, the drawn image that represents figurative forms still has a stylized and generalized feeling rather than attempting

photographic realism'[sic].[21] It is this sense of 'style' and the notion of an expression of 'feeling' which underpins even what might be regarded as the most orthodox of animated films. These elements inform the very subjectivities and personal visions that characterise the most extreme examples of more experimental film art, but their place within what has become naturalised as a mainstream corporate entertainment practice should not detract from their presence and execution, both in animation's evolution as an art-form and as populist cinema. As Joe Adamson has warned though, 'The stylization, the exaggeration, the free-wheeling disregard for earthly reality are liberating enough for a scene or two, but it's a thrill that can wear out pretty quickly, unless it's given guidance beyond the momentary. The liberation is inherent in the medium; the control is up to the individual director.'[22] These points begin to advance an argument for animation as an intrinsically *auteurist* medium, and though this is clearly complex in the light of a great deal of animation from the United States being made within an industrial context, it remains important to address the contributions of individuals in the spirit of determining their particular vision, and, consequently, their particular 'take' on American culture. Repeated viewing of the Warner Bros. cartoon canon clearly shows, for example, that even within the context of 'Termite Terrace', the famed Warner Bros. animation studio, there were very different aesthetic and thematic inflections in the work of different directors, most notably Tex Avery, Bob Clampett, Chuck Jones and Frank Tashlin. Even lesser known figures like Isadore 'Friz' Freleng, Bob McKimson and Art Davis clearly had their own style. Writers and commentators have increasingly recognised this and named key figures across the industry as instrumental in the development of the genre, but have not really defined the principles of authorship underpinning these assumptions.[23] Again, the very attempt to delineate these factors has become a key stumbling block for a number of critics who can somehow sense the distinctiveness of animation, both in terms of its language, and its self-evident demonstration of an individual identity, but cannot quite articulate it.[24] This has resulted, ironically quite usefully, in speculative practices which have only enhanced the credibility of animation, and, perhaps most importantly from the point of view of this discussion, made claims for the animated film which prioritise its uniquely American qualities, while also addressing the ways in which other European and global art-forms have been absorbed within, and impacted upon its meanings and outcomes.

William Kozlenko, writing in 1936, at the moment when the Disney studio was fully establishing its prominence in the field, is merely one speculator, trying to assess the unique appeal of the animated cartoon.[25] Appositely, yet ultimately dismissively, he suggests that psychologists would claim that the appeal for adult audiences would lie in the indulgent regression into an adolescent state or in the opportunity to re-live the freedoms of a child's uninhibited imagination. Certainly, the child in its early years perceives animism both in the animate and inanimate, and clearly as a model by which the appeal of the animated film may be understood, this is a persuasive claim. Further, Kozlenko's view tells us much about the ways in which animation embodies a resistance to aspects of the civilising and socialising processes in western cultures, but for Kozlenko the absolute promise of animation lies in its claims to be free 'from the restrictions of an oppressive reality', and therefore to enable audiences to accept 'the logic of fantasy'. He concludes, thereafter, that in engaging with this logic – presumably the fundamental yet not articulated terms of animation itself – that the audience has to 'accept its conclusions, and though the resultant situations may be unlike those of reality, it does not question them'. For Kozlenko, then, animation is only escapism. It offers a parallel universe determined by its own inner logic, which ultimately requires acceptance not interpretation. This viewpoint wholly misreads the function of animation that I have already alluded to in relation to sublimation and projection, refusing the ways that animation has actually envisaged the wish-fulfilling dimensions of the dream, and re-formed the world in order to inflect representations of 'the real' with caricaturial comment and critique. Arguably, animation in its entirety may be viewed as a fundamental questioning and interrogation of the representational apparatus upon which the dissemination of ideas rests.

Kozlenko maps the trajectory from the 'world of limited movement to one of unlimited movement' in animation as the playing out of 'unrealised objectives', and ultimately, into the realms of a dream. He fails to note, however, whose 'unrealised objectives' these are, or why this parallel dream-like expression is required to accommodate them. This implicit refusal to accept the language of animation as anything more than the achievement of the tangibly unrealisable is to ignore its acts of deconstruction and re-construction, and the distinctive characteristics of animated narrative – metamorphosis; synecdoche; condensation; symbol and metaphor; penetration, sound etc. – as the facilitation of re-imagining,

re-envisaging and re-determining material existence and its psycho-
logical and emotional premises.[26] Inevitably, 'the dream' remains a con-
venient parallel to the language of animation because of its apparently
'like' qualities – most notably, the seemingly uninhibited free-play of
imagery. Arguably, animation may potentially be understood on the same
terms and conditions, and lend itself to psychoanalytic interpretation.
This may prove to be especially crucial in defining how animated films
may be compared to dream-states at the level of identifying the unreal-
ised objectives Kozlenko highlights, and the degree of wish fulfilment
played out in these texts. Martin Grotjahn suggests, for example, that
'[some] symbolic creations of little men trying to deal with the big
troubles of our time may be seen in Ferdinand the Bull with his passivity,
Mickey Mouse with his conquest of the machine, and Superman with his
dreams of glory'.[27] This perspective offers a view of animated characters
which transcends the subjective nature of any one dream and defines a
universal thematic intrinsic to populist definitions of the 'American
Dream'. Consequently, animated films within the United States in
engaging with particular preoccupations, conscious and unconscious,
may be read as projections which sit between 'consciousness' and 'con-
sensuality' defining a terrain which unpacks the ambiguities and contra-
dictions of the American character as it has been defined historically and
culturally. In being able to depict this seemingly inarticulable space,
animation, even in its most overt and readily understood forms offers a
degree of experimentality which oscillates between what Kracauer termed
'plastic beauty'[28] and what Sergei Eisenstein, in a more politicised stance,
defined as a 'plasmaticness', which he claims is subversive because: '[In]
a country and social order with such a mercilessly standardised and
mechanically measured existence, which is difficult to call life, the sight
of such "omnipotence" (that is, the ability to become "whatever you
wish") cannot but hold a sharp degree of attractiveness'.[29] This latter
view is especially provocative in the light of the more ideologically con-
servative views normally accorded to the Disney canon in particular, and
serves as a benchmark for the ways in which animation may be under-
stood as a vocabulary which moves more towards a sense of the 'unregu-
lated', and potentially 'unregulatable'. Animation can, therefore, offer
the greatest potential for expressing a variety of divergent points of view,
while at the same time accommodating a dominant paradigm of estab-
lished social meaning. This becomes especially important when viewing
animated films as a key barometer of any one historical period or context.

Kozlenko acknowledges that Disney cartoons do have contemporary social significance from 1933 onwards because, in his view, they exchange the mythical, .hypothetical, and dream-like for actual social reference points. He especially cites *Three Little Pigs* (1933) because he can prove its apparent social impact in the appropriation of the film's signature ditty 'Who's Afraid of the Big Bad Wolf?' as a rallying cry against the effects of the Depression and as an implied endorsement of Roosevelt's New Deal strategies. Interestingly, Walter Lantz's benchmark 'Oswald the Rabbit' cartoon, *Confidence* (1933), is rarely cited in this way, and yet it is absolutely explicit in its endorsement of Roosevelt's policies as the cure for the ills of the Depression era. Roosevelt advises Oswald that what is required is 'confidence' in the fundamental qualities of the nation, so returning to his small town context, Oswald literally injects the serum of 'confidence' into the local community, and America's economic and social stature is immediately revived nationally and globally. Ironically, it seems that the 'implied' message of the Disney cartoon, matched with an increasingly recognisable sense of status in the Disney 'brand' seems more persuasive than the quasi-propaganda of the Lantz film. Either way, the cartoon must be viewed as directly concerned with social conditions and the belief in progress.

Curiously, Kozlenko's point about *Three Little Pigs* operates as a recognition of the tensions I have already begun to explore in this introductory context. Firstly, it is clear that cartoons were grounded (consciously and unconsciously) in social reference points from the turn of the century and their initial emergence as a form, clearly long pre-dating *Three Little Pigs*. Secondly, animation is defined by the way that it uses the hypothetical and propositional in its interrogation of social reference points. Caught up in endorsing Disney's increasingly hyper-realist stylings – 'aesthetically questionable precisely because they comply with the cinematic approach'[30] – Kozlenko enjoys the mode of animation 'which entails no unhealthy distortion of the world of fact'. In reading animation in this way, Kozlenko, like many others, only promotes the medium as a vehicle for cogent social and political comment when it most approximates the very thing it most disengages with – live-action representation. This also indulges and endorses ideological as well as aesthetic principles, but denies the free-ranging perspectives of the more open and speculative execution of most animated films, even those with overtly propagandistic or informational messages. These perspectives – central to animation as an art – are its truly disruptive and potentially

subversive credentials, but for the most part they have been coralled into the fantasy/reality dichotomy that Kozlenko's piece is predicated upon.

Writing some forty years later, Robert Sklar also suggests that Disney films changed in 1933, delineating a shift from 'fantasy' to 'idealisation'.[31] He does acknowledge, however, that the Disney shorts which most correspond to a 'fantasy' which depicts no obvious social order to existence actually get close to portraying 'the cultural mood, the exhilarating, initially liberating, then finally frightening disorder of the early Depression years'. The 'idealisation' that then follows in Disney's films seems much more in tune with the moral absolutism and social discipline where order becomes paramount and conflict is played out in the certainty that its outcome will be a valuable lesson in the acceptable limits of responsible behaviour. The films from the Warner Bros. and Fleischer Brothers studios were essentially a direct corollary and antidote to this, but arguably Disney films can also be seen in a way that does not confine them to this strict schemata, again, even when they begin to adopt an even greater degree of verisimilitude. As F. E. Sparshott has argued, 'the basic illusion of movement by itself gives an impression not of reality but of a sort of unattributable vivacity'.[32] This is not unlike the perspective offered by veteran Disney designer Zack Schwartz, who suggests that Disney talked of the simultaneity of 'caricature' and 'reality', ultimately arriving 'at the view that "reality" was not the reality of the real world, but conviction'.[33] It remains important to recognise that the dominant paradigms that have come to categorise Disney films, dismiss cartoons, and ghettoise animation in general are all open to question when the alternative perspectives at the heart of the vocabulary of animation are properly recognised. The 'unattributable vivacity' and 'conviction' underpinning what is inevitably a contradictory and ambiguous medium of expression become the clues by which meaning can be attributed, but not fully determined. Consequently, animation in the United States offers the highest degree of discourse, a condition further compounded by the dominance of 'comedy' in the field.

The construction of a 'gag' in itself is a mode of disruption and breech; an alternative version of events and their possible outcomes.[34] As Durgnat has noted the gag is also 'a depersonalisation of emotional release',[35] and again, this usefully chimes with the modes of projection and sublimation I have already accorded to the animated text. In the broad context of American humour, the specific kinds of comic event in animation are distinctive both in their inventiveness and execution, and

as a meta-language by which significant attitudes and models of behaviour are depicted. Animation here offers a particular and historically determined notion of identity, conduct and status constructed through the frameworks necessitated by the comic stylings of a changing American culture from slapstick and visual comedy, through to the new immigrant humour, to post-war subjectivities and the increased levels of cynicism and irony in the contemporary era. As the comic inflections change so does the model of animation accommodating them, and consequently the aesthetic and social sensibility informing them. From the innocent slapstick of Disney's *Playful Pluto* (1934) to the counter-culture satire of *Thank You Mask Man* (1968) to the perverse sex and violence of Bill Plympton's *I Married a Strange Person* (1997), animation has stretched the boundaries of comic representation, and, with that, suggested that what might be previously viewed as a marginal point of view has a much more mainstream currency.

It remains then to address the evolution and development of animation in the United States with a greater degree of openness, taking into account the distinctive vocabulary of animation itself; the theoretical models which have confirmed its status as an art-form with significant sociological meanings and effects; the role of sublimation, projection and distanciation in animated texts as a viable model of alternative and subversive perspectives; and the differing approaches to comedy as they have informed change within animation. The final objective is to analyse the achievements in animation which delineate aspects of America and Americanness in a variety of historical, cultural and thematic contexts. The dominant presence of the Disney canon and the sense of homogeneity in 'the cartoon' has inhibited any potential reading of animation from the United States as anything but a medium which endorses and promotes ideological certainty in the guise of utopian populism and the rhetorical promise of 'the Dream'. At one level, the freedoms of expression available in animation speak rhetorically to the constitutionally determined sense of 'freedom of expression', but at another level, animation facilitates and enables this in a much more troubling and challenging way than has previously been acknowledged. The overused and undervalued term often attributed to the animated cartoon – 'anarchic' – needs considerable re-evaluation in this sense. Ultimately, animation in all of its production contexts has the capacity to subvert, critically comment upon, and re-determine views of culture and social practice. Its very language collapses structural fixities and known frameworks, and

fundamentally is especially responsive to, and expressive of, change. More than any other means of creative expression animation embodies a simultaneity of (creatively) re-constructing the order of things at the very moment of critically de-constructing them. Every animation re-orders the world; every anthropomorphised animal or object comments on what it is to be human; every line drawn, object moved, and shape changed is a destabilisation of received knowledge, and in the case of animation in the United States reveals what it is to be an American citizen, and how the 'melting pot' has figuratively and literally become the 'kaleidoscope' of nation and nationality.[36] In enunciating itself, animation enunciates America: history, mythology, freedom.

Notes

1. S. Kanfer, *Serious Business: The Art and Commerce of Animation in America from Betty Boop to* Toy Story (New York: Scribner, 1997), p. 231.
2. M. Langer, 'Animatophilia, cultural production and corporate interests: the case of *Ren & Stimpy*', in J. Pilling (ed.), *A Reader in Animation Studies* (London: John Libbey, 1997), pp 145–50.
3. This view is partly endorsed by what may be regarded as some of the definitive works in animation history, most particularly Michael Barrier's exhaustive and invaluable study of the 'Golden era'. See M. Barrier, *Hollywood Cartoons: American Animation In Its Golden Age* (New York and Oxford: OUP, 1999).
4. G. Waller, 'Mickey, Walt and Film Criticism from *Steamboat Willie* to *Bambi*', in D. Peary and G. Peary (eds), *The American Animated Cartoon* (New York: E. P. Dutton, 1980), p. 57.
5. See P. Orton, Keynote Address, 'Animation Means Business' Transcript, Producers Alliance for Cinema and Television, March 2000, pp. 2–5.
6. Interview with the author, April 1996.
7. R. Cardinal, 'Thinking through things: the presence of objects in the early films of Jan Svankmajer' in P. Hames (ed.), *Dark Alchemy: The Films of Jan Svankmajer* (Trowbridge: Flicks Books, 1995), p. 89.
8. D. Crafton, 'The View from Termite Terrace: Caricature and Parody in Warner Bros. Animation' in K. Sandler (ed.), *Reading the Rabbit: Explorations in Warner Bros. Animation* (New Brunswick and New Jersey: Rutgers University Press, 1998), p. 119.
9. See K. Cohen, *Forbidden Animation* (Jefferson, North Carolina and London: McFarland & Co, 1997).
10. S. Cavell, 'Words of Welcome', in C. Warren (ed.), *Beyond Document: Essays on Non-Fiction Film* (Hanover: Wesleyan University Press, 1996), p. xix.
11. P. Hames, 'Interview with Jan Svankmajer' in P. Hames (ed.), *Dark Alchemy: The Films of Jan Svankmajer* (Trowbridge: Flicks Books, 1995), p. 111.
12. H. Kenner, *Chuck Jones: A Flurry of Drawings* (Berkeley and London: University of California Press, 1994), p. 33.
13. S. Kracauer, *From Caligari to Hitler: A Psychological History of the German Film* (Princeton University Press, 1947), p. 68.

14. L. Eisner, *The Haunted Screen* (London: Secker and Warburg, 1983), p. 33.

15. For a brief discussion of Lotte Reiniger's career and her film *Papageno* (1934), see P. Wells, 'Art of the Impossible' in G. Andrew (ed.), *Film: The Critic's Choice* (Lewes: The Ivy Press, 2001).

16. G. Waller, 'Mickey, Walt and Film Criticism from *Steamboat Willie* to *Bambi*', in D. Peary and G. Peary (eds), *The American Animated Cartoon* (New York: E. P. Dutton, 1980), p. 50.

17. E. Panofsky, 'Style and Medium in Motion Pictures', in G. Mast and M. Cohen (eds), *Film Theory and Criticism: Introductory Readings* (London and New York: OUP, 1974), p. 160.

18. R. McKee, *Story* (London: Methuen 1999), p. 89.

19. Quoted in P. Wells, *Understanding Animation* (London and New York: Routledge, 1998), p. 231.

20. See E. Smoodin (ed.), *Disney Discourse* (London and New York: Routledge/AFI, 1994); J. Wasko, *Understanding Disney* (Cambridge: Polity Press, 2001).

21. S. Dwoskin, *Film Is* (London: Peter Owen, 1975), p. 230.

22. J. Adamson, 'Suspended Animation', in G. Mast and M. Cohen (eds), *Film Theory and Criticism: Introductory Readings* (London and New York: OUP, 1974), p. 395.

23. See, for example, J. Adamson, *Tex Avery: King of Cartoons* (New York: Da Capo, 1975); L. Cabarga, *The Fleischer Brothers Story* (New York: Da Capo, 1988); H. Kenner, *Chuck Jones: A Flurry of Drawings* (Berkeley and Los Angeles: University of California Press, 1994).

24. I am attempting to address some of these issues in P. Wells, *Animation: Genre and Authorship* (London: Wallflower Press (forthcoming)).

25. W. Kozlenko, 'The Animated Cartoon and Walt Disney' in L. Jacobs (ed.), *The Emergence of Film Art* (New York: Hopkinson and Blake, 1969), pp. 246–53.

26. See P. Wells, *Understanding Animation* (London and New York: Routledge, 1998), pp. 68–127.

27. M. Grotjahn, *Beyond Laughter: Humor and the Subconscious* (New York and Toronto: McGraw Hill, 1957), p. 206.

28. S. Kracauer, *Theory of Film* (Princeton: Princeton University Press, 1997), p. 186.

29. J. Leyda (ed.), *Eisenstein on Disney* (London: Methuen, 1988), p. 21.

30. S. Kracauer, *Theory of Film* (Princeton: Princeton University Press, 1997), p. 89.

31. R. Sklar, 'The Making of Cultural Myths – Walt Disney' in D. Peary and G. Peary (eds), *The American Animated Cartoon* (New York: E. P. Dutton 1980), p. 57.

32. F. E. Sparshott, 'Basic Film Aesthetics' in G. Mast and M. Cohen (eds), *Film Theory and Criticism: Introductory Readings* (London and New York: OUP, 1974), p. 213.

33. From 'Disney Discourse: On Caricature, Conscience Figures, and Mickey, too' in P. Wells (ed.), *Art and Animation* (Academy Group/John Wiley, 1997), p. 6.

34. P. Wells, *Understanding Animation* (London and New York: Routledge, 1998), pp. 127–87.

35. R. Durgnat, *The Crazy Mirror: Hollywood Comedy and the American Image* (London: Faber and Faber, 1969), p. 102.

36. For a useful explanation of these metaphoric positions see J. Macdonald, 'Conceptual Metaphors for American Ethnic Formations' in P. Davies (ed.), *Representing and Imagining America* (Edinburgh: Edinburgh University Press, 1996), pp. 84–92.

Animation and Modernism

The emergence of the animated film in the United States is coincident with what is recognised as the period of late Modernism. Little work has engaged with the particular problematics animation poses within the dominant paradigms of Modernist thought and achievement. On the one hand, early cartoon animation speaks only to sources in the populist forms of vaudeville and the comic strip,[1] and, as Donald Crafton has noted, also takes its predominant aesthetic from the 'lightning sketch' in its improvisatory and transitory status.[2] On the other hand, it is possible to locate animation within some of the Modernist practices across the arts, and some of the philosophic aspects of the avant garde. Significantly, this re-contextualisation enables animation to be viewed as a progressive language which refuses the ahistorical stances of much Modernist art while at the same time re-determining the formulations of graphic expression beyond the established codes of pictorialism and motion picture design. In this respect animation distinguishes itself from the quickly emerging generic tendencies of the early cinema – itself, perhaps, the embodiment of the Modernist age – by having a specific vocabulary that was different to the language of live-action film. This scarcely acknowledged fact, and the secondary status therefore accorded cartoonal forms, has prevented animation in this period being fully noticed as a new language, and an intrinsically Modern form. Interestingly, this chimes with other aspects of the visual arts in the late nineteenth and early twentieth centuries. As Nigel Whale has suggested,

> Pictorial art of the period has focused on the surface of the painting itself as the locus of attention, as the flatbed or plain where abstraction articulated the exchanges of perception and memory; this was done in reaction against the pre-Modernist view of painting as a perspective on a version of the visual world.[3]

Animation in the United States at this time is highly correspondent to

this model. The films of J. Stuart Blackton, Raoul Barre, Earl Hurd, Otto Messmer and Winsor McCay essentially work as explorations of the limits of graphic space, playing out abstraction through the narration of perception and memory in rapid metamorphoses – literally the perceivable evolution of one form into another – and intense condensation – the maximum of suggestion in the minimum of imagery. The 'abstract' here is the play of lines, shapes and forms in the enunciation of time, space, weight and flow; a 'caricature' of realist practice at best; the collapse of received perspective thereafter. The primacy of the comic practices within this mode of abstraction has done much, however, to detract and distract from the art-making in this process, and, indeed, the possible recognition of the sovereignty of the artist – figures like those named above, who historians have reclaimed as unrecognised pioneers.[4] Largely, these figures have essentially been championed in a spirit of resistance to Disney's claims as the defining spirit in the development of animation as an art-form. In many senses, of course, Disney's position is unassailable, and his achievements as artist-provocateur, technical innovator and industrialist irresistable.[5]

There is an intrinsic problem with a Modernist approach when applied to Disney, though, in the sense that Disney himself has no status as a graphic artist, as he was not a particularly able draughtsman or animator, but he has significant status as a 'moderniser' of the form in relation to enhancing the technology, industry and 'idea' of the medium. Richard Schickel has suggested that 'It is the business of art to expand consciousness, while it is the business of mass communications to reduce it. At best this swiftly consummated reduction is to a series of archetypes; at worst it is to a series of simplistic stereotypes. Since the eyes of proprietors, especially after the initial act of creative inspiration is finished, are usually focused on something other than this matter of consciousness and sensibility – if indeed, they are aware of it at all – the reductive process usually proceeds erratically. This was so in the case of Disney'.[6] Schickel's perspective both acknowledges and diminishes Disney's investment in the form, but it does enable an approach which at least allows for greater recognition of the initial issues which were at stake when Disney was seeking to establish himself and his 'idea', and influence those who worked with him. Arguably, his collaborator, Ub Iwerks, has significant Modernist credentials as it was he who executed the first successful Disney shorts in a distinctive signature style which was modified only through Disney's increasing movement back towards realist tendencies.

As Michael Barrier has noted, 'Iwerks was that great rarity, an animator who could work straight ahead without losing control of his animation',[7] but this approach caused problems because Disney wanted to adopt the working process of drawing two 'extreme' poses for his characters, and 'in-betweening' the movement from one to the other, rather than drawing in the 'direct' fashion of moving from one image to the next – the process used by illustrator and comic strip artist Winsor McCay. This approach was predicated less on using the graphic codes which informed the more open and immediate visual improvisation and artifice championed by Otto Messmer in the *Felix the Cat* cartoons, and looked more to 'realist' conventions. Disney's idea did not sit well with Iwerks' Modernist styling. Barrier again notes 'turning characters into machines was the sort of thing that came easily to an animator with Iwerks' facility; "character action", or animation that aroused interest in the characters themselves, was another matter'.[8]

The Disney/Iwerks Laugh-O-Grams of the early 1920s 'featured numerous comments about Kansas City events' but were distinctive in their desire to 'present a look of quality ... using wash tones and tremendous amounts of background details – which was something missing from competing cartoon studios'.[9] Acknowledged by fellow animator Friz Freleng as 'a genius when it came to the mechanics of animation',[10] Iwerks did much to enhance graphic aesthetics and quality of movement. Barrier adds '[Iwerks] could have made a strong claim to stand on an equal footing with Walt as a creator of cartoons, and any such claim would have had a legal dimension because Iwerks was part owner of the studio. [Composer Carl] Stalling, too, could have made claims that came with ownership – he had invested two thousand dollars in a separate Disney Film Recording Company – and, like Iwerks, he had resisted accommodating himself completely to Walt's demands'.[11] This is an important observation as it allows the view that before Disney completely imposed himself and his creative principle upon the industrial manufacture of cartoon forms, other authorial voices underpinned its claims to Modernity. Iwerks' most specific achievements may be seen in *Gallopin' Gaucho* (1928), *Steamboat Willie* (1928) and *The Skeleton Dance* (1929), in which the characters' 'rope-like' design corresponds with Russian film director and theorist Sergei Eisenstein's notion of 'plasmaticness', and the sense of elasticity which he cites in related art-works as diverse as those of German caricaturist Walter Trier, the illustrations of John Tenniel, the woodcuts of Japanese artists Toyohiro, Bokusen and

Hakusai, and the work of Wilhelm Busch. Iwerks uses the freedoms of the graphic space and the literal surfaces of figures and forms to achieve what Eisenstein describes as 'a rejection of once and forever allotted form, freedom from ossification, the ability to dynamically assume any form'.[12] In beginning to define the potentiality of the cartoon, artists like Iwerks were re-determining the established codes and conventions of the pictorial, and radically re-determining the perception of the cinematic space as a reconciliation with, and representation of, 'the real'. The social was rapidly re-aligned with a radical aesthetic which played out the very implications of change that it was implicitly recording.

The art making of Blackton, Mesmer, McCay, Iwerks *et al.* is disguised predominantly by its apparent simplicity, but this, coupled with the often subversive content of early animation, again speaks to some of the contradictions within the Modernist profile of the industrial age. Again, as Wheale has noted,

> ... one tendency within it can be described as a rationalist, modernising ambition which endorses technological progress and the renovation of society through aggressive administration and directed change. Simultaneously ... there is a reaction against everything that is to be understood as modernity – rejection of the metropolis, of technology, of the scientific administration of life and the social sphere ...[13]

It is clear that in animation, the pioneers embraced the notion of technological progress and, ultimately, its rationalisation into an industrial mechanism, but at the same time readily engaged with the impact of new urbanity, the role of science and technology, and the re configuration of what it is to be human under these new conditions. In one sense, it may be argued that this is a key reason for the deployment of a 'folk' idiom as a reaction to change, but more significantly, the freedom of expression afforded by animation facilitated the simultaneity of abstraction and accessibility, creating ambiguous discourses concerning technological determinism. Further, it is perhaps no accident that the implied discourse about the fate of humanity is principally played out through the abstraction of anthropomorphism. In many senses, confronting animality was addressing another dimension in which the relationship between the animal and humankind was in some way unfathomable yet somehow an implied mirror of what it is to be human at a critical moment when this seemed under threat.

Eisenstein goes further and argues,

It's interesting that the same kind of 'flight' into an animal skin and the humanisation of animals is apparently characteristic for many ages, and is especially sharply expressed as a lack of humaneness in systems of social government or philosophy, whether it's the age of American mechanisation in the realm of life, welfare and morals, or the age of mathematical abstraction and metaphysics in philosophy.[14]

In this early period, the 'difference' embodied by the animality of Gertie the Dinosaur, Felix the Cat or Mickey Mouse also embraced the freedoms of the medium and its potential meanings and effects. Once again, as Disney further impacted upon animation as a form, marshalling its possibilities more into a hyper-realist style, he also inhibited its expressive possibilities. Patrick D. Murphy suggests '[the] denial of *wild* nature serves the fabrication of a timeless, universal and unchanging order articulated in part by means of cultural values and generalisations'.[15] This process towards a sense of 'universality' in Disney's films may be read, therefore, as a quasi-censorial engagement with his proposed material, that Richard Schickel argues was a drive towards 'multiple reductionism': 'wild things and wild behaviour were often made comprehensible by converting them into cutenesses, mystery was explained with a joke, and terror was resolved by a musical cue or a discreet averting of the camera's eye from the natural processes'.[16] This approach to story-telling carries with it an ideological charge and a moral outlook that came to characterise Disney's work, and, arguably, won the studio its popular audience. The ideological imperative in Disney's *Silly Symphonies* and early features may be understood as populist utopianism, accentuating the positive, the aspirational and the rural, in the face of an advancing modern world. Ironically, this folk sensibility ran in parallel to Disney's own on-going development of an industrial base for the production of cartoons. The modernising principles Disney sought to bring to the production process also fixed an aesthetic style that was intrinsically and increasingly bound up with conservatism, consensus and conciliation. This commercially and industrially viable sense of the 'modern', however, carried with it little of the modernity of expression at the heart of early cartoon forms. Early animation insisted upon a sense of otherness, and a resistance to such limitations in the face of this fast-changing social climate. This becomes the presiding tendency of this exploratory period before Disney's industrial process and the development of the animated feature privileged personality animation, story-

telling in the classical mode, and aesthetics encultured in tradition, rather than progress. Steven Watts has suggested that this resulted in a version of a 'sentimental modernism', which may be understood as the hybridisation of realist and fantastic forms within a Victorian ethical coding, that embraces the material world as a place that can be ultimately rationalised, reconciled of its dangers, and invigorated by the buoyant energies of popular creative idioms, all of which fundamentally underpin what has become identified as 'Classic Disney'.[17]

Frederick Karl notes, however, that '[the] sense of Modern and Modernism in any era is always of "becoming". It may be becoming new and different; it may be subverting the old, becoming an agent of disorder and even destruction'.[18] This readily relates to the dominant characteristic of metamorphosis in animation where all the events depicted in the graphic space are literally 'acts of becoming', transitory and formative. Animation is the very language of the Modernist principle, often transcending linguistic necessity and enhancing fine art practice by challenging compositional and representational orthodoxies. In this paradigm it is important that 'Modernism' is recognised not as a monolithic entity, played out only through the dominant aesthetic influences of the bohemian élites of Paris, New York and Chicago, but as an impactive imperative upon all aesthetic cultures to address the mechanisms of expression and perspective. Ultimately, such art becomes a symbolic inflection of changing models of experience and is not confined to any one historical period, but social moments which insist upon revising existing rules and consensual guidelines which have arguably been naturalised in a way that sustains outmoded ideological frameworks. At its most basic, it is clear that the turn of the century agendas which became the radical modifications of modern life right through until the Second World War changed the physical and material world. This inevitably led to a changed sensibility. Humankind had to come to terms with the psychological and emotional implications of a new age. The inherent stability of previous eras was collapsing in the face of a recognition of the increasing relativity, subjectivity, and incoherence in modern life. At one level this was conceived in an iconoclastic and potentially revolutionary way; at another it merely informed a heightened mode of thinking in the ways that the 'artificialities' of art practice could serve adversarial, or merely 'different', values.

Michael Featherstone has articulated a number of characteristics of Modernity which reinforce these points.[19] He suggests that there occurred

'a rejection of the notion of an integrated personality in favour of an emphasis upon the de-structured, de-humanised subject'. Although the prevailing orthodoxy concerning animated characters is their supposed cohesion around dominant personality traits and predictable behaviours, it is arguably more pertinent to view these characters as literally 'de-humanised' both in regard to their graphic status, their representation as 'animal' forms, and working in the service of the immediate needs of the gag, the narrative or the theme. It is no accident that characters like Felix the Cat, or even Mickey Mouse in his formative years, increasingly assume the status of 'Everyman' as they take on a greater diversity of roles and levels of engagement. Donald Crafton usefully delineates the thematic breadth enjoyed, for example, by Felix the Cat.[20] He exists as an outsider and rebel in *Felix Revolts* (1924); under threat in *Felix in Holly-wood* (1923); starving and rejected in *Felix Gets the Can* (1924); dream-like and hallucinatory in *Felix Dines and Pines* (1927); as a good samaritan in *One Good Turn* (1926); and, somewhat contradictorily, as a philanderer and 'stop out' in *Felix Woos Whoopee* (1928). Crucially, though, Felix also needs to be understood as the distinctive outcome of the *auteurial* imagination, not yet bound into the orthodoxies of an industrial process or a studio brand. Michael Barrier suggests 'because Felix was wholly [Otto] Messmer's creation, he could act as a surrogate for both his creator and the audience, exploring on their behalf a strange and treacherous place'.[21] Mickey Mouse, too, adopted an extraordinarily broad range of roles and contexts: 'a gaucho, teamster, explorer, swimmer, cowboy, fireman, convict, pioneer, taxi-driver, castaway, fisherman, cyclist, Arab, football player, inventor, jockey, storekeeper, camper, sailor, Gulliver, boxer, exterminator, skater, polo player, circus performer, plumber, chemist, magician, hunter, detective, clock cleaner, Hawaiian, carpenter, driver, trapper, whaler, tailor and Sorceror's Apprentice'.[22]

These factors relate to Featherstone's view that Modernism favoured 'a rejection of narrative structure in favour of simultaneity and montage' and 'an exploration of the paradoxical, ambiguous and uncertain open-ended nature of reality'. In being played out through an often self-contained, fragmentary, improvisatory short-form, animation's condensation effects offer increased degrees of suggestion and a sense of spontaneity, often using juxtapositional and counterpointing strategies to drive the progress of the visual events. With the 'gag' predominantly at its centre any animated context offers contradiction; at once providing a significant representational position yet simultaneously challenging its

status, particularly in the spirit of realist orthodoxies and ideological certainty. This inevitably begs the question of how the form itself is readily servicing these agendas and who is addressing them. The position of the animation pioneers, therefore, can be read as part of Featherstone's ultimate condition of Modernist culture in demonstrating 'aesthetic self-consciousness and reflexivity'.

Ironically, the form's greatest acknowledged 'auteur', Walt Disney – a man whose limited draughtsmanship signalled his early disengagement from the actual process of making animated films – has come to symbolise a mode of authorship which actually misrepresents the 'signature' developments of key figures in the pre-Disney-dominated era. It is in this sense, as much as any other, that it is crucial that early animators are recognised because they represent a model of creative endeavour which is of its time, and both precedes and anticipates, as well as informs, the rapid changes in the form as it became a modern 'industry'. Indeed, it is this development which determines how animators and animation were perceived thereafter. Once the Disney studio cast its long and profoundly influential shadow over the art of animation, it was extraordinarily difficult to view alternative kinds of work as comparable, or even artistic, let alone 'Modern'. If the élite avant-garde writers and artists essentially enjoyed the economic security of societal contexts which in effect sponsored work or endorsed the emergent voices of social and class allegiance, then the pioneer animators became the victims of the labour-intensive, financially draining aspects of the medium. With the need to create an industrial base for animation to facilitate cost-effective methods of production and distribution came the concordant perception of animation as an artless comic genre; ultimately 'branded' rather than authored. While the avant garde could afford to promote its individualism and identity, the graphic artists in animation and the Modernist credentials of animation itself became increasingly unacknowledged.

Animation was a language by which the 'ephemeral' understanding of the Modern could be both philosophically suggested and literally depicted. The early animators were essentially taking the codes and conventions of the comic strip, vaudevillian performance, perspective drawing and observational modes of realist representation, and re-designing a form. This is a practice highly comparable to those made in the fields of music, painting and literature. The process of animating shapes, forms and figures, and the outcomes of re-configuration move towards levels of abstraction which echo the practices of Braque and Kandinsky. The

chief influence of early American animation in this way was Frenchman Émile Cohl,[23] whose work emerged out of the 'Incoherents' school of quasi-surrealist artists working between 1883 and 1891 which insisted upon spontaneity and improvisation in art-works. His animation was described in *Moving Picture World* (19 December 1918)[24] as 'geometry at play', and this usefully defines the way that 'incoherent' animation – effectively the freeplay of lines evolving into often unrelated pictorial and narrational events – informed the work of Blackton, McCay and Messmer. Here the relationship to Modernist literature is also clear, in the sense that the rapid metamorphoses at the heart of these films, and which were distinctive to animation, were highly correspondent to the stream of consciousness, free-associational work of Joyce and Woolf. As Karl has noted, '[it] made a kind of coherence of what we know intellectually to be the incoherence of the unconscious'.[25] The animated form embodied the very 'contingency' of Modern art, but in demonstrating a new typology of 'order' was not wholly antipathetical, nor disparaging of the familiar. Essentially the form called attention to itself and its departure from the normal conventions of graphic representation in order to properly facilitate a view of contemporary life rather than a resistant perspective upon it. Further, while being a self-evidently 'different' film form, it was still predicated upon the idioms of established popular entertainment, and even in spite of its costs and its time-consuming means of production, was believed to be commercially viable.

Here Karl's configuration of moderate, radical and conservative Modernism[26] proves useful in the sense that it helpfully engages with the potential difficulty in accepting a correspondence between the ramifications of major art movements and the progress within the field of popular art-forms. Further, it enables a distancing from the 'sentimental Modernism' identified in the works of Disney by Watts. 'Moderate' Modernism is effectively a contemporary art-work which is located in its period but is only partially experimental or not experimental at all; 'radical' Modernism resists generic absorption and is predicated on committed experimentation; while 'conservative' modernism is effectively a found object in the present which is merely an inevitable development or pastiche of past models. Many artists, even within single works, can oscillate between these positions, and often create works in which assimilation and de-familiarisation are simultaneous effects. The early animation pioneers uniformly achieved this, and though they did not politicise their art through high-profile social posturing or the

proliferation of manifestos or journals, they certainly came to increasingly constitute the milieu artiste which operated as both an aesthetic and a policy-driven 'cell' comparable to the self-conscious intellectual and political groupings of the American avant garde. There is perhaps no surprise in this if it is recognised that, as Steven Watson has suggested:

> Mainstream culture in turn-of-the-century America was moribund. In the years before the formation of the American avant garde, the National Academy of Design seemed incapable of responding to change, American poetry had lain fallow for a generation, and theatre consisted of little more than crude melodrama and frothy comedy. It was almost a cliché to remark that all art had already been painted and all poetry had been written. The cultural establishment was ripe for takeover.[27]

The 'shock of the new' was in some senses inevitable, and was not confined to the most radical or overtly transformational contexts. Animation is a self-conscious art that does 'de-humanise' in the same fashion claimed of the new plastic arts but refuses any anti-human stance. Instead its re-determination of the human facility in sometimes near oneiric, or what might be simply termed projected, states offered as many new perspectives. Freud's ideas were slowly disseminated, diluted, distorted, and (consciously and unconsciously) appropriated into many forms of artistic expression. 'Aberrant' human expression became part of a seamless continuity with lineal, sequential, waking perspectives, yet was demonstrably 'alternative' and a considerable fuel for new artistic endeavours and achievements. The breaking of boundaries was easily facilitated in animation; so much so that its conditions have not been properly acknowledged as the engine of truly 'Modern' thought in its effacement of orthodoxy and its substitution of the 'new'. What occurred, and has in many ways prevailed, was an understanding of animation which was based on the naturalisation of impossible events, and, thereafter, a 'taken-for-granted' acceptance of a magical and comical language in animation, not its aesthetic openness.

I have discussed elsewhere aspects of the evolution of animated film in the United States, and this is well documented in a number of contexts, so here I do not wish to recount the detail of events; rather I wish to discuss them within the frame of reference I have outlined. J. Stuart Blackton's stop-motion film *The Enchanted Drawing* (1900) is an example of a film text which is predicated on some of the early camera tricks

which emerged out of literally experimenting with the possibilities of the new photographic medium. The motion picture camera could stop, start, be under-cranked, over-cranked, fade, dissolve, elide and so on, but it wasn't until film-makers became conscious of the ways these effects could be used to create particular outcomes that the illusionary 'magic' of moving image-making became clear. Part-Vaudevillian in its execution – a fat man's face literally scowls when images of a bottle and glass (and the implied promise of a drink) become three-dimensional and are removed by an unseen hand – this proto-animation almost offers a demonstration of the sleight-of-hand seen only at a distance in the theatre. The sense of surface is being foregrounded at the expense of narrative or spectacle. *Humorous Phases of Funny Faces* (1906), also created by Blackton, and Albert E. Smith, is effectively an animated 'lightning sketch' and operates in the same way, positing the same question of 'how is it done?' at the same time of its near revelation. The chalk-drawings – basic configurations – defy the logic of their seemingly static demeanour, crucially demonstrating an early version of the manipulation of graphic space in a way that flouts previous modes of representation. This 'moderate' modernity becomes an important signifying practice for later developments because it posits the idea of an apparent dislocation into a parallel context in which representational norms are in flux even when still depicting predictable outcomes to gags or events. The very 'artificiality' of the space is being used to create new relations between space, time, weight and flow. Effectively, the film is a set of experiments in using this vocabulary.

In the first instance, of course, this was often related to 'unimaginable' states, or highly correpondent to the idea that 'supernatural' or 'magical' forces beyond the comprehension of humankind could in some way be captured or more readily understood. This added to the mystique of animation as an unknown technique which was seemingly bringing a different perspective to perceived existence. In many senses, Blackton's groundbreaking *The Haunted Hotel* (1907) (produced by the enterprising and entrepreneurially aware Vitagraph company) as well as proving that animation could potentially operate as a commercially viable practice in its own right, serves as a bridge between the gothic sensibilities of late Romanticism and the effects of Modernist re-configuration. If the anxiety underpinning the gothic outlook was the intrinsic fear of the unknown, then here was that anxiety literally played out through objects which had

a life of their own – a knife slicing sausage; utensils laying themselves on a table; beverages pouring themselves and, ultimately, the house itself metamorphosing into an organ. As Clive Bloom has noted, '[although] usually immaterial, the supernatural planes are deemed to be superior to the visible and material and are feared and held in awe accordingly' and their representation and its outcome in expressive forms depicts 'trans-substantiations, metamorphoses or other acts of direct control over the material and invisible environment' and consequently, reveals the combination of 'belief with technique and a mastery over process'.[28] Seemingly, the nature of change and the underlying primal and social sensibilities which drove it were evidenced in the very form of the animated film. Animation moved beyond 'the trick' and posited 'otherness' as anything from a state of mind to a destabilised environment. Almost in anticipation of the horror genre in mainstream movie-making in the 1930s, animation literalised what may be viewed as the development of 'science' in the late nineteenth century as a tension between legitimate exploration into the world of the unknown (and the very creation of life itself) and a supernatural context which revealed a new-world psychology potentially akin to 'madness'. Crafton argues that 'the turn-of-the-century fascination with self-propulsion' and the self-evident progressive dynamics of the aeroplane and automobile, with their 'liberating freedom of movement' was found in 'inanimate objects of everyday life' and vividly depicted in animated films.[29] *Le Mouvement Américain*, as it was known in France, proved to be an approach to film-making which invested the taken-for-granted aspects of the material environment with their own kinetic aesthetic and found in them the 'essence' of autonomy. The utilitarian sense of the 'real' was replaced by the dramatic process of a spectacular subjectivity which advocated its own Modernist credentials.

A crucial figure in the progress of the animated film in this sense was *New York Herald* cartoonist Winsor McCay. In many ways it is McCay who insists upon the movement from the aesthetics of the 'lightning sketch' and the open graphic palette into more developed forms. As Michael Barrier notes, '[Otto] Messmer was wholly a cartoonist, whereas McCay drew in an elaborate illustration style – but as film-makers they worked much alike'.[30] Arguably, it is McCay who also properly recognises animation as a Modernist practice and seeks to extend the quickly established 'formula' of the 'lightning sketch' film – predominantly the presence of an artist sketching on an appropriate surface until the shapes and forms seem to move of their own accord – into a model which

foregrounds the significant presence and work of the artist. This is partially related to the fact that McCay was already renowned as a comic-strip artist, and the later contextualising live-action in a number of his shorts serves only to enhance this notoriety and the sense that McCay himself is an artist willing to engage in a challenge which self-evidently progresses the form.

Like Blackton, McCay worked initially as an artist-reporter, sketching news events for the *Cincinnati Commercial Tribune*. His understanding of the immediacy and necessary accuracy of his depictions grounded him in a journalistic mode of representational realism that he was to reject in his comic strips like 'Dream of a Rarebit Fiend' in William Randolph Hearst's *New York Herald*, and later, his animation. Indeed, he was to use animation to depict the very things that could not be enacted in the material world, but were intrinsic to it – dream-states, projected illusions, primal memories of extinct or unfamiliar creatures, fantasies and so on. *Little Nemo* (1910) includes a prologue in which McCay responds to a challenge from his club friends 'to make four thousand pen drawings that will move – one month from date'. This effectively foregrounds McCay as an artist with intent and originality, yet posits the labour-intensive nature of the project as potentially insurmountable. Having drawn the characters of Nemo, Impy and Flip in 'lightning sketch' style, where the audience literally witnesses McCay's skill as an artist, and the banter with his colleagues, McCay proceeds to make the film, surrounded by a plethora of materials. An image of Flip, with the title 'watch me move' written above his head, begins a sequence in which all three figures become arbitrary graphic projections, compressing, stretching, elonga-ting; shapes and forms which dispense with the orthodox representa-tional capacity of the body, indeed with the very notion of the body itself. Nemo creates his own princess and rides away with her in a dragon's jaws while Impy and Flip drive off in a car that eventually explodes. Fragments of fairytale mix freely with the sense of circus frivolity and machine angst.

Judith O'Sullivan argues that in both his art nouveau comic strips and the later films 'McCay's vision anticipates Surrealist explorations: appearances are unstable, nature is hostile, objects come together in irrational conjunctions, mechanical devices are frequently threatening'.[31] McCay's alternative worlds capture the contradictions of the modern age, caught between pragmatism and progress. His second animation, based on one of his early 'Rarebit Fiend' strips, *The Story of a Mosquito*

(1912), is arguably one of America's first horror films in that it depicts a mosquito with a sharp penetrating proboscis drawing blood in ample quantities from a sleeping assailant before exploding through over-indulgence. Only the 'personality' of the mosquito and the vaudevillian asides save the creature from being a monstrous 'other', and, as Crafton has suggested, '[there] is certainly a disconcerting Freudian aspect to this image of compulsive vampirism'.[32] The sleeping man is open-eyed, rest-less and anxious in his sleep. Again, there is an ambiguity here that refuses stability and foregrounds the underlying threat that McCay perpetually portrays in his vision of dreams, which are rarely inflected with secure and reconcilable conditions. It seems likely that McCay was merely playing out the very contradictions of being an artist in the formative years of the century in which industrialism, commercialism and art were coerced into a new configuration. As O'Sullivan notes,

> His love of technology led to his pioneering efforts in the develop-ment of the film, although he himself never exploited the commercial possibilities of the medium. His oeuvre reflects the tensions origin-ating in his paradoxical personality. An intensely private person, McCay became a vaudevillian but performed in absolute silence. An accomplished inventor who contributed to the development of the American motion picture, McCay maintained an ambivalent attitude towards technology, in the comic strip *Dream of a Rarebit Fiend* treating the mechanical as a threat and in real life refusing to drive an automobile. An artist of vast imaginative ability with an affinity for the fantastic, McCay suffered from a troubled social conscience, which manifested itself in the intrusion of reality into the world of the dream.[33]

In some ways, McCay's more socially oriented perspectives are manifest in his most famous creation, *Gertie the Dinosaur* (1914), and in the quasi documentary, *The Sinking of the Lusitania* (1918). Gertie was shown as part of McCay's vaudeville act, and was an early example of interactive media in which McCay, as a ringmaster, appears to instruct Gertie, comment on her demeanour, throw her objects, and eventually ride away with her in what must have been an appealing transition as McCay moves from his physical presence on stage to apparently take his place within the cartoon. Shown in this non-cinematic but theatrical context, and still operating with the same degree of mystique and surprise where-by audiences remained uncertain about how the illusion was achieved,

Gertie was a phenomenal success. Images of unimaginable creatures, and a 'fantastic' primitive setting, played out through the open vocabulary of a freely used graphic space defined *Gertie the Dinosaur* as another example of an 'abstract animism'[34] which engaged popular tastes for the new. Interestingly, though, and partly confirmed by the prologue to its theatrical release as a film (which features a number of McCay's cartoonist colleagues working for Hearst, who view a brontosaurus skeleton at the Museum of Natural History), there is a perceptible shift to a grounding in an authenticity informed by historical research. The film was conceived partly in association with the American Historical Society, and the imperative to render a plausible creature stresses to a much greater degree the need for anatomical correctness, especially in regard to the size of the dinosaur and its movement capabilities. The playfulness of the character and its 'spot-gag' spontaneity, however, are clear examples of the kind of 'personality animation' which Disney was influenced by, and came to specialise in. McCay's influence on Disney is acknowledged in Disney's re-enactment of McCay's stage performance in 'The Art of the Animated Drawing', an episode from the *Disneyland* television series, shown in the late 1950s and early 1960s. Such acknowledgement was perhaps the necessary endorsement of McCay's actual achievement as it properly foregrounded the artist in the way that his 'interactive' reflexivity both on film and in performance sought to do. Such a model was later followed by Disney himself in the *Alice in Wonderland* series, the Fleischer Brothers in the *Out of the Inkwell* films and in films by Raoul Barre and Charles Bowers and much later throughout the Warner Bros. canon. Simply, in identifying the artist, and literally demonstrating the distinctiveness of the animation medium in comparison to a live-action context, this method revelled in a modernity which exposed the already determined aesthetic and ideological limits of realist representation.

The *Sinking of the Lusitania* (1918), however, constitutes a seminal moment in the development of the animated film because it was one of the first films to be based on an actual historical event, and, most importantly, was a film that both re-located the animated form back in the codes and conventions of 'realism', and demoted the artist beneath the necessary priority of advancing a persuasive propaganda message. I have discussed elsewhere how *The Sinking of the Lusitania* operates as an 'imitative' mode of documentary,[35] attempting to echo newsreel actuality

footage in becoming a 'film of record' of an event that was not actually photographed. The *Lusitania*, Cunard White's 'wonder of the age', and self-evidently in the vanguard of industrial achievement, sailed from New York to Ireland and was perceived by the Germans as a legitimate target because it carried 4200 cases of small arms and $6m gold bullion. Ironically, the presence of 159 Americans among the 1300 passengers, including celebrities like author Albert Hubbard; playwright Charles Klein; multi-millionaire sportsman Alfred Vanderbilt and theatre entrepreneur Charles Frohman, was perceived as a deterrent for the Germans, as they would not wish for an early American entry into the War. The Imperial German Embassy had published warnings in the *New York Times*, however, that passenger steamers and other craft not displaying the correct signalling insignia to identify themselves and their cargo would be subject to possible attack. On 7 May 1915, a U20 submarine, fired on the *Lusitania* eight miles off the Irish coast and the ship sank within eighteen minutes. McCay's film illustrates these events with a high degree of authenticity, interleaving photo-realistic modes of animation with 'factual' information – dates, locations, shipping details and personal profiles. Ultimately, though, McCay's anger and emotion filter through into a more expository and didactic expression of feeling, perhaps best epitomised by the concentration on an image of a mother holding on to her baby as she drowns beneath the waves. The quiet doom of the film is palpable and fuelled by the sense of further disillusion and injustice that comes with its construction with hindsight. While there is no sense of objectivity, there is an engagement with 'reality' that is determined by McCay's wish to foreground the nature of this event as something which resulted in American fatalities and signalled utter contempt for the United States and its citizens. The implied 'nationalism' of McCay's investment in his own urban culture and its art is made overt in his depiction of a key moment in early American twentieth-century history. *The Sinking of the Lusitania* is a film which moves away from the inward-looking stances of an evolving conception of American identity through art, and projects an overt view of a nation which is forced to look outward and not merely confront the 'otherness' of other nations and cultures but the anxieties of the new 'melting pot'.

In many ways, McCay's films after 1918, *Gertie on Tour*, *Flip's Circus* and *Bugs Vaudeville*, try to recover what Norman Klein has called 'the dizzying confabulations of the stunt',[36] fully demonstrating their relationship to the carnivalesque culture of the circus. It is only the latter that

fully plays out the tension between 'geometry at play' – essentially the configuration of insects as abstract lines and forms – and the context of performance. Figurative constructs and the free play of graphic expression are indistinguishable in places, and fully facilitate an illusionism which is simultaneously predicated on the fantastical nature of the creatures and the desire to play with symmetry, perspective and geometric tension. McCay's typographical interests usefully reveal his interest in working through a graphic experiment and suggesting his nostalgia for a vaudevillian level of address that was increasingly no longer in vogue, ironically supplanted by the cinema. Huntly Carter, writing much later in 1930, recognised that cartoons 'have a distinct sociological value' noting that they depict humankind consistently attempting to escape the consequences of what they do, adding 'They are in fact a comment, a very witty, instructive and biting comment on the absurdities of man and other living things seen in the light of materialism'.[37] McCay's radical Modernity lies in his aesthetic, his social conscience and his respect for the undervalued artfulness in popular forms, all of which comment upon the impact of material culture. His eventual retreat into conservative Modernity in the post-*Lusitania* era is ironically a comment upon the effects of Modernity, and the inevitability of the ways that innovative, ideologically charged aesthetics are either absorbed or suppressed within misrepresentative commercial, industrial and, ultimately, political processes. Arguably, this is the fate of all the pioneers, and it reaches its zenith with the all-encompassing and profoundly influential impact of the Disney studio. The *Lusitania* episode was also a painful reminder that the 'modern age' was the machine age, and that the conduct of human life was intrinsically related to the impact and effect of its machine culture. This defining principle characterises many of the agendas underpinning the cultures of cartoons in their formative period, and, interestingly, demonstrates the ways in which the animation pioneers struggled with its imperatives in the attempted maintenance of their emerging aesthetic.

Notes

1. See N. Klein, *7 Minutes* (New York: Verso, 1993); J. O'Sullivan, *The Great American Comic Strip* (Boston and Toronto: Bulfinch Press, 1990); P. Wells, *Understanding Animation* (London and New York: Routledge, 1998).

2. D. Crafton, *Before Mickey: The Animated Film 1898–1928* (Chicago and London: University of Chicago Press, 1993), p. 48.

3. N. Wheale (ed.), *Postmodern Arts* (London and New York: Routledge, 1995), pp. 21–2.
4. See D. Crafton, *Before Mickey: The Animated Film 1898–1928* (Chicago and London: University of Chicago Press, 1993); J. Canemaker 1987; C. Solomon 1989.
5. For a full discussion of Disney and Authorship see P. Wells, *Animation: Genre and Authorship* (London: Wallflower Press (forthcoming)).
6. R. Schickel, *The Disney Version* (London: Michael Joseph, 1986), p. 43.
7. M. Barrier, *Hollywood Cartoons: American Animation In Its Golden Age* (New York and Oxford: OUP, 1999), p. 44.
8. Ibid, pp. 47–8.
9. J. Lenburg, *The Great Cartoon Directors* (New York: Da Capo, 199).
10. Ibid.
11. M. Barrier, *Hollywood Cartoons: American Animation In Its Golden Age* (New York and Oxford: OUP, 1999), p. 67.
12. J. Leyda (ed.), *Eisenstein on Disney* (London: Methuen, 1988), p. 21.
13. N. Wheale (ed.), *Postmodern Arts* (London and New York: Routledge 1995), p. 24.
14. J. Leyda (ed.), *Eisenstein on Disney* (London: Methuen, 1988), p. 33.
15. P. Murphy, ' "The Whole Wide World Was Scrubbed Clean": The Androcentric Animation of Denatured Disney' in E. Bell, L. Haas, and L. Sells (eds), *From Mouse to Mermaid: The Politics of Film, Gender and Culture* (Bloomington and Indianapolis: Indiana University Press, 1995), p. 125.
16. R. Schickel, *The Disney Version* (London: Michael Joseph, 1986), pp. 51–2.
17. S. Watts, *The Magic Kingdom: Walt Disney and the American Way of Life* (New York: Houghton Mifflin, 1997), pp. 104–5.
18. F. Karl, *Modern and Modernism: The Sovereignty of the Artist 1885–1925* (New York: Atheneum, 1985), pp. 3–4.
19. M. Featherstone, 'In Pursuit of the Postmodern: An Introduction', *Theory, Culture and Society* No. 5, pp. 195–215.
20. D. Crafton, *Before Mickey: The Animated Film 1898–1928* (Chicago and London: University of Chicago Press, 1993), pp. 329–38.
21. M. Barrier, *Hollywood Cartoons: American Animation In Its Golden Age* (New York and Oxford: OUP, 1999), p. 31.
22. R. Schickel, *The Disney Version* (London: Michael Joseph, 1986), pp. 141–2.
23. See D. Crafton, *Emile Cohl, Caricature and Film* (Princeton and Oxford: Princeton University Press, 1990).
24. Ibid., p. 84.
25. F. Karl, *Modern and Modernism: The Sovereignty of the Artist 1885–1925* (New York: Atheneum, 1985), p. 14.
26. Ibid.
27. S. Watson, *Strange Bedfellows: The First American Avant Garde* (New York: Abbeville Press, 1991), p. 8.
28. C. Bloom (ed.), *Gothic Horror* (Basingstoke and London: Macmillan, 1998), p. 17.
29. D. Crafton, *Before Mickey: The Animated Film 1898–1928* (Chicago and London: University of Chicago Press, 1993), p. 32.
30. M. Barrier, *Hollywood Cartoons: American Animation In Its Golden Age* (New York and Oxford: OUP, 1999), p. 33.
31. J. O'Sullivan, *The Great American Comic Strip*, (Boston and Toronto: Bulfinch Press, 1990), pp. 33–5.
32. D. Crafton, *Before Mickey: The Animated Film 1898–1928* (Chicago and London:

University of Chicago Press, 1993), p. 109.

33. J. O'Sullivan, *The Great American Comic Strip*, (Boston and Toronto: Bulfinch Press, 1990), p. 38.

34. Ibid., p. 35.

35. P. Wells (ed), *Art and Animation* (Academy Group/John Wiley 1997), p. 42.

36. N. Klein, *7 Minutes* (New York: Verso, 1993), p. 24.

37. H. Carter, *The New Spirit of the Cinema* (London: Wishart & Co, 1930). p. 30.

CHAPTER 2

The Disney Effect

Animated films in the 1920s and 1930s reflected some of the broader concerns of the new industrial age, and showed the ways in which the technological and aesthetic imperatives of American culture were bound up in a version of progress that was grounded in the archetypes of lived experience. The issue of technological determinism is of particular interest in relation to the field of animation and, as I indicated in the previous chapter, is a primary factor in the evaluation of early American animation as the vanguard of radical Modernism, and its shift into more moderate and conservative forms. Lewis Jacobs argues, for example, that Disney advanced and exploited the technological imperatives of cinema, noting that he had a 'technical dexterity and remarkable command of the medium [that] gives all his efforts a brilliancy of rendition that makes even the least of them dazzling'.[1] While this view is undoubtedly true at one level, it once more misrepresents the idea that there are different kinds of command which may be afforded to the medium, and which characterised earlier work. Further, this kind of view accords 'technology' itself the underpinning determinacy of the aesthetic, and prioritises the Disney aesthetic as one which determines the art. The synthesis of Disney's style and its intrinsic relationship to the technology which 'miraculously' produces it demote the artist, but promote the entrepreneurs and innovators that claim their effects. With this process comes the promotion of 'Disney' as part of a 'Great Man' tradition of progress, and *not* the representational aspects of the art addressing modern concerns through modern expression.

The Fleischers' work becomes extremely pertinent here as they too sought to pioneer technological innovation, and nearly succeeded in their experiments with sound, their own studio system and their commercially oriented interests, but all of their films were still in the service of animation as a radical form aesthetically *and* socially. The

Fleischer Brothers – Max, Dave, Joe and Lou – fascinated by 'cartoons', 'science' and 'mechanics', created the rotoscope – a technique where live-action figures could be traced over to create cartoon forms; made the hour-long quasi-documentary *Einstein's Theory of Relativity* (1923); the 'Song Car-Tune' sing-along cartoons (1924–7), using live accompaniment and a 'bouncing ball' following the lyrics and the half-animated, half-live action 'Out of the Inkwell' series, featuring Ko-Ko the clown, all before the end of the 1930s. Their version of *Snow White*, featuring Betty Boop, made four years before Disney's groundbreaking feature, *Snow White and the Seven Dwarfs* (1937), was animated virtually single-handedly by Roland 'Doc' Crandall in six months, but is more faithful to the spirit of the Grimms' fairytale, and to 'cartoon' as a unique vocabulary of expression.[2] As Allen and Gomery have noted, 'nothing inherent in basic film technology predisposes the cinema to the production of narrative films or, indeed, to the use of editing to tell a story, and yet since 1908 the predominant form of commercial cinema in Europe and America has been a narrative form based in part on a particular style of editing'.[3] It was this fundamental imperative that Disney saw and embraced ahead of the other animation pioneers, but in moving towards the imperatives of live action and the populist utopianism of his narratives, he was responding to what he believed was a perceived need in an audience and in the commercial context that he sought to place his films. Disney's originality lay at first in the aesthetics created by Ub Iwerks, and later as the pioneer of using animation as a *feature-length* form. This, of course, was modern enough, and, indeed, artistically extraordinary, but less engaged with the particularities of animation as a medium of exploration intrinsic to the advances of the modern age at the *social* level. As Gilbert Seldes has argued, '[fundamentally,] Walt Disney brought no single new principle into the movies, but he combined virtually all of the good principles and created a series of masterpieces'. He continues '[in] him, without a doubt, the machine becomes human – just when humanity is afraid mankind will be turned into a machine. To an American familiar with the American habit of tinkering with mechanisms, Disney's attitude in this respect is not particularly surprising. An American is not a machine worshipper – he is far too familiar with the machine. But he likes machinery and one might say machinery likes him'.[4] Seldes' astute remarks site Disney as an everyday American who has embraced and *naturalised* the developments of the machine age, not using them as the formal subject of the work, but as the object of its

material progress. Consequently, Disney does not consciously embrace modern art, nor the socio-cultural conditions that produce it. This is to argue that Disney's Modernity is moderate or conservative at best, and, while aesthetically sensitive, was not grounded in the artistic imperatives embraced by artists themselves, nor in the radical Modernity intrinsic to the form. Disney's engagement with the machine age is, however, pertinent in the sense that it is a vehicle for viewing how the folk idioms and sensibilities his work foregrounds sit with the new industrial culture and its promotion of change.

Especially important here is the impact of Sergei Eisenstein, both in his acknowledgement of Disney's work and in his critique of it, which takes into account the particularities of its Modernity, but, most significantly, its place within the social practices of the American system. Though Eisenstein was essentially seeking to reconcile aesthetic questions when he addressed Disney's films, he read them less in the light of what their narratives apparently engaged with, and more in the spirit of the ways that 'animation' itself liberated the text to support ideological speculation. He suggests:

> Disney is a marvellous lullaby for the suffering and unfortunate, the oppressed and deprived. For those who are shackled by hours of work and regulated moments of rest, by a mathematical precision of time, whose lives are graphed by cent and dollar ... From birth to death. Grey squares of city blocks. Grey prison cells of city streets. Grey faces of endless street crowds. The grey empty eyes of those who are forever at the mercy of a pitiless procession of laws not of their own making, laws that divide up the soul, feelings and thoughts, just as the carcasses of pigs are dismembered by the conveyor belts of Chicago slaughterhouses, and the separate pieces of cars are assembled into mechanical organisms by Ford's conveyor belts ... Disney's films are a revolt against partitioning and legislation, against spiritual stagnation and greyness. But the revolt is lyrical. The revolt is a daydream.[5]

Eisenstein's extraordinary perspective on the Depression era and the deep fragmentation of American culture and the industrial infrastructures which have caused it, casts Disney as the epitome of comfort and consolation, healing the 'damage' of Modernity through the spirituality inherent in his particularly distinctive creative practice. Eisenstein does not recognise 'Modernity' in the supposed progress of urban development and Taylorist commercial efficiencies, seeing these initiatives as, in

many senses, inhumane and, more importantly, oppressive in their rigour and determinism. The very 'freedoms' of the animated form are signalled as freedoms from such oppression, and the colour and gaiety of the imagery an indictment of the sense of entrapment at the heart of American life. Little wonder that Disney's *Playful Pluto* (1934) is used in Preston Sturges' *Sullivan's Travels* (1941) as a signifier of good humour and release for a group of convicts made criminal by the effects of the Depression. Eisenstein was prescient in his view that '[the] triumphant proletariat of a future America will erect no monument to Disney as a fighter either in their hearts or on street squares',[6] and, indeed, the very opposite has occurred; the contemporary era castigating the Disney canon, for example, for its unacceptable representation of gender and race types and issues. Eisenstein identifies an important point, in the sense that he perceives Disney as a film-maker who is using the intrinsic nature of the medium he works in as the tool to *challenge* the assumptions and outcomes of social progress, and to *comment* upon the modern 'machine' age. Eisenstein suggests that Disney articulates a tension between the assumed freedoms of democratic expression in this supposedly progressive era, but also potentially inappropriate models of socio-cultural conformism which may be part of its agenda. Eisenstein's concept of 'plasmaticness', which he identifies in Disney animation, challenges a 'social order with such a mercilessly standardised and mechanically measured existence, which is difficult to call life', and which he argues holds with it 'a sharp degree of attractiveness'.[7] Such a claim supports the definition of animation as a distinctive language of expression, but also suggests Disney is its most progressive outlet. Crucially, though, Eisenstein bases his claims predominantly on the early *Silly Symphonies*, recognising in them a visual equivalent to the freedoms of music, where 'Disney forced the self-contained objective representational form to behave as a non-material volitional play of free lines and surfaces', and which he still recognises in Disney features until the hyper-realism of *Bambi* (1941), which he views as 'the very opposite'.[8] This is, in effect, an endorsement of the Iwerks aesthetic, and may be allied once more with the progressive and pioneering forms of animation represented particularly by Messmer and McCay, but also by the Fleischers.

So preoccupied was Eisenstein with the version of 'modernity' perhaps best epitomised by Chaplin's conflict with the machine age in *Modern Times* (1936) that he cast American culture as the bastion of formal logic, mechanisation and political interventionism, in which he

finally saw Disney's increasing *industrial* success as a radical achieve-
ment. It represented a version of the machine age that was dedicated to
socio-cultural fantasies that were rooted in the pre-logical and in the
folkloric and mythic cultures of fairytale, fable and animal stories. Even
as it became subordinated to the effects of a technological change that
moved its conditions ever closer towards an imitative version of live-
action representation, this was the modernity of subverting the machine
age rather than denying or resenting its implications and consequences.
Eisenstein notes Disney's short *Merbabies* (1938) on a number of
occasions as embodying modes of resistance to the new enculturing of
the urban infrastructures, suggesting that transformation and liberation
in such cartoons encourage the view that the individual can change; can
move beyond prescription and exist outside the implied parameters of
urban culture by recalling the primal and the 'animal'. There is some
irony here as *Merbabies* was actually made by the Harman–Ising studio,
as most Disney personnel were involved in the *Snow White* feature. The
short did have a high degree of input from Disney staff David Hand and
Ben Sharpsteen, but it was created by Harman–Ising in the hope of both
releasing their own similarly styled cartoons through Disney and
gaining further work from the Disney studio. Neither transpired, and
Harman–Ising filed for bankruptcy in the same year *Merbabies* was
released.[9] There is perhaps further irony in the fact that *Merbabies* was
later a key source for the 'whale' sequence in *Pinocchio* (1940) and the
'elephant march' sequence in *The Jungle Book* (1967).

Eisenstein's claims for the short are irrefutable, but the production
process outlined here merely demonstrates that his political claims are
those for the liberations of the aesthetic, rather than for 'Disney', though
Disney represented its most self-evident, popular and high-profile
presence. As I argue later in my discussion, this is important because it
identifies the nature of the production process as one which at one level
denies the specificity of authorship and ideological coherence, while at
the same time producing an open 'text' that can fully accommodate the
idea that its sources are in modern art-forms, but relevant to the social
flux it embraces through its aesthetic conditions. Disney's works operate
as a transposition and translation of the socio-cultural and not a conscious
imitation, but it is part of the necessary condition of animation to
transpose and translate; its intrinsic ability to metamorphose, condense
and symbolically and metaphorically 'associate' speaks to the alternative
and the radical, even in its most seemingly conservative and reactionary

of forms. This is often made invisible by the fact that the imagery itself is the outcome of a process of immersion or embodiment; it is a consequence of multiple application in the procedure which ensures that what appears on the screen is a mode of artifice that possesses its own character and motion abstracted from the visible imposition of its creators and makers. It is of itself, and it determines its own modes of change and perpetuity. It is a protean phenomenon rather than merely an 'object' or a 'subject', and works as a synthesis of cultural resources which simultaneously retain their aesthetic specificity but also offer the possibility of an alternative reading of their social context and place.

Animation, particularly in its emergent forms from the turn of the century right through to the benchmark of hyper-realism that was *Bambi* in 1941, effectively spoke to modes of change that viewed modernity as a projection into the future at the cost of a potentially stable and substantive view of the present. Modern America was a conditional state. As Leo Charney has suggested, '[as] each present moment is remorselessly evacuated and deferred into the future, it opens up an empty space, an interval, that takes the place of a stable present. This potentially wasted space provides an opening to drift, to put the empty present to work not as a self-present identity or a self-present body but as a drift, an ungovernable, mercurial activity that takes empty presence for granted while manoeuvring within and around it'.[10] This view corresponds readily to the idea that animation was a 'mercurial activity' that was *the* language of presence and absence in the sense that it perpetually worked in an empty space, an interval, a mode of hyper-illusionism. It is both a structure and an experience, working self-reflexively in the interpellation of change. Disney's engagement with this premise may be viewed as allying the 'empty space' with a view of America rooted in possibility and potential, but nevertheless is a past 'folk' idiom and a Victorian ethos. This reconciles what Charney has again described as 'a culture of representation in which experience was always already lost, accessible only through retrospective textualisation'.[11] Animation is, at once, a process which resists such 'fixedness' while being an act of cinematic record; its premises are grounded in the representation of motion and the interrogation of 'realist' illusionism and its concomitantly naturalised conditions of 'presentness'. Consequently, while Disney is often accused of being backward-looking, quintessentially hyper-realist and, ultimately, 'orthodox', it is arguably the case that the studio *consolidated* the process of modernity pioneered by McCay, Iwerks and Messmer by ensuring

that the vocabulary of animation was predicated on the folkloric flux and mythical metaphor of oral story-telling traditions. The very 'movement' of this kind of narrational activity synthesised naturally with the complete freedoms of the animated form. Further, it commented upon and interrogate d cinema itself.

C. A. Lejeune, writing in 1931, suggested, 'Walt Disney's cartoons are, to my mind, the most imaginative, witty and satisfying productions that can be found in the modern cinema',[12] firmly placing Disney's *Silly Symphonies* in the vanguard of cinematic form, and as a radical example of its progressive place within new populist contexts. She adds, 'I seem to remember that Miss Florence Austral, in a newspaper report of a recent speech, was made to complain that the modern public is neglecting Mozart for Mickey Mouse, as though that were the extreme measure of popular stupidity. For my part, I can think of nothing in modern entertainment for which Mozart could be more fitly neglected'.[13] Lejeune, long in anticipation of the 'dumbing down' debates of the 1990s, dismisses the criticism of Disney films as unworthy successors to previously established works from the 'high art' canon, and consolidates her own view of their value and worthiness by arguing, '[the] work is a whispered and wicked commentary on Western civilisation through the medium of civilisation's newest and most cherished machine'.[14] Her latter remark, still emphasising the 'newness' of machine culture in the 1930s, and the subtle quasi-satirical approach of Disney's shorts in reflecting upon notions of 'civilisation' as they are increasingly determined by the machine age, usefully reinforce the sense that the form and the meaning were intrinsically allied; often an unconscious synthesis of the possibilities of the medium as an inherent consequence of its historical and socio-cultural emergence. Disney ultimately becomes responsible for formally locating the laws of a cartoonal form in relation to, as a commentary upon, and as a subversion or abstraction of, the physical, psychological and emotional laws of nature. While McCay, Messmer, Iwerks and others had done this before him, it was Disney who properly established this in the public and critical domain.

Frank Tashlin, Warner Bros. animator and, later, successful live-action feature director of such notable comedies as *The Girl Can't Help It* (1956) and *Will Success Spoil Rock Hunter?* (1957), insists that the Disney studio was the fundamental source for all cartoon animation that followed, arguing:

Bugs Bunny is nothing but Max Hare, the Disney character in *The Tortoise and the Hare* ... And Max Hare had a voice that's really a cross of the woodpecker's [Woody Woodpecker] today, and Daffy Duck's ... Now, take the mouse that everybody's used, and that [Joe] Barbera and [Bill] Hanna used at MGM for years [Jerry]. That mouse was designed by Disney and Wilfred Jackson directed it in a picture called *The Country Cousin*. [I'll] tell you another thing that came from Disney's ... the whole idea of no story, of using a basic situation.[15]

While Tashlin's view clearly has authority, it might properly be argued that all cartoon animation that follows the Disney output is a *reaction* to Disney, aesthetically, technically and ideologically, and this is essentially the premise of the rest of my discussion, in the sense that American animation is effectively a history of responses to Disney's usurpation of the form in the period between 1933 and 1941. As a result it is also a response to and a development of a variety of 'modernities' and a consistent commentary upon America as a machine culture.

Having established how the Disney Studio effectively colonised the field of animation by creating an ethos which embraced and defined the machine age in regard to its creative output and its industrial standing, and having looked at some of the imperatives of the machine culture as they became translated into animated films, I will now address the ways that the form moved away from the 'sentimental' or 'moderate' Modernism that the Disney Studio consolidated and the new age of 'mechanism' endorsed. Disney made animation a credible art-form, but simultaneously veiled the capacity of the form to more readily exhibit its subversive credentials. Its success in evidencing its own modernity was effectively measured by its aesthetic, industrial, technological and cultural comparison to the rest of Hollywood's finest, which thereafter viewed the Disney output as the stylistic and creative orthodoxy of the medium itself. This was largely due to the substantive achievement of *Snow White and the Seven Dwarfs* as a full-length narrative feature; simply, an industry norm by which the other studios, critics and audiences could evaluate its distinctiveness and comparability.

As Pare Lorentz commented, 'If I were asked to list the most important movie activity of 1937 ten years from now, I should have only one item to report: Walt Disney made a full-length movie. And this one event may save the industry as it is now organised.'[16] Stressing Disney's independence and artistry, Lorentz emphatically endorsed the distinctiveness of the

auteur and the medium, but distances the work from its previous status as a short 'filler' subject. James Shelley Hamilton also distances the achievement of the film from its roots, suggesting 'it is a landmark, of a significance hardly to be calculated, in the development of the motion picture. That is not to say that animated cartoons (a term hitherto used for the mechanics Disney uses, but totally inadequate as description) are likely ever to supercede the use of human actors on the screen'.[17] The extraordinary artistry of the film and its intrinsic artifice were its prevailing currency, encouraging a response which perceived the film not as a 'cartoon' but firstly as a progression in motion-picture making *per se,* and secondly as an art-form which in spirit was related to traditional forms of fine art. This was inevitable, but the achievement of the film beyond its self-evident aesthetic quality was to divorce the medium from an understanding of its own distinctiveness at anything but the level of its superficial difference from live action. Animation was, thereafter, perceived as 'figurative graphics in motion', and not a form with freer, non-prescriptive cartoonal vocabulary. Simply, animation had been absorbed into a conventional model of appreciation and criticism which perceived the form on the same terms and conditions as other mainstream 'art'.

Snow White and the Seven Dwarfs simultaneously advanced and regressed the form. In prioritising a movement towards classic narrative and hyper-realism the film ultimately proved that animation could sustain these imperatives and transcend the implied limitations of the cartoonal idiom. In achieving this feat, however, the form, at its most highly profiled and accessible level, atrophied, abandoning the distinctive dynamics of the cartoon and the experimentation inherent in the abstract. Progress was measured in the ways that the technological conditions of production had facilitated an art *comparable* to live action, not in the ways that the language of animation could be used to effect alternative aesthetic and socio-cultural perspectives. Arguably, *Fantasia* (1940), while seemingly speaking to these issues, merely consolidated Disney's entrenchment in a highly aestheticised engagement with the figurative and the literal, even in its most seemingly abstract sequences. The conscious straining after 'classical art' becomes a sustained interrogation of the ways animation either significantly fails to authenticate the 'material world' or misrepresents its own credentials in more pertinently expressing emotion through 'visual music'. The critical reception of *Fantasia* and the debates that still continue to accrue around the film are not my concern here, however, suffice to say that Disney's aspiration to 'art' and 'culture' follows on from the position

of consolidation he achieved through the success of *Snow White and the Seven Dwarfs* and the *Silly Symphonies* that preceded it.

Crucially significant was the way in which the film consolidated a view of 'Walt Disney' that chimed with an important currency in American life. As Richard Schickel explains:

> Walt Disney belonged to a special American breed, middle-class and often midwestern in origin. He was the sort of man who possesses and is possessed by a dream that seems to be particularly and peculiarly of a time only recently past. It is a dream now much satirised but, for all that, no less common among the middle-aging generation. Simply summarised, it is that 'it only takes one good idea...' In the United States one need not even complete the sentence, so clear is the implication: all you need is one winner to get started properly on the road to success.[18]

Snow White and the Seven Dwarfs was, therefore, not merely a consolidation of a particular art-form, but reassuring evidence of a populist myth finding clear example in the material world. Further, it was also an example of the key relationship in American life between what might be described as 'symbolic' individuals and the organisations they come to represent. Disney defined the values and identity of a business organisation in a spirit which transcended the corporate principles that came to actually define it, replacing this with an acceptable ideological platform that was more important to the American public. Disney's desire to establish a popular art-form is in many senses an adjunct to this achievement, and one of the reasons why 'Disney' in a certain sense remains a sacrosanct ideological category even in a much changed political and economic contemporary climate, and even in spite of escalating cultural criticism. Historian Daniel Boorstin suggests,

> Emerson said in a much simpler age that an institution is the length and shadow of a man. We might say, thinking of Disney, that the man is the foreshortened shadow of an institution because when we try and separate the man from the organisation we find it extremely difficult. Much of what has been done in American culture is collaborative. And in this sense the motion picture as an art-form is characteristically American, it's a kind of community product. It was an organising achievement, comparable to that of the American Department Store or Mail Order. We might call Disney the 'Sears, Roebuck' of the American entertainment world.[19]

This observation usefully underlines the ways in which Disney success-fully embraced the modernity of organisational cultures, business principles and a view of entertainment as a distinctive commodity. *His* success in many senses was more important than the film's art in validating the very principles of American achievement. David Robinson notes that 'Disney's decline was already ... evident at the very peak of his celebrity' as the consequence of producing *Snow White and the Seven Dwarfs* was to create a mode of expansion in the following years where 'Disney products had lost their individuality and charm: the characters had become stereotypes; the graphic style had succumbed to gloss and cliché and was already beginning to seem archaic'.[20] Ironically, accept-ing the validity of this view arguably re-promotes *Fantasia* as Disney's last moment of risk and experimentation until the late 1980s.

This is not to discredit the art – Disney had indisputably proven the aesthetic quality of the form – nor to misconstrue the ways in which Disney had configured his short films, the *Silly Symphonies*, in order to engage with public experience and expectation. Writing in 1931, C. A. Lejeune argues, 'Disney draws his cartoons under the influence of contemporary Western thought, derives his plots from the affairs of daily life, and their popularity is only the drawing together of a generation and its problems, the discovery by an audience of its own face'.[21] Clearly, Disney wished to achieve empathy and identification within his films, but this was to ultimately promote a particular kind of 'Americanism', and *affirm* an art-form rather than further *progress* one. Disney wished to be compared to his peers in Hollywood, but on his own comparatively small-scale, financially independent and artistically inno-vative terms and conditions. *Snow White and the Seven Dwarfs* enabled him to achieve this, but to a certain extent this was at the expense of fore-grounding and promoting the distinctive aspects of the medium itself. Lejeune's remarks confirm a view of Disney's short films as anthropo-morphised tales of homespun story-telling and backwoods charm which result in an unchallenging reassurance about 'Old World' ruralism and its accompanying myths of community consensus and control. *Snow White and the Seven Dwarfs* enabled Disney to take his audience into the 'modern' era, but on terms and conditions they understood. This was an effective mix of nostalgia and progress; backward-looking feelings attached to forward-looking forms. The overall outcome of the film was to confirm the transition of the animated form from a transient, quasi-playful entertainment to full-scale Hollywood spectacle, but in such a

way that its intrinsic ideological values, fundamentally allied to a populist utopianism, comforted its audience rather than confronting it with 'the shock of the new'. Ironically, Disney was highly invested in such 'newness' in regard to the industrial infrastructure and technological innovation he brought to his films, but this sense of the 'new' was harnessed to the veiling strategy of a perpetuation of the 'old'. The overriding concern was to use the animated form as a *popular* avant garde in order to foreground 'difference' as proof of ideological and commercial 'sameness'. This 'Classic Disney' style and outlook has been maintained and naturalised into the contemporary era, and has created a style and standard by which other animators and animation studios are often measured. Ironically, this enabled Disney's peers – for example, the Fleischer Brothers, Warner Bros., MGM and UPA – to differentiate their output. This differentiation continued with avant-garde work from the late 1940s onwards; counter-culture uses of animation in the 1960s and 1970s and challenges by other major studios in the 1980s and 1990s.

At one level, Disney has been imitated and copied, encouraging a view of homogeneity in the field and an understanding in the public imagination that 'animation' *is* Disney; at another level, Disney's prominence has only prompted other practitioners to view themselves in opposition to or, at the very least, different from, the Disney form. These animators have championed the continued exposition and amplification of 'modernity' within the form that was arguably arrested with the attainment of 'Classic Disney' by 1941. As Marc Eliot notes, 'While the style of Disney's cartoons remained in the chilly clasp of their prewar Fundamentalist vernacular, Warners offered the kind of warm, streetwise Yiddish humour post-war America lovingly embraced. "Looney Tunes" were clever social satires generously overlaid with sexual innuendo, their characters always winking knowingly at the audience rather than innocently batting their eyes'.[22] This distinction, and the proper recognition that goes with it, remained long unacknowledged, and required a shift in critical perspective that allied animation with progressive rather than conservative forms of art. Kevin Sandler's anthology of essays about the Warner Bros. output, published in 1998, is a long overdue address of the range of perspectives that the studio's work embraces. Timothy R. White, for example, suggests that the clearest indication of this critical shift in favour of the Warner Bros. cartoons comes with a new post-war attitude that embraced the brashness and urbanity of Bugs *et al*, but, most crucially through film criticism

which acknowledged the relationship between the fragmentary and insubordinate nature of the cartoon and anti-Classical structures of European art cinema.[23] This elevation validated the Warner Bros. approach but never significantly undermined Disney's position as the defining player in the animation field. The Warner Bros. cartoonists effectively focused on making 'adult cartoons' with the requisite degree of slapstick to appease a children's audience, but at a level that was ultimately a sustained critique of Disney's modes of storytelling, its aspiration to visual symphony and its reassuring sentimentality. European art cinema was identified through its *auteurs*; 'Termite Terrace' was arguably its populist counterpart. Directors emerged, who while expressly confessing their respect and admiration for what had been achieved by the Disney studios, maintained an explicit critique of the Disney output.

What figures like Tex Avery, Chuck Jones, Frank Tashlin and Bob Clampett actually did, however, was significantly more than lampooning the self-evident characteristics of 'Classic Disney'. In effect, these directors reclaimed the freedoms of the cartoonal form that Disney had seemingly jettisoned in favour of the pursuit of classic narrative techniques and outcomes. The more urbane, less coherent, cacophonous agenda of the Warner Bros. cartoon essentially reorientated the form to accommodate a more streetwise immigrant humour localised in a self-conscious understanding of human interaction and social mores. Less supernaturally or ethereally surreal than their counterparts at the Fleischer Brothers' studio, who had also invested in a more mature engagement with the cartoon form, prioritising their own fascination with machine culture, adult pastimes and popular art, the Warner Bros. animators re-invented the cartoon as a model of incongruity and irony, caricaturing popular figures, satirising institutional conduct and re-exploring graphic and narrative idioms. Both studios had, in effect, re-prioritised the creation of what Mark Winokur has called the 'eccentric mise-en-scène',[24] which chimed with, and arguably inspired, aspects of the imaginary contexts and bizarre scenarios of American mainstream comedy in the 1930s and 1940s. Winokur adds the 'tendency to represent ethnicity within an exotic and eccentric world is even more part of the American animation aesthetic' and results in 'a popular-culture version of a fantasy landscape that conflates United States culture and a host of other cultures'.[25] This re-investment in innovation sought to re-modernise and

radicalise the form in the light of Disney's now reactionary style and outlook. In insisting upon subjecting the unities of the cartoon to interrogation and revision, the Warner Bros. animators proved that the parameters of the form could address aesthetic principles and socio-cultural conditions in a way that offered a fresh insight and pertinency, challenging any notion of a 'mainstream' orthodoxy which supposedly accommodated and reconciled 'difference'. Avery, Jones, Tashlin and Clampett re-visualised the codes of motion pictorialism to literally illus-trate the relationships which interrogated the core values and principles of American culture *in transition*. This challenged the received wisdom of the folk populism imbued in 'Classic Disney'. The rejection of this paradigm was both a critique of the sentimentalist, rural, archetypal politics underpinning Disney's output and a dispensation of the moral and ethical infrastructure implied in populist agendas. Simply, the resolution, redemption and reward in this model was unrealistic in the eyes of the Warner Bros. sceptics, whose model of social critique was an abandonment of consensual, ideologically charged story-telling, and an engagement with the pragmatism of using animation to reveal the chaotic, arbitrary and inchoate nature of the micro and macro models of exchange in American society. In addressing the power struggles, social motivations and cultural currencies of individual characters in conflict, the Warner Bros. animators readily illustrated the fears, anxieties and con-fusion of a multi-cultural people, and a national culture seeking identity. Their expression of constant antagonism, fuelled by often inarticulable needs and desires, speaks to an extremism which resists the logic and outcome of 'principled' narratives, which endorse an assumed status quo.

More importantly, in refuting the classical models of narrative predi-cated on aesthetic and ideological *synthesis*, the Warner Bros. animators point up the capacity of animation to split the imperatives of graphic idioms and the agency of cohesive narrative resolutions. In doing this *explicitly* – and, simultaneously, provoking interpretation of essentially incoherent texts – the Warner Bros. animated shorts reveal that anima-tion can maintain a mutually exclusive relationship between a 'narrative' and a 'text', a point which, as I will discuss later, even renders Disney films as less ideologically inscribed and prescriptive than suspected, and, in principle, once again offers a solution to the conundrum of Disney's global popularity set against the increasing criticism since the 1960s of its politics of representation and quasi-dogmatic perspectives. This 'open-ness' in the animated form offers a high degree of pluralism and,

ultimately, different modes of 'synthesis' allying aesthetics not merely to ideological currencies, but to highly personalised preoccupations; the depiction of states of consciousness; the address of 'concrete' propositions and so on. One useful example of the way in which Warner Bros. may be evidenced in their resistance to Disney perspectives and their insistence on new syntheses and 'openness' in the cartoon, may be charted through Gene Walz's work, which usefully engages with these issues by tracing the influence of former Disney designer Charlie Thorson as his style and technique impacted upon the Warner Bros. cartoons between 1939 and 1940.[26] Though Thorson's lyricism clearly informs Chuck Jones' early cartoons, any degree of formulaic 'cuteness' in Warner Bros. production was soon arrested by the more self-conscious, irreverent and overtly adult approaches of Tex Avery and, later, Bob Clampett. Arguably, it is in the work of these two key figures that the distinctiveness of the cartoons from 'Termite Terrace' truly rests. Michael Barrier notes that 'alone among cartoon directors in the mid-thirties, Avery accepted the challenge of finding a way to make [self-reflexive] gags work in a climate created by Disney's logical fantasies', adding, 'Avery demonstrated that a silly idea could become a funny idea if a director pursued it with disarming vigour and single-mindedness'.[27] By concentrating on adult themes (lust, power, paranoia, pleasure-seeking and so on); extending the 'inner logic' of a joke beyond the parameters of its situation and context and consistently taking 'pot-shots' at Disney's posturing and sentimentality while always seeking to innovate in the design and execution of the cartoon, Avery and later Clampett and, indeed, Jones changed the cartoon's very identity. Ultimately, they created a deeply influential vocabulary which not only re-defined the parameters of cartoonal animation but also determined a number of *cinematic* effects which have become the uniform conditions underpinning contemporary visual cultures *per se*. This is self-evident in what Norman Klein describes as the new 'hybrid cinema' of the Jim Carrey vehicle, *The Mask* (1994), which explicitly uses the effects created by Tex Avery,[28] but is equally present in most of the applications created by Industrial Light and Magic for a host of productions from *Star Wars* (1977) to *The Mummy Returns* (2001).

It has always been the case, of course, that some of the greatest of American animation has been absorbed within the Effects tradition rather than receiving recognition in its own right, and than working as

an explicit acknowledgement of its sources both at Warner Bros. and their pioneering antecedents. One clear example of this is in the work of Willis O'Brien and Ray Harryhausen, the two most significant stop-motion animators in the field whose *auteurist* work facilitates key films like *King Kong* (1933) and *Jason and the Argonauts* (1963).[29] The lack of recognition for such work may be explained by a number of factors. As I have stressed, Disney effectively branded 'animation'. The art of the form was explained by Disney and through Disney, in the behind-the-scenes vehicle, *The Reluctant Dragon* (1941), through his participation in a proliferation of articles in the 1930s and 1940s, and, ultimately, in his television series, including episodes like Richard Heumer's 'The Art of the Animated Drawing', and which, while acknowledging Hurd and McCay, nevertheless places Disney, and only Disney, as the developers and promoters of the form. Animation within ostensibly live-action contexts, like that produced by O'Brien and Harryhausen, suffers from a lack of exposure because of the need not to undermine the live-action aspects. Historians and academics are rectifying these absences, but a key issue remains concerning how Warner Bros. represents its own histories and valorises its own work. In seeking a corporate identity, and an identifiable 'brand' which can compete with Disney on commercial terms, it has seemingly been necessary to create a sense of coherence and continuity in its lead characters, rather than to acknowledge the aesthetic and ideological breakthroughs facilitated by the work of its 'Golden Era' animators. Kevin Sandler warns that commercial strategies that refuse to acknowledge the previous achievements in the Warner Bros. cartoon not only inhibit further innovation but also ignore the technical and aesthetic achievements in the past.[30] He argues that Warner Bros. have increasingly exercised a policing strategy on past cartoons, limiting the degree to which Warner Bros. animation may be perceived as politically incorrect, culturally inappropriate and, most significantly, commercially unviable. This falsification echoes the apparent need for a homogeneity which characterised the development of a Disney 'brand', but in the case of Warner Bros. cartoons wholly misrepresents the anarchic modernity at the heart of the work, which ultimately defined a different approach to the medium. Perhaps more importantly, it also signalled a different approach to a changing America, one which saw that it was the multiplicity of determinacies which underpinned social progress, rather than one previously constructed view of cultural and national consensus. Raymond Durgnat usefully delineates a view of 'Republican' and

'Democratic' thought which chimes with the differences between Disneyesque and Warneresque perspectives and helps to articulate the necessary change in the aesthetic approaches which seek to accommodate them:

> Democratic thought tends to admit, and discuss, the tensions in American society, since admitting them leads to attempts to manipulate and reform the social system. The Republicans tend to see problems not in terms of social malfunction, so much as individual moral flaws, e.g. 'moral decay', or of non-social class networks, such as communist agents and their intellectual sympathisers. Republican sociology tends to an anti-urban view of American society. It sees the small town as a stronghold of traditional neighbourliness and idealism, the city as a melting-pot of corrupt, cynical, imperfectly assimilated un-Americans. The Democrats tend to share this myth, but ... insist that, under its placid surface, the small town also seethes with self-interest and prejudice. Thus Democratic thinking tends to be more cynical, and more tolerant of cynicism, than Republican thinking, which is more idealistic, but paranoid about any absence of idealism ...[31]

It is not difficult to see a clear dialectic here between Disney's Small Town Republicanism and Warners' Big City Democrat position, and the self-evident opposition between Disney's moral certainty and Warner Bros.' more ambivalent and, arguably, more 'realistic' stance. Interestingly, what this ironically more 'realistic' perspective necessitated was a mode of narrative and aesthetic expression which challenged the ways in which the Republican ideology had been naturalised into the Disney style, and its prevailing status as the defining generator and engine of the medium itself. This required a revision of the aesthetic which was not merely about challenging Disney, but was also about recovering and refining some of the dynamics of the pioneer cartoons and making the cartoon a 'self-conscious' medium which consistently foregrounded its intentions as a representational form. This concept is best illustrated by noting how the Warner Bros. cartoons differed from their counterparts at the Fleischer Brothers' studio, because at another level the Fleischers can be credited with the most consistent challenge to the Disney studio technically, industrially and creatively over a concerted period of time. Mark Langer, for example, has outlined how the studios competed in

relation to works which combined animation and live action; the introduction of sound and sound synchronisation; the embrace and development of colour systems; the 'dimensional' enhancement of the cartoonal mise-en-scène and the movement towards longer animated formats.[32] Crucially, though, what the Fleischers achieved was in some senses less conscious in terms of its aesthetic outcomes. Like Warner Bros., the primacy of the 'gag' as a narrative premise was well established, but the visual gag in the Fleischer universe is essentially bizarre 'business' which accrues around the execution of movement itself. This is often intrinsically related to the bodies of the characters but is enacted across the whole mise-en-scène, so that the seemingly arbitrary shifts of proportion, speed, imperative and 'attitude' of the context are in essence laughing at the absurdity of the 'concreteness' of the material world, and the idea of physical inhibition and control. The outcome of this lack of 'direction' in the gag is a much more ambivalent and contradictory mise-en-scène, and a more perverse surreality which does not find its source in the expression of the imposition of a view *about* 'the abnegation of all mental law', but the unconscious consequence of aesthetic decisions. Michael Barrier, slightly uncharitably, suggests:

> [Dave] Fleischer's casual contributions to the cartoons left untouched their essentially mechanical, unimaginative core. Interpolating bizarre gags and rhythmic twitching into cartoons otherwise dominated by smooth, unaccented animation meant that those cartoons took on a hallucinatory quality: they were in their zombielike pacing, their aimlessness, and their arbitrary transformations, literally dreamlike.[33]

Arguably, this mode of working reveals some of the intrinsic qualities of animation and revises ideas about time, change and human endeavour that locate them more in the spirit of an 'inchoate' reality, rather than the dictates of traditional cinema narrative infrastructures, but, more importantly, in becoming 'dreamlike' reveal that animation can apprehend and illustrate states of consciousness. This in many senses brings a distinctive quality to the work which better reveals its subversive tendencies, particularly in regard to the depiction of sexual and social desire; the centrality of 'playfulness' in human exchange; and the emotional imperatives that underpin cultural 'action' which may range from inarticulable to unspeakable, but nevertheless find purchase in the American psyche. This once again chimes with an observation by Durgnat, who notes 'The once inner-directed, individualistic, competitive American ethos, caught

in an age of conformism and teamwork, constantly hesitates (more vehemently than the more staid and cynical European) between aggression and goodwill'.[34] The Fleischer Brothers' films, in effect, absorb the tension between aggression and goodwill in the inner directedness of the mise-en-scène, naturalising the emotional flux within that tension in the aesthetic styling itself. Significantly, the Warner Bros. cartoons consciously and specifically *dramatise* this tension, and in doing so revise their own aesthetic, challenge the visual orthodoxies established by Disney and reveal the cultural issues and antagonisms naturalised within the Fleischer text, and metaphorically submerged, absented or revised in the Disney text. The Warner Bros. style and approach, now the staple of the cartoon idiom, and, ironically, its quasi-reactionary currency, were once radical, experimental and intrinsically 'modern'.

As Hank Sartin notes, this experimentation was especially important during the studio's adaptation to the sound era. Re-contextualising vaudevillian performance tropes within new, more interpretive strategies in the use of sound and music, the cartoon became more self-conscious about its audience, its reception and its own place within an era of industrial and technological determinism.[35] The role of Black and Blackface performance in this transition, for example in *Congo Jazz* (1930), and, indeed, many cartoons thereafter, however, remains problematic. It is important to stress that while it may be true that issues of representation and identity in some cartoons may be viewed as provocative, even unacceptable, they are equally, and undeniably, complex, and rather than censor or absent such material, it is crucial to address it. On the one hand, Warner Bros. cartoons may be viewed as subordinating the sensitivities of representation to the needs of the gag; on the other, these comic scenarios may be perceived as celebratory; subversive rather than exploitative; perversely sensitive in challenging orthodoxies rather than reinforcing them. Once again, the key issues here remain intrinsically related to the ways in which animation 'reformed' itself as a medium through the work of the Warner Bros. animators, while accommodating the speed and effect of modernisation throughout the 1930s, and escalated through the onset and conduct of the war in the 1940s. Norman Klein has persuasively argued that Bob Clampett's *Coal Black and de Sebben Dwarfs* (1941) both reflects white anxiety about modernity and is a response to the integration of 'black' and immigrant cultures, where the use of Black artists in the re-negotiation and parody of black stereotyping is actually a progressive model of subverting what had become

naturalised representational aesthetics. As Klein suggests, '*Coal Black* was not intended to be a statement about black life, only about big-band anarchy as a raunchier alternative to Disney'.[36] If Disney's *Snow White and the Seven Dwarfs* is the apotheosis of Disney's consolidation of his position within American cultural mythology, the primacy and new orthodoxy of the animated art-form and the assertion of a naturalised Republicanism resistant to change, then Clampett's work is its exact antithesis. It challenges the critical and cultural conservatism of the social and aesthetic principles championed by Disney, substituting the 'anarchy' of what was necessarily a 'white-mediated' form.

Clampett used Warner Bros.' more self-conscious *dramatisation* of social tensions to release the stereotypes from their static, marginalised and naturalised condition. The 'aggression' of the humour, the music, the performance, the parodic imperative challenges the 'goodwill' of passive acceptence and unquestioning continuity, aesthetically and socially. This is a self-conscious activation of the cultural 'difference' and affective presence of black people in American society, and a representative model of an America dealing with its issues about 'otherness' measured against a mythic orthodoxy of small-town, white, rural consensus. The Warner Bros. cartoons and, to a certain extent, those from the Fleischer Studios too may be read as a consistent reaction to the inability of the United States to accept the consequences of its own modernity. Contemporary readings of the cartoons support this view. Mark Winokur writes,

> The Fleischer and Warner Brothers companies especially tended to represent overt ethnicity in such films as *Romantic Melodies* (1932), in which you see Hebrew letters on the ambulance picking up a vagrant German brass band. Fleischer ... Warner Brothers (whose gangsters and golddiggers conduct their own discourse about ethnicity), and even Disney (despite his anti-semitism) all represent the world as an impossible marriage between animals of different species, between animals and humans, and between live action and animation. That this mixture refers to ethnic and racial miscegenation is being made overt even decades later, in *Who Framed Roger Rabbit?* (1988).[37]

Kirsten Moana Thompson's evaluation of Pepe le Pew addresses this underpinning anxiety in the comedy of miscegenation which is often played out against the romantic exotica of an implied 'Oriental' other.[38] The most important aspect of the projection of this 'otherness', though,

is in many senses an explicit use of the cartoonal aesthetic to employ caricature, and sometimes stereotype, as the agent of revelation. The Warner Bros. cartoons ultimately mock America's failure to address the extent of its ambition and the ironies of its lived experience in the light of its ideological and utopian rhetoric. It is clear that even into the contemporary era American animation has embraced the Warner Bros. style but, more importantly, has embraced this fundamental position. It is a position, too, which is implicit in alternative forms of animation which have first embraced the freedoms implicit in its vocabulary, but also the inherent capacity of animation to enunciate its own 'difference' and 'otherness', while *simultaneously* addressing the implications of 'difference' and 'otherness' in what it signifies and represents.

Notes

1. L. Jacobs, *The Rise of the American Film* (New York: Teachers College Press 1939), p. 505.
2. See M. Langer, 'The Disney-Fleischer Dilemma: Product Differentiation and Technological Innovation', *Screen*, 33 No. 4 (Winter 1992), pp. 343–60.
3. R. C. Allen and D. Gomery, *Film History: Theory and Practice* (New York: McGraw Hill, 1985), p. 113.
4. G. Seldes, *Movies for the Millions* (London: Batsford, 1937), pp. 45–7.
5. J. Leyda (ed.), *Eisenstein on Disney* (London: Methuen, 1988), pp. 3–4.
6. Ibid., p. 8.
7. Ibid., p. 21.
8. Ibid., p. 99.
9. M. Barrier, *Hollywood Cartoons: American Animation In Its Golden Age* (New York and Oxford: OUP, 1999), pp. 290–91.
10. L. Charney, *Empty Moments: Cinema, Modernity and Drift* (Durham and London: Duke University Press, 1998), pp. 6–7.
11. Ibid., p. 7.
12. C. A. Lejeune, *Cinema* (London: Alexander Maclehouse & Co, 1931), p. 83.
13. Ibid., p. 84.
14. Ibid., p. 87.
15. M. Barrier, 'Interview with Frank Tashlin' in R. Garcia (ed.), *Frank Tashlin* (London: BFI, 1994), pp. 156–7.
16. P. Lorentz, *Lorentz on Film* (Norman and London: University of Oklahoma Press, 1986), p. 148.
17. From S. Hochman (ed.), *From Quasimodo to Scarlett O'Hara: A National Board of Review Anthology* (New York: Frederick Ungar Publishing Co, 1982), pp. 272–4.
18. R. Schickel, *The Disney Version* (London: Michael Joseph, 1986), p. 42.
19. D. Boorstin, speaking in 'A Spoonful of Sugar' (TX: 25/10/1973), BBC Recording Services Transcript, 1973, p. 4.
20. D. Robinson, *World Cinema 1895–1980* (London: Eyre Methuen, 1981), p. 397.
21. C. A. Lejeune, *Cinema* (London: Alexander Maclehouse & Co, 1931), p. 85.

22. M. Eliot, *Walt Disney: Hollywood's Dark Prince* (London: André Deutsch, 1994), p. 198.
23. T. White, 'From Disney to Warner Bros.: The Critical Shift' in K. Sandler (ed.), *Reading the Rabbit: Explorations in Warner Bros. Animation* (New Brunswick and New Jersey: Rutgers University Press, 1998), pp. 38–48.
24. M. Winokur, *American Laughter* (London and Basingstoke: Macmillan, 1996), p. 154.
25. Ibid., p. 156.
26. G. Walz, 'Charlie Thorson and the Temporary Disunification of Warner Bros. Cartoons' in K. Sandler (ed.), *Reading the Rabbit: Explorations in Warner Bros. Animation* (New Brunswick and New Jersey: Rutgers University Press, 1998), pp. 49–68.
27. M. Barrier, *Hollywood Cartoons: American Animation In Its Golden Age* (New York and Oxford: OUP, 1999), pp. 331–3.
28. N. Klein, 'Hybrid Cinema: *The Mask*, Masques and Tex Avery' in K. Sandler (ed.), *Reading the Rabbit: Explorations in Warner Bros. Animation* (New Brunswick and New Jersey: Rutgers University Press, 1998), pp. 49–68.
29. See P. Wells, *Animation: Genre and Authorship* (London: Wallflower Press, (forthcoming)).
30. K. Sandler, 'Introduction: Looney Tunes and Merry Metonyms' in K. Sandler (ed.), *Reading the Rabbit: Explorations in Warner Bros. Animation* (New Brunswick and New Jersey: Rutgers University Press, 1998), pp. 38–48.
31. R. Durgnat, *The Crazy Mirror* (London: Faber and Faber, 1969), p. 185.
32. See M. Langer, 'The Disney-Fleischer Dilemma: Product Differentiation and Technological Innovation', *Screen*, 33 No. 4 (Winter 1992), pp. 343–60.
33. M. Barrier, *Hollywood Cartoons: American Animation In Its Golden Age* (New York and Oxford: OUP, 1999), p. 181.
34. R. Durgnat, *The Crazy Mirror* (London: Faber & Faber, 1969), p. 185.
35. H. Sartin, 'From Vaudeville to Hollywood, from Silence to Sound: Warner Bros. cartoons of the Early Sound Era' in K. Sandler (ed.), *Reading the Rabbit: Explorations in Warner Bros. Animation* (New Brunswick and New Jersey: Rutgers University Press, 1998), pp. 67–85.
36. N. Klein, *7 Minutes* (New York: Verso, 1993), p. 193.
37. M. Winokur, *American Laughter* (London and Basingstoke: Macmillan, 1996), pp. 156–7.
38. '"Ah, Love!, Ze Grand Illusion!": Pepé Le Pew, Narcissism and Cats in the Casbah' in K. Sandler (ed.), *Reading the Rabbit: Explorations in Warner Bros. Animation* (New Brunswick and New Jersey: Rutgers University Press, 1998), pp. 137–53.

CHAPTER 3

Synaesthetics, Subversion, Television

The Warner Bros. output ensured that 'cartoonal' distinctiveness survived and served to inform alternative forms of animation within the United States. If Disney is viewed as the aesthetic and ideological orthodoxy, and Warner Bros. its initial most significant challenger and revisionist, the following examples take this position further to identify the extent of 'otherness' and 'difference' that may be recognised in the form; the nature and purpose of its differentiation; and the continuing way in which the aesthetic principles are intrinsically bound up with the re-interrogation and re-definition of socio-cultural politics and perspectives. Interestingly, and perhaps unsurprisingly, this view of what is essentially non-Disney animation correlates readily with a perception of the form as one which both radicalises film practice and speaks to progressive agendas. This in itself may ring of the rhetoric of 1960s idealism and, partly in this spirit, I wish to draw upon Gene Youngblood's concept of 'expanded cinema' written in 1970 to progress my definition of these characteristics and their place as a view of American culture.[1]

Youngblood's proposition is in many senses a re-interpretation of 'modernity' as a consequence of the counterculture's engagement with new technological imperatives, and the implicit re-formulation of the avant garde. It embraces all modes of expression as forms of 'education' as a direct result of their functions as communications systems, but most importantly synthesises 'expanded cinema' as a model of 'expanded consciousness', and 'life like, it's a process of becoming, Man's on-going historical drive to manifest his consciousness outside of his mind, in front of his eyes'.[2] Though suitably 'cosmic' in their signature sixties philosophic style, Youngblood's theories usefully conceptualise *synaethestic cinema*, a principle of cinema in which technological applications operate as a decentralising aspect of visual expression, challenging the terms and conditions of what he describes as 'official' communication structures,

and the generic paradigms that represent them. Youngblood's thesis has a number of shortfalls, and, inevitably, it is a piece of its time, but it does anticipate some of the re-configurations and new media agendas of the early twenty-first century and enables some creative thinking about the status and distinctiveness of animation within American culture.

Youngblood configures the deep structures of popular entertainment as those which define and address the human condition in a spirit of *idealisation* (happy and heroic); *frustration* (intention or desire inhibited or blocked) and *demoralisation* (unhappy and/or defeated), but suggests that art-works transcend this paradigm by using their aesthetic specificity to create symbolic interpretations of more complex and contradictory aspects of human experience. Approaches which seek to innovate and explore boundaries within popular idioms seek to address what Youngblood describes as '[the] entropy of commercial entertainment' and its 'retrospective nature',[3] and it is in this context that I wish to place post-'Golden era' (Disney) animation in the United States. The fundamental principle of Youngblood's conception of *synaesthetic cinema* is that it is composed of 'forces and energies' and is worth considering at some length. As he notes,

> It's not what we're seeing so much as the process and effect of seeing ... synaesthetic cinema abandons traditional narrative because events in reality do not move in linear fashion ... It is concerned less with facts than with metaphysics, and there is not a fact that is not also metaphysical. One cannot photograph metaphysical forces. One cannot even 'represent' them. One can, however, actually evoke them.[4]

He continues by explaining the 'kinetic empathy' the viewer may experience:

> In perceiving Kinetic activity the mind's eye makes its empathy-drawing, translating the graphics into emotional-psychological equivalents meaningful to the viewer, albeit meaning of an inarticulate nature. 'Articulation' of this experience occurs in the perception of it and is wholly non-verbal. It makes us aware of the fundamental realities beneath the surface of normal perception: forces and energies.[5]

While it is possible to question Youngblood's conception of the psychological processes of 'the mind's eye', and his assumptions about 'the viewer', his broad point about the ways in which graphics in motion – the simplest definition of animated forms – become metaphysical principles

and 'felt' mediations of the forces and energies which propel, create and sustain the complex imperatives of human experience is a persuasive one.

Crucially, while accepting Youngblood's view about the inarticulable nature of the perception of this experience, I wish to argue that the presence of the animator within the work always offers significant cues to its point of access, empathy and interpretation. This concept of 'self-figuration' was first discussed by Donald Crafton, and relates to the overt presence of the animator in early animation: 'At first it was obvious and literal; at the end it was subtle and cloaked in metaphors and symbolic imagery designed to facilitate the process and yet to keep the idea gratifying for the artist and the audience'.[6] This seemingly omnipotent 'presence' in most non-Disney animation, non-mainstream feature animation, has a 'mystical' feel that echoes Youngblood's cosmic insights, but is intrinsically linked to the special status of the animator as one who literally brings life to inanimate forms. This 'god-like' imperative gives Maureen Furniss cause to wonder:

> If an animator uses video assist, or instead chooses to store every-thing in his or her mind, is there a qualitative difference in the end product? If there is a very close relationship between one artist and the actual movement of the figures in a production, how does that impact on the aesthetics of a work and the way in which it is evaluated, if at all?[7]

While there might be a clear and obvious case to properly evaluate the interface between the artist and his creation in early animation, self-evidently 'independent' animation and the process of stop-motion anima-tion because of their literal evidence of the animator's practice being the most obvious self-enunciating outcome of the process, I wish to reiterate my view that this condition is endemic in most forms of animation *per se*, and is the signifying agent in the process of interpretation. The Warner Bros. approach was effectively this process made explicit, but is one variant in a range of inscriptive practices that signal a particular viewpoint. Crucially, though this 'viewpoint' must be understood as the way that the artist has chosen a specific artistic practice and how this is imbued with aesthetic, cultural and political meaning.

This paradigm effectively elevates 'the cartoon' and its related forms, drawing it away from the assumption that it can only be understood within the realm of popular entertainment. Youngblood provides a further

set of tools by which this may be interrogated through his concept of 'post-stylisation', here meaning the aesthetic manipulation of 'natural reality', as it has been created through cinematic fiction, documentary and cinéma vérité. 'Synaesthetic cinema', he claims, 'is all and none of these'; it embraces realism, surrealism, constructivism and expressionism, drawing upon each in a way that collapses conventional modes of fictive representation, privileging the 'mythopoetic' as its ultimate outcome.[8] The presence of the animator, the mode of post-stylisation, and the socio-cultural context become the cues by which the clear and distinctive interaction with American mores takes place. Animation, capable of embracing the ambiguous and contradictory through its symbolic vocabulary, becomes the literal depiction of the artist's perceptions as they have transmuted into metaphysical entities. It was this that United Productions of America (UPA), effectively a breakaway group from the Disney studio, saw in the animated form, and wished to make yet more explicit in its overt use of modern art.

Writing in 1956, Bernard Orna notes that American cartoons were characterised by 'stereotyped "comic strip" ideas, overdependence on crude gagging, vulgarity of characterisation, and even ugly drawing', but adds, noting of *Magoo's Check-Up* (1955), that 'UPA again does something to redress the balance'.[9] UPA was established in 1945 by three ex-Disney artists, Stephen Busustow, Zack Schwartz and Dave Hilberman, who left the studio in the wake of the 1941 strike, championing liberal and left-wing ideas thought suspicious and challenging within Disney's then non-unionised, right-leaning, working culture. The trio had formed the 'Industrial Films and Poster Service' during the war years and, sponsored by the United Auto Workers, they made a pro-Roosevelt election film called *Hell Bent for Election* (1944), directed by Chuck Jones. With the same backer, they made *Brotherhood of Man* (1946) about race relations, and it was clear that the imperative of the company was to wrest animation from the Republican conservatism of Disney and the comic bravura of the Warner Bros. studio to place it properly within the context of a visually obvious set of modern art sources, a seriousness of approach, and a politicised culture. Here is Youngblood's 'synaesthetic cinema' writ large; an 'educational' form; a 'post-stylised' agenda rooted in modernism; a culture of *auteurs* explicitly foregrounding the 'forces and energies' underpinning the medium and its purpose. UPA embraced a non-hierarchical structure which privileged and encouraged individual artists, and stood in direct opposition to Disney's industrial culture and

its orthodoxies. Inevitably, this meant that artists displayed less loyalty to the company, and often worked for short periods on their own projects before leaving it. As Ralph Stephenson has argued,

> The UPA breakaway was undoubtedly a rejuvenating, fertilising influence whose value can hardly be overestimated. Even its offshoots, though they may have weakened UPA itself, established important creative artists in the animation field: Gene Dietch, Bill Sturm, [Ernest] Pintoff, [John] Hubley. The diversification of UPA also encouraged further diversification and made it easier for later avant garde experimental work by Carmen D'Avino, Robert Breer, Ed Emswiller and Teru Murakami.[10]

UPA specialised in 'Limited' or 'Planned' Animation, which, in the American context, operates as a more economic form of animation by using fewer and less detailed backgrounds; creating fewer animated movements – often only the movement of eyes, mouth and functional limbs on key characters; employing simple, repeatable movement cycles and stressing sound over some aspects of action. The design of the cartoons was radically different, and suggested a range of symbolic and metaphoric meanings. The Zagreb School of Animation used this minimalism – 'Reduced Animation' – for greater metaphorical and political purposes, preferring aesthetic rather than narrative innovation, and was highly influential upon the work of UPA, who specifically attempted to challenge the Disney hegemony in the 1940s and 1950s with innovative works like *Gerald McBoing Boing* (1951), directed by Robert 'Bobe' Cannon; *The Tell-Tale Heart* (1953), directed by Ted Parmalee, and *Unicorn in the Garden* (1953), directed by Bill Hurtz.

It becomes pertinent to note that these shifts in metaphorical and political perspective were reflected in David Riesman's renowned study of the changing American social character, *The Lonely Crowd*, which looked at post-war, newly-affluent Americans as they sought identity in 1950s consumer culture, suggesting that 'tradition-directed' America was being replaced by a new 'inner-directed' sensibility.[11] The previous model of acquiescence to a conservative, conformist and consensual orthodoxy was being usurped by a more individually determined mode of securing social identity and reward, which also had a further implication in the creation of 'other-directed' individuals seeking new models, in what Riesman calls the 'characterological struggle'.[12] Riesman notes that 'even in a society dependent on tradition-direction there still

remains strivings which are not completely socialised',[13] and it is clear that the Disney approach is coloured by a resistance to this shift of emphasis, one wholly embraced by Warner Bros. and UPA. Disney sought to embody this 'tradition-directed' approach and its Republican leanings, and imbue it within the rationalised aesthetic of the Disney output; the 'narrative' and the 'text' often evidencing a contradictory or ambivalent stance in its embrace of what was essentially a reactionary agenda. The 'inner-directed' and 'other-directed' sensibilities of the rival studios had long embraced their radical potential, the former taking up the preoccupation with 'the internal production of ... character', and the 'change of meaning in the same pursuits'; the latter taking up a 'people-minded' approach addressing the meaning in the 'development of new pursuits'.[14] If Disney is understood as 'tradition-directed', it is interesting to note that within this perspective, Riesman notes that there is a prevailing attitude that 'politics is someone else's job',[15] though this stance is not without political acumen. This very much chimes with Richard Schickel's assessment which suggests that:

> Disney never did think much about political affairs in any programmatic or even pragmatic way. The political conservatism for which he was often attacked by liberal commentators and praised by conservatives was no more than an acting-out of an instinctive feeling about life and society, very much on the order of the other fairly simple, even primitive, ideas that formed his work. If he had any politics at all, they were politics of nostalgia.[16]

Disney's 'tradition-directedness' continues to manifest itself in this mode, set against the increasingly overt *difference* and *otherness* played out in other approaches to the form, championed in the work at Warner Bros. and UPA.

Unicorn in the Garden is a particularly useful indicator of the mode of transition which exposed Disney's 'tradition-directed' imperatives and served to reveal the new 'inner-directed' or 'other-directed' sensibilities that were to replace them. An adaptation of a James Thurber story and illustration, the film tells the simple story of an ordinary man who one day sees a unicorn in his garden, which has a long golden horn and eats lilies. His attempts to persuade his seemingly bedbound, harridan wife that he has seen the creature are met with incredulity and abrasive disbelief, ultimately resulting in his wife reporting her husband's 'madness' to 'I. Ego', the Freudian psychiatrist. Ironically, it is the wife whom the

psychiatrist believes to be mad, and she is taken away in a strait-jacket to the quiet delight of her long-suffering husband. Regardless of what one might feel is an understatedly misogynist narrative, the tensions expressed in the story are important in the sense that the film signals a belief in fantasy and mythology, and a rejection of the social, cultural and institutional imperatives that seek to suppress it. The unicorn cavorts in a brightly coloured garden while the man's wife plots against her husband in the dark and oppressive indigo interiors of the house. The psychiatrist sits under a bright beam when the wife talks to him, yet actually offers no illumination. The UPA studios were instrumental in recovering animation from the structures and limitations that sought to define it, returning the form to the proper embrace of *perceived reality* and its place within artistic and cultural contexts. Though essentially a construct to create 'gags' about misperception and misunderstanding, it is no accident that the studio's enduring and most popular character was Mr Magoo, whose whole agenda is concerned with perceived reality. Writing in 1953, David Fisher stresses the importance of this:

> Mr Magoo personifies a contemporary situation; Disney's heroes no longer do. They were essentially the creations of the 1930s, the period of Astaire musicals and confident madcap comedies. Donald Duck, for instance, did the sort of things that we did not dare ourselves: he was the arch anarchist, the rebel we would have liked to have been. Since then, however, we have experienced a hot war and are in the throes of a cold one. We have had every opportunity, therefore, of studying the nature and results of irresponsible action – and we no longer admire it. Mr Magoo represents for us the man who would be responsible and serious in a world that seems insane; he is a creation of the 1950s, the age of anxiety; his situation reflects our own.[17]

Magoo also represents a loosening of boundaries between perceived and lived experience, and the cartoons, the embrace of re-physicalising and re-materialising the world, redesigning experience in a wholly different spirit to the hyper-realist contexts so determined by Disney. Disney's own desire to break the mould resulted in a movement towards adaptations of English children's literature in films like *Peter Pan* (1953), and even an overt response to UPA's modernist style, in the Academy Award-winning musical history *Toot, Whistle, Plunk and Boom* (1953). Biographer Marc Eliot notes,

When Walt returned from Europe and screened [*Toot, Whistle, Plunk and Boom,*] he was appalled at its unrepresentative, non-Disney visual style and lack of formal narrative. Walt and [its director, Ward] Kimball argued vehemently over the film. Frustrated by what he took to be Kimball's obstinacy, Disney at one point considered firing his animator, and would have done so if *Toot* had not won the Academy Award for Short Subject (Cartoon) of 1953. Nevertheless, Walt explicitly banned all further stylistic experimentation by any animator and limited Kimball's participation in future film productions.[18]

UPA did not see Magoo's shortsightedness and irritability as an infirmity; rather they saw his 'inability to see clearly', like the wife in *Unicorn in the Garden*, who both cannot see and refuses to see, as the spirit of the times. This required the fresh-sightedness of artists versed not merely in progressing modern art traditions, but in artists who would embrace a philosophical approach to perception, and to the possibilities of synaesthetic cinema, and ways of 'post-styling' the reality of both the real world and the Disneyesque orthodoxy. These artists proved to be John and Faith Hubley and their family. John Hubley, an ex-Disney animator from its artistic peaks through to the hyper-realist impasse of *Bambi* (1941), worked with Frank Tashlin and Dave Fleischer in the post-war period before working at UPA on *Brotherhood of Man* (1946), a film influenced by Saul Steinberg's flat cartoonal graphics, and working as a quasi-agit-prop film addressing racial equality. After working on *Magoo* cartoons, he finally joined up with his wife to make *Adventures of an* * (1957). The central premise of the Hubleys' work is 'an image that plays dramatically (a visual metaphor) and will develop into a scene',[19] and which aspires to the work of modernists like Picasso, Dufy and Matisse, while also embracing the freedoms of jazz idioms. His chief influences, though, were the 1929 formalist animation *Post*, by Russian Mikhail Tsekhanovsky, and the works of Norman McLaren. Hubley agreed with the commitment underpinning such experimentation to revise both technique and its ideological imperative with each new work. *Adventures of an* *, made with wax crayon and watercolour, epitomised the idea of looking at things from multiple points of view, and suggested once again that there were alternative perspectives to the mainstream Disney output and the new minimalism of television cartooning. The Hubleys, like their fine artist forbears, saw the art-form as a holistic, pictorial form which was based on the dynamic freedoms of lines, shapes, colours and

forms before it was subject to the demands of configuration or repre-
sentational orthodoxy. These perspectives were increasingly related to
the avant-garde agendas of using modern art for spiritual and philo-
sophical enlightenment.

Of Stars and Men (1962), Eggs (1971) and Everybody Rides the Carousel
(1976) engage with universal and cosmic questions about the evolution
of humankind, the meaning of existence and godhead, and the sense of
predicament in life which must be overcome and learned from. Windy
Day (1968) and Cockaboody (1972) feature the Hubleys' children, their
spontaneous, imaginative, innocent conversation, the stimulus for free-
flowing imagery prompted by and through an immediacy of reponse to
nature and creativity. In some senses this harks back to the context for
Adventures of an * which Faith Hubley describes as 'a child's vision'
about 'how what is perceived by those eyes for the first time is tactile and
felt, and about how that pure vision, as the child slowly grows in society,
is made to follow certain rules'.[20] Eggs is perhaps most revealing in its
representation of 'God'. The soundtrack deliberately abstracts the voice
of God, while the three faces of God and the multiplicity of mouths on
the faces speak to the multiplicity of perspectives at the heart of the
Hubleys' art and also to ancient and Eastern religious systems; clear and
fundamental alternatives to Christian orthodoxies. The aesthetic and
spiritual aspects of other cultures played an increasingly important part
in the movement away from the 'Americanness' imbued within, and
associated with, the Disney output, even in spite of its own European art
sources.[21] Similarly, it took a high degree of radicalism in form and
meaning to challenge the view that Disney was the epitome of 'art' even
among artists. British caricaturist David Low, speaking in the 1940s,
notes,

> I do not know whether he draws a line himself. I hear that at his studio
> he employs hundreds of artists to do the work. But I assume that his is
> the direction, the constant aiming after improvement in the new
> expression, the tackling of its problems in ascending scale and with
> aspirations over and above mere commercial success. It is the
> direction of a real artist. It makes Disney, not as a draughtsman but as
> an artist who uses his brains, the most significant figure in graphic art
> since Leonardo.[22]

This perspective renders the Disney outlook and ethos as fuelled by an
integrity which was intrinsically related to the creation of art in a way

that essentially processed the form from the characteristics of new and fundametally fragmentary production environments. The Hubleys wished to work in a different way that both preserved their identities as creative artists working in animation but also as designers and film-makers. This is an important distinction because it focuses upon the difference between actually determining the authorial purpose of the art, and its execution. As Faith Hubley notes,

> there isn't really a word for an animated film-maker, but they're really two things. There's animation, the craft, and there's animation, making the whole film. In the Disney studios the craft people were the animators. Disney knew exactly what he was doing when he emphasised the craft separation so that nobody would have the film-making power; that's not only a political observation, it's an artistic one.[23]

The Hubleys, like similar artists working in the avant garde, wanted to re-invest the art form with a more 'integral' view of creative practice, and an inclusive view of art as a mediator of aesthetic sources which were also intrinsically bound up with individual responses to the natural and social world.

Francis Lee, working from the mid-1940s, for example, used a calligraphic style reminiscent of Chinese painting, deploying a variety of coloured inks and other materials like glass and sand for various textured effects. *1941* (1942) was an interpretation of the Japanese bombing of Pearl Harbor, essentially using the shift from sea-hues to blood-red to grey to intimate the emotional experience of the event. *Le Bijou* (1942) comments on the place of the animator poet within society, and stresses the meditative and transformative processes of art as a significant social activity which should not be marginalised through its very place within art practice. This is one of the most crucial aspects of animation and its related forms within this context. Artists insist that the form can embrace not merely a range of metaphysical ideas but a range of processes and experiences which are enabling as enriching human practices. *Idyll* (1948) is a lyrical endorsement of this view privileging an abstract landscape and a fish-like form engaged in mysterious movements as a context which seeks to draw the human sensibility back to a contemplation of its pre-industrial temperament as a mode of modern understanding. There is a similar agenda in the organic forms in Douglass Crockwell's *Glens Falls Sequence* (1946), and later in James Whitney's *Lapis* (1963–6), and

the films of Jordan Belson. In recovering this more 'primal' premise in the work, such artists also recall other traditions. Harry Smith, most notably, worked in the mode of 'magical illusionism' and clearly saw his own art-making practice as a cipher for the 'forces and energies' he mediated. 'My cinematic excreta', he suggests, 'is of four varieties: batiked abstractions made directly on film between 1939 and 1946; optically printed non-objective studies composed around 1950; semi-realistic animated collages made as part of my alchemical labours of 1957–62 and chronologically superimposed photographs of actualities formed since the latter year'.[24] Consequently, Smith's work sometimes offers the possibility of interpretation through the allusive qualities of some of the materials he uses, but *Heaven and Earth Magic* (1960), probably his best-known work, obfuscates as it suggests, drawing upon Cabalist thought, contemporary scientific thought on brain surgery, Eastern philosophies and the work of Max Ernst. The film is primarily an address of the liberation from material life and existence on to an elevated, spiritual plane, which offers challenges and promotes anxiety but also the pleasures of 'difference' and 'otherness' as modes of being. A skeletal figure balances a baby within the human brain; death precariously balanced in life within the frame of knowledge beyond everyday experience. Smith's film, like much animation in this form, seeks to access this frame of knowledge. In seeking to produce art-work which embraces psychological phenomena and emotive reactions, Smith refuses a hierarchy of conscious and focused ideas, preferring instead to literally present 'a state of consciousness'. 'Since the viewer never knows the desired end of an operation or series of operations,' argues Adams Sitney, 'he must divide his attention evenly among the endless and varied procedures'.[25] Larry Jordan's surrealist work which includes *Our Lady of the Sphere* (1969), *The Orb* (1973) and *Once Upon a Time* (1974) and which has the quality of a moving engraving, suggests that 'the imagery in my animated films has always concerned unknown continents and landscapes of the mind. Some call this a real place. Certainly the Egyptians did, so did the Greeks (the underworld) and so do the Tibetans (Bardo). In most cases it is the world of the so-called dead. In this sense it can be a negative world. To me it is not, or has not been'.[26] Jordan, like Smith, is animating the 'felt' space, and the 'open' space of consciousness, partly echoing former traditions, partly in the spirit of using art for quest and exploration. This 'openness', both in the form itself and as a perspective on perception and behavioural alternatives, is a key aspect of animation as a synaesthetic cinema and a

mode of production which at one level speaks once more to the 'inner-directedness' of revising known experience and the 'other-directedness' of suggesting and promoting 'new experience'. Where this has been particularly crucial in American animation is in the area of gender, and the representation of women and women's experience. What is important here is the full recognition that this kind of personal experience, expressed through art, is as much part of the social and cultural domain as political ideology and commercial enterprise.

Mary Ellen Bute's 'abstronics' — the aesthetic and rhythmic manipulation of light in electronic forms to illustrate 'invisible events' germane to the sub-atomic or micro-world — resulted in *Abstronic* (1954) and signalled an important departure not merely in the way that a woman embraced avant-garde and animated film practice, but in the way that she embraced technology as the key element of progress in differentiating the art-form. This 'embrace' of the mechanism by which women can create authorially determined pieces outside the constraints of structures and systems created and designed by men, has proved attractive to a range of women film-makers, and has seen women attain creative independence. Beyond this kind of work, Bute also enjoyed engaging with the tensions between configuration and abstraction in a film like *Spook Sport* (1939) which brings a sense of the supernatural to the movement and development of abstract forms, once more suggesting a kind of playful mysticism beyond, for example, the gothic entertainment of *Skeleton Dance* (1928), which has its own claims to a perverse abstraction. Bute's pioneering work was an inspiration to the new wave of female independent animators much later in the 1970s as there was a prevailing sense that women had impacted on the field of animation only in the craft idioms, and not as the director or *auteur*.

Jayne Pilling has written,

> The impact of the women's movement clearly had something to do with this, in creating an encouraging climate and influencing, to some degree at least, the availability of funding at national and state level, as well as creating an audience for the films themselves. Animation, with its ability to play around with the parameters of fine art on the one hand, and accessible cartoons on the other, seemed to present new opportunities for exploring issues (particularly gender stereotyping and sexist imagery) as well as offering a potentially unlimited field for self-expression.[27]

This particularly provoked a range of films which in the spirit of the 1960s counterculture and issues about sexual liberation, enabled women to address sex and sexuality overtly. Suzan Pitt's film *Asparagus* (1975) uses provocative images of a phallic asparagus, which early in the animation is defecated, throughout, caressed, and towards the film's conclusion, fellated, in order to address the relationship between 'phallic' or patriarchal imperatives, and the ways women have had to suppress their felt experience within the phallic order. The excretion is at once an acknowledgement of the phallic order as 'a waste', but similarly operates as an organic image of emission from the female body, which is a recognition of the things that are 'felt' by women, but remain 'unseen' by them, and others. The natural cycles of consumption have been over-taken by formal, institutional and artificial social constructs, confining women to the privacy of the domestic space. This is represented in the film by a doll's house which the main 'faceless' female protagonist engages with as a metaphor for her constraint, and her freedom to imagine. This is the provocateur of her creative fantasy, which she later acts upon, releasing a bag of free-flowing images into a theatrical context. Even as she fellates the asparagus at the end of the film, it changes form and substance, in recognition of the thoughts, feelings and sensations the woman is imparting and in control of. She has re-defined phallic power through her creative and pro-active libidinous identity. Pitt's film is a *tour de force* of lush colour and provocative symbolism, accompanied by a near atonal score by Richard Teitelbaum, which challenges notions of easy associativeness and interpretation. Pitt is clearly reviving a primal agenda in the private space to challenge public and political orthodoxies, but most of all is suggesting that art and life are intrinsically linked, if not inseparable, and once more should be acknowledged as a social agent.

Jane Aaron,[28] in her films *Interior Designs* (1980) and *Remains to be Seen* (1983) uses animation as a method by which to act upon both photorealist and live action interior and exterior environments, re-determining their 'taken-for-grantedness' and their naturalised meanings. This essentially re-politicises the environments too, in a spirit of speak-ing to issues of ownership and control; form and function; reactionary thinking and radical action. If Aaron's work engages with the very living spaces that define identity, Sally Cruikshank re-engages with the cartoonal tradition, bringing a maturity to the apparently 'child-like'. Hoberman suggests, 'Adroitly, Cruikshank evokes a range of native fantasy verna-cular styles, from fin-de-siècle Coney Island and 20s movie palaces to

the futurama deco of Hollywood cabaret scenes and Miami Beach hotels, to the Day-Glo gaudiness of cities' psychedelia'.[29] Drawing also upon the radical imperatives of underground cartoonist Robert Crumb and the teaching of Larry Jordan, Cruikshank eventually introduces her characters, Quasi and Anita in *Quasi at the Quackerdero* (1975), who go to a carnival where time, place and states of consciousness (from dream to sexual fantasy) are in animated delirium, set against an implied backdrop of surreally normative Americana. *Make Me Psychic* (1978) features the pair again, amidst a plethora of anthropomorphised landscapes, and a mise-en-scène in Fleischer-like flux, where Anita's telekinetic rage animates the natural and concrete world around her, sending them out into the cosmos. While wildly different from Harry Smith's vision of the psychological and emotional dynamics of presenting a 'state of consciousness', Cruikshank nevertheless presents a gendered variant on Smith's 'endless and varied procedures', not merely re-defining the cartoonal space, but satirising the shift from everyday cultural engagement into an aspiration for elevated spiritual life, a mode of social being. Cruikshank challenges America through its most obvious and established form of animation by adopting a part-avant-garde, part-Clampett, part-UPA, part-feminist, part-populist stance, using the very imagery that the United States knew to be innocently crazy, but in the context of the 1970s was a recognition of its complete loss of stability and coherence. In the age of Vietnam, Watergate and the loss of consensus and identity in the United States, it was a profound vision of change.

Such change was also documented in a significant way by one of the key film-makers in the field of feature animation in the 1970s. Ralph Bakshi's 'X-rated' *Fritz the Cat* (1972); semi-autobiographical *Heavy Traffic* (1973) and anti-*Song of the South* feature *Coonskin* (1975) were overt and unsubtle in their social critique, but their address of sexual promiscuity, drug culture, urban politics, violence and black ghetto life revolutionised animation in the public imagination, which had only ever configured the form as the innocence of Disney. Bakshi's version of synaesthetic cinema was not 'absolute animation' in the style of the avant garde or in the 'post-styling' of reality, but in the emphatic caricature of social types and contexts. In many senses, the explicit nature of these depictions was in some way counterproductive, however, as Bakshi's perspective in once more seeking to promote an America of multiple voices was challenged by those who assumed that he wished to represent those voices, too. This

was most notably the case with the NAACP who objected to the 'racism' in his films, which the 'Blaxploitation' films made by black directors avoided, although many of the idioms and attitudes expressed were similar. Bakshi radicalised the feature-length animation by embracing the contradictions of a society in crisis. His representation of the freeing of sexual inhibitions, the street-culture of the civil rights movement and the ambivalent place of art in the mid-1970s was profoundly important, and in being *about* anxiety, alienation and change, was misunderstood as *promoting* fear and conservatism. While, arguably, there are aspects of these films which may provoke anger and resentment, there is much else that sees America as a place which refuses its multi-culturalism unless it can commercially exploit it, and as a nation which is desperate to maintain its populist myths in the face of socio-cultural antagonism which insists upon its recognition of reality. It is little wonder, perhaps, that the United States needs its 'Disney'. The 'Unicorns in the Garden' have other things to say which many do not wish to hear or see. This is pivotal in the sense that with the 'Golden Era' drawing to a close, 'mainstream' animation preserved largely in increasingly disappointing Disney features and more radical forms perceived as peripheral or irrelevant, the transition of animation in the television era was, arguably, the 'final nail in the coffin' for the form. There is another way of viewing this moment, however, which once more views animation as a 'subversive' language in its own right that challenges and resists easy conformism or marginalisation.

If the 'tradition-directed' sensibility in American cultural and aesthetic life is alive and well in the Disney ethos, then the 'inner-directed' and 'other-directed' sensibility of the 'cartoonal' camp and the independent film-maker has, arguably, survived in the context of mainstream television programming as well as on festival circuits. The television era was greeted with scepticism and a fundamental break with the view of animation as an art. Further, the specific market economy of television production and its viewing audience led to a view that animation was a children's entertainment medium. Richard Schickel noted, however, that the 'Saturday Morning Cartoon', as a devalued and demoted form, seemingly un-noticed by adult audiences and not given serious attention by aesthetic critics, enabled animators to once more exploit the 'unregulated' aesthetic of animation:

> As a result a certain amount of satire went on down there in the bargain basement. It was not great stuff, but it was often more lively

and pointed than what went on in prime-time situation comedies. Bullwinkle, Dudley Do-Right of the Mounties, and Roger Ramjet ... were healthy spoofs of traditional mass media heroic attitudes and one was grateful for them as small favors, slight correctives to the steady drip-drip-drip of banality in most children's programming.[30]

A wide range of 'generic' approaches to animation have characterised the output in American television schedules since the 1950s, many based on other popular culture forms, from comic strips to television situation comedies. With the proliferation of broadcast outlets, and a wide demographic attracted to the medium, many shows have become successful on a global scale and, ultimately, this has defined the form in a different way for many audiences in the contemporary era. While it has always been the case that 'Disney' defines the cinematic space in animation, it is Hanna Barbera who first properly embraced the possibilities afforded by television in necessarily having to re-define animation for the new medium. This inevitably reconfigures the form within institutional infra-structures, facilitating cost-effective production, execution and distribution of animation for television, and invites a response to the form within the confines of the domestic space, raising debates about how animated programmes have been received and perceived by parents and children alike. John Kricfalusi's *The Ren and Stimpy Show* is a pertinent example of this issue. Nickelodeon's market research test-screenings using sample audiences demonstrated that both adults and children uniformly preferred *Doug* and *Rugrats* as entertaining cartoon series, but Nickelodeon's commissioning editors retained the project on the basis that *The Ren and Stimpy Show* was the cartoon that observably and self-evidently children laughed at most.[31] This immediately raises issues concerning the tensions between animation predicated on maintaining social and ideological consensus – effectively the premise of *Doug* and *Rugrats*, and the 'alternative' agendas and textual variations available in cartoons which potentially liberate children from a previously determined moral or cultural order – represented in this example by *The Ren and Stimpy Show*, but equally applicable to *The Simpsons* or *Beavis and Butthead*. A central aspect in this tension is in the ways that the 'tradition-directed' modes have been absorbed in the cultures of production within television in relation to *process-driven* work, while the 'inner-directed' or 'other-directed' sensibilities have remained in *creator-driven* projects; the latter, perhaps inevitably, sometimes falling foul of the limits placed upon them

in the broadcast context, while equally inevitably challenging them through the 'openness' of animated form. Clearly, however, with the increasingly expansive number of channels available to viewers in the digital era, and vast amounts of broadcast space needing to be filled, the televisual c ontext may enter a period of radical change. This in itself necessitates a need to engage with aesthetic strategies; institutional and economic contexts; and the impact and effect of particular kinds of representation concerned with identity and social and/or educational achievement in a different light. *God, the Devil and Bob*, which featured the archetypal struggle of good and evil through the everyday figure of 'Bob', was still deemed ultimately unacceptable, however, even in the promised liberal era, having raised objections from Christian Fundamentalists and other religious groups for its depiction of God as Jerry Garcia, guitarist in legendary 'pot-head' band The Grateful Dead. Ironically, it was the very prominence of animation as a form within prime-time schedules that prompted this concern, one unthinkable in the early developments of animation on television.

In October 1954, *Disneyland* debuted on American television, ushering in an era of recognition that television was to compete with, and surpass, film as a popular medium. The success of the show, and particularly in the first instance the appeal of the live-action 'Davy Crockett' saga, both enabled ABC to gain an established foothold in the issues of ownership and control played out by the vying networks, and shift the emphasis of influence and effect from New York to Hollywood, back to the 'players' in the film community keen to establish themselves in the 'new' medium. In the first instance, ABC provided a $5 million budget for the series, one minute of commercial time per hour in order for Disney to promote his own output and products, and invested $500,000 to support the concomitant development of the Disneyland theme park, plus $4.5 million in loan agreements in exchange for a 34 per cent stake in the park and all concessions profits for a ten-year period.[32] *Disneyland* was a Top Ten ratings success, and essentially saved a financially ailing ABC through its appeal to a family audience, but most specifically children. Disney himself saw the potential of the medium to speak directly to the public, and anticipated what in later market cross-platform terminology would be called 'synergy'. Scheduled against artists like Arthur Godfrey, renowned for variety shows which drew an older demographic, *Disneyland* successfully found the adult audience of 'baby boomers' who were re-familiarising themselves with the cartoons they saw in their own

childhoods (and at the zenith of Disney's public profile and popularity) and the children's audience who were seeing some of the Disney shorts for the first time in the comfort of their own home. Significantly, Disney saw television as a way of marketing the rest of the Disney franchise, most notably the new theme park in Anaheim, California. The *Disneyland* programme itself was divided into four categories – 'Frontierland', 'Tomorrowland', 'Adventureland' and 'Fantasyland' – which echoed the four areas of the theme park; 'Fantasyland' mainly featuring cartoons. This ensured that there was also an enduring market for Disney's less successful cinema output, by this time. The hour-long television version of the seventy-five-minute feature *Alice in Wonderland* (1951) was clear evidence of the way in which cartoons would be re-cycled through revision and repeat, speaking favourably to the new economies of television production. In 1958, the series moved to NBC, and became first *Walt Disney Presents* and then *Walt Disney's Wonderful World of Color*, a vehicle to essentially promote NBC's parent company RCA's production of colour televisions, and, once again, foreground a mixture of classic cartoons and some startling nature photography. Crucially, Disney's output represented a 'modernisation' of children's programming; *The Mickey Mouse Club*, for example, engaging with children in different ways from the homespun 'amateurism' of *Howdy Doody* – as Steven Stark has suggested:

> *Howdy Doody* was New York, live, with adult performers and a studio audience; *Mouse Club* was Hollywood, on film, with child performers but no studio audience. Because *Howdy Doody* was live (which meant no repeats) it was less profitable. Though both 'named' characters weren't real, one was a marionette, one was a cartoon character. The future belonged to the mouse.[33]

While the Disney studio embraced the television revolution, seeing the potential of re-defining its output accordingly, other studios were less enamoured, perceiving animation production in general as uneconomic, and closing units accordingly. William Hanna and Joseph Barbera, named heads of production at MGM in 1955, and seemingly secure in their reputation and achievements with the *Tom and Jerry* cartoons from the 1940s, suffered this fate early in 1957. Escalating costs of film production *per se* and, ironically, the increasing impact and effect of television in general caused studios to re-think production in a cost-effective way. In halting the production of new cartoons, and selling the

back catalogue of cartoon shorts, both MGM and, later, Warner Bros., who finally closed their theatrical cartoon division in 1964, found the most economically efficient way of dealing with the crisis. Of greater significance, however, was the way Hanna Barbera found production methods by which animation on television could be cost-effective. At first, suggesting new animation as 'bookends' to the re-packaging of old cartoons, Hanna Barbera persuaded CBS's John Mitchell, Head of Sales at Screen Gems, to support the concept of 'limited' or 'planned' animation in the creation of new characters, 'Ruff and Reddy', a cat and dog pairing allied against such villainous counterparts as 'Scary Harry Safari' and the 'Goon of Glocca Morra'. Premiering in December 1957 on NBC, *The Ruff and Reddy Show*, hosted by Jimmy Blaine and a number of puppet characters, was broadcast in black and white, but the cartoons were made in colour in anticipation of the inevitability of colour television, and the equally inevitable profits made from syndication. As Barry Putterman has remarked, '[Hanna Barbera's] financial success with this strategy unalterably changed the direction of Hollywood studio animation'.[34] Right through to the present day, however, this has prompted resentment. In his obituary for William Hanna, in March 2001, Denis Gifford, notes:

> True, animation would become a worldwide industry with cartoon-ists feeding their sequences to Hollywood headquarters for assembly. True, Taft Communications bought the company in 1966 for $26m, and true that in 1977, CBS televised a special called *The Happy World of Hanna-Barbera*. But it is also true that the contrasting clips from their MGM days show up the boring awfulness of their more recent productions.[35]

Warner Bros. began making direct-to-television cartoons in 1960, like MGM re-packaging post-1948 cartoons with new 'bridging' animation. *The Bugs Bunny Show* premiered on ABC and was produced by veterans Chuck Jones and Friz Freleng. This served to showcase cartoon shorts to a new audience, and in some senses foregrounded the previous achievements of the 'golden era', arguably, once again, both pointing up the deficiencies of the new made-for-television animation that was to compete with it in the schedules and encouraging a reflexive relationship between the two 'styles'. Chuck Jones suggests that 'Saturday Morning' cartoons were essentially 'illustrated radio' in which the dialogue had prominence over the visual and graphic elements, adding 'the drawings

are different, but everybody acts the same way, moves their feet the same way, and runs the same way. It doesn't matter whether it's an alligator or a man or a baby or anything'.[36] Crucially, this emphasis on dialogue, and 'voice' rather than 'sound', is one of the key determining factors in the way 'animation' became subject to changing perceptions among its audience. The intonations and dynamics of Hanna Barbera's voice artists, Daws Butler, Don Messick and June Foray, in defining 'characters' supplanted the urban *cacophony* of Warner Bros. and MGM cartoons and the more *symphonic* sound cultures of Disney films,[37] allying the cartoon to the model of theatrical performance in early television drama and situation comedy. This is a significant difference in the sense that the 'demotion' of the intrinsic vocabulary of animation in its own right has determined that 'animation' itself has been perceived differently by the generation who was ostensibly brought up on made-for-television cartoons, and those viewing generations thereafter, who use the Hanna Barbera series from the late 1950s onwards as their point of comparison to new animation, and not the works of the 'golden era'.

From the late 1950s to the present day, the social and economic terrain of the 'Saturday Morning Cartoon' in the United States has been fiercely contested by the main networks, ABC, CBS and NBC.[38] Live-action series produced to appeal to children were often cancelled when it was realised that cartoons performed better in the re-run cycle, and thus became more cost-effective, in the sense that fewer cartoons could be broadcast on more occasions over a longer time frame. In the early 1960s, NBC prospered with both *The Ruff and Ready Show* and *The Bullwinkle Show*, but by 1964 the latter show had transfered to ABC and was broadcast with *The Jetsons*, following its successful run in prime time. In the following season, ABC both consolidated and pioneered in their approach to the Saturday morning slots, premiering *The Beatles*, made in England by TVC, deliberately seeking to find the adult/child crossover audience already aware of, and participating in, the cultural success of the 'Fab Four'. This principle of producing cheaply made cartoons which sought to embrace crossover audiences or already established demographics became an intrinsic approach within television animation in the United States. Series about popular music groups followed with *The Jackson 5ive* in 1971 and *The Osmonds* in 1972. Again, in 1967, ABC broke new ground with the introduction of *The Fantastic Four* and *Spiderman*, animations based on popular comic books, which already had a committed fan base and market. Though CBS were

partially successful in response with their comic-strip adaptation of *The Archies* in 1969, their competitive edge ironically returned in the re-packaging of classic Warner Bros. cartoons in the *The Bugs Bunny/ Roadrunner Show*, but ratings success for the network was properly achieved in the next season with the *Wacky Races* spin-offs, *Dastardly and Muttley* and *The Perils of Penelope Pitstop*, and the appeal of *Scooby Doo, Where Are You?* Scooby survived on Saturday morning television for the next twenty years, and is still one of the most popular cartoon characters on 'The Cartoon Network'.

Stefan Kanfer has suggested that 're-runs and short-lived characters could not fill the intense demands of network schedules', however 'TV needed an unending parade of new faces to accompany their familiar standbys', and this resulted not merely in cartoonal work, but stop-motion animation like Art Clokey's *Gumby*, who survived for 'three decades, first as an eccentric comedian, then as a rubberised toy, and finally, when he got religion, as a medium of moral instruction for the National Council of Christian Churches'.[39] Gumby's survival over some 127 episodes is in some senses accounted for by the transitions and developments in his creator, Art Clokey, who, in my own paradigm, moves from being an 'inner-directed' creator to a 'tradition-directed' director. In 1975 he made an abstract film called *Mandala*, in which he notes 'I attempted ... to suggest a time-and-mind expanding experience, the evolution of consciousness, by orchestrating deep cultural symbols from the collective unconscious',[40] and in this he echoed the work of Smith, Belson and the Whitneys, and the centrality of the 'mandala' as a visual concept to the avant-garde 'inner-directed' or 'other-directed' sensibility. As Maureen Furniss has suggested,

> A 'mandala' (Sanskrit for 'round' or 'circle') is a symmetrical image, usually circular but sometimes square, lotus-shaped or of another geometrical form, that is an important component of Hindu and Buddhist religious practices. In that context, mandalas have symbolic meaning – generally representing the cosmos, deities, knowledge, magic and other powerful forces – and often are used to assist concentration and meditation.[41]

Animation was crucial in bringing 'life' to these symbolic associations, energising static forms into an active model of spiritual participation and engagement for their audiences. Clokey's commitment to an avant-garde

perspective on spiritual life gives way, however, to a more 'tradition-directed' approach in the figure of Gumby, who carries with him 'spiritual' meaning in the guise of his overt Christian 'goodness', and, most importantly, does this within what is the highly conservative context of mainstream television, which readily embraces such an outlook. Clokey suggests, however, that beyond the meaning and value of the character, a mode of more abstract spiritual connection survives in the construction of Gumby as a 'clay' character: clay is 'a symbol of the basic nature of life and human beings. As I've toured the country with Gumby, I've realised that kids pick up on that. Their fascination with Gumby is a gut reaction to clay – not the character – just to the clay itself'.[42] Gumby remains unusual, however, as the mass production of the cartoon was central to television scheduling and hastened the dominance of 'process-driven' work.

Crucial to the advances in the Saturday morning cartoon schedules were animated versions of popular prime-time series. *The Brady Kids* followed on from the live-action *The Brady Bunch* in 1972; *The New Adventures of Gilligan*, *My Favorite Martians* and *Jeannie* based on the live-action sit-coms *Gilligan's Island*, *My Favorite Martian* and *I Dream of Jeannie* were made between 1973 and 1974; *The Fonz and the Happy Days Gang* based on *Happy Days* debuted in 1980; versions of *Laverne and Shirley* and *Mork and Mindy* followed; *The Dukes* based on *The Dukes of Hazzard* began in 1982, interestingly scheduled against *Pac man*, the first of the computer games-inspired animations that have reached their recent zenith with *Pokémon*. Clearly, though, the 1970s and 1980s were charac-terised by animation which was uninspired and aesthetically redundant. The form was merely employed as a graphic echo of live-action forms, extending the shelf-life of popular series by using what had become *the* visual language by which it was assumed children were addressed. The television generation only essentially understood 'animation' as 'the cartoon' as it had been produced for television and the children's demo-graphic. This became extended when television producers realised that the television generation was once again becoming a new movie generation in the 1980s with the rise of the multiplex, and that the line between fast-maturing children and 'young people' was increasingly blurred. Consequently, animated versions of *The Real Ghostbusters*, the Michael J. Fox vehicle, *Teen Wolf* and *Beetlejuice* quickly followed on from their movie successes; a model that continues in the contemporary

era with animations like *Men in Black* and *Jumanji*. The final crossover area was inevitable. Will Vinton's *The California Raisins* gradated from their status as popular characters in commercials to secure their own series. Increasingly, the interface between a cartoon and its possible merchandising was effectively effaced in series like *Thundercats*, when concerns were raised by parents that series were only being created by and for toy manufacturers, working in their own interests.[43] The shift from an aesthetic orientation to a consumer orientation was complete; animation essentially used as the cheapest form of advertising for a range of children's toys. Stefan Kanfer has noted that much of the decline in animated cartoons, and the general contempt in which they were held – 'You could animate a [Superhero] series on toilet paper and the networks would buy it' (Friz Freleng) – was related to a 'changing domestic and foreign climate. Tooling up for defense had created more than a million jobs in the United States, and the early war protesters were overshadowed by good economic news, as well as reassurances that the fighting in Southeast Asia would be over soon'.[44] Though the commercial and right-wing agenda had gained credibility, and the lax advertising codes for children's broadcasting were freely exploited, it was still the case that the very artifice of animated cartoons foregrounded the archetypal conflicts and ambivalent resolutions that seemed increasingly out of place set against the kinds of social backdrop of conflict and confrontation resulting from the protests of the civil rights movement and counterculture groups. Further, not all television cartoons refused responsibility. *Jonny Quest* (1964) was described as

> the first attempt at an intelligent science-fiction prime-time cartoon
> … it came at a time when very few shows presented scientists in a
> favourable light … But Dr Quest, a middle-aged scientist, was an
> intelligent and thoughtful character – a role model for pre-teens.[45]

Jay Ward's *Rocky and his Friends* had earlier set precedents with its use of satire and its general ambivalence to a consensual America. Rocket J. Squirrel and Bullwinkle J. Moose are constantly embroiled in adventures which refer to Eastern Europe – 'Pottsylvania' and, most particularly, Mr Big in the 'Krumlin', but this is a world which consistently seems inchoate and resistant to any notion that the United States has anything but an anxiety-laden naivety about its own identity in the face of 'Cold War' villains. In 'Box Top Robbery', villains Boris and Natasha fraudulently acquire all the free gifts and related merchandising from

cereal packets; Boris revelling in 'vital consumer goods'. Sponsor General Mills found Ward's irony unacceptable and objected to the story, and it became clear that the dual pressures from both commercial enterprise and social activists and advocacy groups placed a pressure on cartoon-makers to conform to consensual political and economic agendas; a conformity that 'creator-driven' works continued to resist.

Cartoons did lost their ability to be controversial. *Mighty Mouse*, which debuted in 1942 and was produced by Terrytoons, in its early years made an occasional nod to Fleischeresque sauciness in its bashful hero's engagement with female protagonists like Krakatoa Katy – 'She ain't no lady when she starts to shake her sarong!'. *Mighty Mouse* also moved with the times, his 'Superman'-like evolution in the 1940s and 1950s governed by anything from the consumption of the again widely available post-war foodstuffs; the taking of vitamins in the suburbanite, health-conscious early 1950s; the absorption of atomic energy, still the currency of Cold War diplomacy or through his acknowledged 'Alien' powers, once again chiming with post-Roswell invasion anxieties. *Mighty Mouse* only featured in his own cartoons, however, in last-minute appearances, when, hollering 'Here I come to Save the Day!', he did exactly that. The character became more central to the more melo-dramatic adventures that emerged throughout the 1950s, and in the reincarnations of the cartoon in the *Mighty Mouse Playhouse* in 1955 and *The Adventures of Mighty Mouse and Heckle & Jeckle* in 1979, where he was also used in educational contexts to advise children about the environ-ment, encouraging them not to drop litter or sully forested areas. This morally sound, socially aware Mighty Mouse was to change slightly, however, in the more self-reflexive *Mighty Mouse: The New Adventures*, beginning in 1987.

These Ralph Bakshi-directed *Mighty Mouse* cartoons of the late 1980s were made by a team including a young John Kricfalusi, later the creator of *The Ren and Stimpy Show*, and they reflected a much more self-conscious appreciation of cartoon culture and tradition, most particularly in the ways that subversive representations and agendas could be 'invisibly' placed within the seemingly innocent and 'unregulatable' space of the cartoon form. The 'inner-directed' and 'other-directed' sensibility sought to undermine the new 'tradition-directed' model essentially put in place by the television regulators. 'Program Practices at CBS has ruled that a character that has been hit or in a fight cannot have: 1. eyes at

half-mast 2. eyes twirling 3. tongue hanging out 4. dazed or hurt look 5. Closed eyes 6. circle of stars around head'.[46] This kind of advice essentially sought to withdraw any of the intrinsic 'cartoonalness' from the imagery, and supposedly the non-consensual anarchy that was concomitant with it. Ironically, however, even the most innocuous of cartoons – *My Little Pony* – fell foul of right-wing Christian Fundamentalists who saw the devil in the be-horned unicorn featured in the series, while the American Family Association claimed Timon and Pumba in *The Lion King* were overtly homosexual characters. The cartoon 'form' itself invited suspicion because of its artifice, and seemingly all representational forms were subject to scrutiny and anxiety. Bakshi, a Terrytoons veteran from 1956, often unsettled the studio with his claims to 'auteurism',[47] later fully justified, of course, through his work in *Fritz the Cat* (1972), *Heavy Traffic* (1973) and *Coonskin* (1975). Having achieved some success with his *Mighty Heroes* cartoons in the late 1960s, he was a self-evident choice to revive Mighty Mouse's fortunes. The new cartoons parodied other cartoons like *Alvin and the Chipmunks* (Elwy and the Tree Weasels), *Batman* (Bat-Bat and Tick, the Bug-Wonder, who drove a Man-mobile) and *The American Tale* (Scrappy, an orphan mouse, a critical take on Spielberg's over-sentimentalised Fievel) and were, clearly, more 'adult' in their outlook. So much so that the Reverend Donald Wildmon of the American Family Association alleged that one cartoon, *The Little Tramp* (1989), depicted drug abuse in the act of inhaling cocaine, though to more innocent eyes this may look like the sniffing of a crushed flower.[48] This event did irreparable damage to the series, for in spite of the fact that the offending three-and-a-half seconds were removed, and that, somewhat ironically, the series won an award from another parent watchdog group, the Action for Children's Television (ACT) body, *Mighty Mouse: The New Adventures* was cancelled. Essentially, what had been assumed as innocent in theatrical cartoons, and principally 'Disney' animation, suddenly assumed a more challenging quality in the context of television, and prompted an engagement with the possible pedagogic function of the animated television cartoon and the need to evaluate its possible effects on children. This has always been closely monitored by a variety of advocacy groups, on the one hand acknowledging the persuasiveness of animated characters in entertaining and educating children; on the other, bringing 'adult' eyes to the censorship of imagery that is deemed unsuitable for children, yet which at the same time would not necessarily be noticed by them.

This was also the case with the apparently alternative agendas of *The Garbage Pail Kids*, which was perceived as endorsing misguided values which might adversely affect children and their behaviour. Even though these particular cartoons caused small-scale moral panics, this was largely uncommon as animators became self-censoring, but curiously it remained the case that cartoons, however innocuous, were still viewed with suspicion, caution and sometimes overt hostility – issues seemingly emerging out of adult anxiety about an aesthetic which on the face of it seemed innocent and child-centred, but which was nevertheless an aesthetic produced by adults. Clearly, there was some recognition by advocacy groups – among them The National Coalition on Television Violence and the National Federation for Decency – that theatrical cartoons of the 'Golden era' did have adult themes, and that Warner Bros. shorts did deliberately 'play' to adults. The Fleischer Brothers were also notorious for the sexual imagery of their Betty Boop cartoons. Such cartoons were viewed with a degree of nostalgia, and a contradictory view of these works emerged, partly endorsing their status as an intrinsically 'American' form, but also demonstrating a self-conscious realisation about the scale of 'inner-directed' and 'other-directed' representation in the texts which challenged and subverted social orthodoxies. The legacy of the racier, more surreal, more 'cartoonal' aesthetic of the 1930s and 1940s was an underlying suspicion about the motives of the artists and an anxiety about the apparent freedoms of the graphic idiom. Even though it was quite clear that the television aesthetic could not share these qualities, and that the artists responsible for the new era of television cartoons were fully aware of the moral and social constraints imposed upon representation in programmes for a domestic medium by the Broadcast Standards and Practices Department, the threat of 'anarchy' in the cartoon remained. In some contexts, this view was critically endorsed. Radical critic Harlan Ellison passionately opposed the regulatory apparatus for comics, inspired by the campaigns of Dr Frederic Wertham, and spoke out in defence of television cartoons which seemingly raised the same concerns among parents. Writing in 1968, Ellison claimed that cartoons worked as 'a genuine training ground for [children's] thinking' and contained 'tolerable terror' and useful 'simplifications of the complex world of good-and-bad, when they are at an intellectual age when they cannot grasp the subtleties of inter-personal relationships and global politics', adding, 'there is nothing on prime time to compare with the social comment and satire' in some children's cartoons.[49]

Ben Crawford has noted that this 'television aesthetic', though, has consequently had significant effects, both in the ways that such cartoons have since been evaluated and understood within the rubric of the heightened criticism of American television *per se*, and in the subsequent ways that animation has been made for television. He notes that 'almost all discussion of TV cartoons for kids adheres to a single model and participates in a single discourse – the condemnation of cartoons on TV on the basis that they contribute to the corruption of children, to a televisual *détournement de mineurs*'.[50] More controversially, he adds that the generation first watching television cartoons have a sensibility which is directly reflected in these animations:

> that generation wants and receives a culture which is high on impact and low on significance, without any basis or need for justification … their response to the imperatives of any system of values is cynical at its most energetic and usually exaggeratedly phlegmatic or insouciant. They live precisely beyond freedom and dignity, contemptuous of both the discipline of non-violence and the structures of meaning. In short their desires correspond to the features of the Saturday morning cartoons on which they were raised.[51]

Interestingly, here Crawford essentially confirms that the 'inner-directed' and 'other-directed' sensibility has prevailed in promoting and endorsing an ideologically charged and supposedly amoral model of cultural 'difference' or 'otherness', even in the light of the changing standards during the 1960s and early 1970s, and the subsequent evolution of the television cartoon in the 1980s and 1990s. *The Simpsons* is inarguably an inevitable product of the cultural influence exerted by the 'baby-boomer' generation Crawford speaks of, while *The Ren and Stimpy Show* works as a self-conscious parody of the aesthetic codes and conventions of the animation-for-television era, played out through the cultural identities of the late millennium. Further, the brutalist minimalism of *Beavis and Butthead* and its correpondence to the 'slacker' generation may be both an anti-culture critique and a statement about the redundancy of visual cultures[52] in the same way that *King of the Hill* reveals the limitations of 'naturalism' and 'gags' within the (live-action) sit-com. It is clear that animated forms have always been able to *intrinsically* subvert because of the very ambiguity identified in the previous chapter between 'narrative' and 'text'. The 'gap' between the two facilitates alternative perspectives; the same fissure informs the relationship between the 'text' and the

'social context'. As Leslie Felperin has noted, for example, 'If the Simpsons were in line with modern American demographics, Marge and Homer would be divorced and remarried, rather than the ironic exemplars of happy married life that they are'.[53] This enables the programme to work on similar lines to consensual forms of situation comedy, but to use the artifice and flexibility of the animated form to play out the sub-textual apparatus of the characters as the 'text' of the programme. In this way all the complex variables about the representative aspects of animated texts are rendered simultaneously 'active' and 'provocative', while seemingly regulated and 'contained'. This is an important obser-vation in relation to the ways, for example, that 'violence' in cartoons has been evaluated and understood.

In 1956, Alberta Siegal published her findings on the relationship between aggressive behaviour in children and the viewing of animated cartoons. Simply, she concluded that children who had viewed the slapstick violence of *Woody Woodpecker* behaved no differently from those who had viewed *The Little Red Hen*, a non-violent cartoon.[54] This report proved unusual in the sense that most studies sought to conclude that animated cartoons were harmful and encouraged imitative behaviour. Most influential in this respect was Albert Bandura's famous 'bobo-doll' studies during the 1960s, which simplistically suggested that children aped the violent behaviour of a cartoon-like clown character in re-enacting similar kinds of aggression towards a bobo-doll after viewing the clown in a quasi-televisual context.[55] This tension between the influence and effects of cartoons, and their subsequent uses and gratifi-cations has informed debates about the form since its absorption into television culture, and little has been resolved, but one of the most significant developments which shifted the terms and conditions of the debate was the emergence of *The Flintstones* as the first 'prime-time' animation.

If child psychologists had been concerned with effects, a continuing lobby remained concerned about the art of animation. Leonard Maltin argues 'the cartoons produced by Hanna Barbera and their legion of imitators are consciously bad: assembly-line shorts grudgingly executed by cartoon veterans who hate what they're doing', adding that 'the same canned music, the same gags, the same sound effects and gimmicks, and the same characters in different guises ... [most notably] the tall guy and a short sidekick wore out its welcome'.[56] Self-evidently, William Hanna

and Joe Barbera did not set out to make 'consciously bad' cartoons –
their credentials had long been established in the classic *Tom and Jerry*
cartoons of the 1940s – but they recognised that 'limited animation', a
drastically different, and in their hands, a comparatively 'artless'
approach was their only alternative in sustaining 'cartoons' of any sort in
a major marketplace. Where UPA had explicitly embraced limited
animation as a method of evidencing their affiliation to modern art-
forms, and different models of non-Disney, 'tradition-directed' animation,
Hanna Barbera sought to embrace the established narrative codes of
radio and television story-telling. The emphasis was placed less on
'animation' (i.e. the execution and quality of 'movement') and more on
comic writing and engaging design. Accents, catch-phrases, rhymes and
verbal jokes became more important than any complex 'physical' sight-
gags, while character design was predicated on what William Hanna
describes as 'a pleasing and congenial appearance that would appeal to
children … [a look that would] arouse interest or excitement in a child
but never fear or revulsion', and whose personality may be likened to the
charisma of a live-action actor, 'a quality composed of both an intangible
essence and specific mechanics'.[57] There is seemingly little subversion in
this approach, and a high concession to the needs and demands of
television – a simple sense of 'flat', two-dimensional theatricality, played
out through the 'proscenium arch' of the television screen. The enhanced
sense of performance by predictable and consistent characters, who
exchange personality for 'celebrity' in acting as a cipher for a simple and
accessible ideological, ethical or moral archetype becomes the staple of
what may be viewed as a highly conservative representation of American
values and aspiration. Huckleberry Hound did not possess the moral
ambivalence of Bugs Bunny; Yogi Bear does not engage in the social
disruption on the scale of the not infrequently 'insane' Daffy Duck. The
reference point of the cartoon was not its own instability but the *necessity*
for certainties of a material world, which in reality was increasingly
destabilised. This is an important observation in that it reinforces the
view that there is a fissure between the animated 'text' and the 'social
context' in which there may be self-evident relationships between the
representational forms and their social referents. Equally, there may
only be a reconciliation of the 'self-enunciative' nature of animation
itself, and a participation in its apparently freer, more speculative, more
provisional and more fluid environment.

The Huckleberry Hound Show won an Emmy in 1959, and featured not

merely the multi-identitied Huckleberry Hound, but two other popular stalwarts of the Hanna Barbera output, Pixie and Dixie (with Jinx the cat) and Yogi Bear. Yogi was partly modelled on Art Carney's Ed Norton from *The Honeymooners*, and represents the first direct referencing to sit-coms of the period and an example of the symbiotic relationship between television animation and the sit-com thereafter. Quick Draw McGraw, Snooper and Blabber, and Augie Doggie and Doggie Daddy (1959–63) became equally popular characters, foregrounding the talents of story-men like Michael Maltese and Warren Foster who were merely secondary figures to the director in the hey-day of the cartoon short. Sponsored by Kelloggs, Hanna Barbera cartoons featured on over one hundred stations and enjoyed a circulation throughout the day, often being broadcast in early evening slots which anticipated a prime-time scheduling position. Screen Gems' John Mitchell approached Hanna Barbera and asked them to consider creating a half-hour series, using animated people rather than animals, which might have the potential longevity of a situation comedy. *The Flintstones* (1960–6), directly predicated on the already successful series *The Honeymooners*, featuring Jackie Gleason as Ralph Kramden, was essentially rooted in the suburban family narratives of the early 1950s sit-com (e.g. *I Love Lucy* and *Father Knows Best*) but enjoyed the comic-incongruity of playing out the consumer artefacts of post-war modernity in the context of the Stone Age. Equally incongruous were the show's initial sponsors – Winston Cigarettes (Reynolds Tobacco Company) and One-a-Day Vitamins (Miles Laboratories) – who recognised and invested in the originality of concept, believing it to have an intrinsic 'difference' yet a culturally acceptable 'familiarity' which made it commercially appealing. The 'narrative' here works in conjunction with the 'text'. In the same way as the Disney aesthetic became the naturalised form that defined animation in the cinema, the Hanna Barbera aesthetic as it was epitomised and refined in *The Flintstones* became the naturalised aesthetic for animation on television, once again signalling its 'otherness' only by virtue of its difference from live-action performance.

Though broadcast in prime time, *The Flintstones* retained its children's audience. Though critics were initially hostile,[58] it also gained its intended adult audience. Fundamental to the programme's success, and repeated later in *The Simpsons*, is the importance of the role played by what Richard Butsch has termed the 'White Male Working-Class Buffoon'.[59] Fred Flintstone represented one of the few portrayals of working-class

fathers in the 1960s, a mark of the predominance of a middle-class consumer ethos in most programming. Interestingly, British critic Geoffrey Nowell-Smith, when writing his observation of 'C', a two-and-a-half-year-old girl, who sang the 'Make Your Hubby Happy' ditty from *The Flintstones* in his presence, notes,

> Clearly, she identified me with Fred Flintstone. Less clear, however, was whether she was getting to grips with the structure of relations in her family, comparing me to a stable and easily recognised cartoon character, or if she was simply finding her way about the cartoon by fitting its figures into familiar and familial roles. Identifications of herself and others with creatures from books and television pro-grammes seem to be an important part of her inner life.[60]

For adult audiences, sponsors needed to be assured that the represen-tation of affluence and comfort would encourage viewers to aspire to these conditions and buy the relevant household items. *The Flintstones*, in not actually portraying the post-war suburban home, and, indeed, using many of its tenets for satiric or parodic effect, needed to create an empathetic character who illustrated the vicissitudes of paternalist aspira-tion as well as domestic achievement. Fred and, indeed, his neighbour, Barney, are at their most sympathetic when trying to improve their social status and move into other realms of 'culture'. Similarly, their schemes to get more money, or evade the threat of unemployment, play out anxieties about how the roles and functions of family and social life may be defined and acted upon. Their recurrent 'failure', essentially an acceptance of, and need for, the status quo, reinforces a consensual view of domestic order which casts Wilma and Betty, their wives, as sensible, supportive and pragmatic; the workplace as a context in which the established hierarchy is rarely challenged and 'society' presented as a mechanism which can generate and secure the populist notions of individual achieve-ment, good neighbourliness, community support and institutional success, as long as power remains in the right hands. This populist agenda is once more supporting the 'tradition-directed' aspects of American life and the satisfaction with the post-war structures of domestic aspiration and the organisational principles of business cultures.

Though the limited animation style of the Hanna Barbera studio was much criticised, the very language of animation as the facilitator of impossible events and situations was self-evidently crucial in creating a pre-historic environment in which the modern physical and material

world is re-determined through visual puns and the free use of graphic illusion. Elephant trunks become gasoline pumps; bird-beaks become hi-fi styli; a pterodactyl (a creature that only exists through graphic representation) becomes an aeroplane on the basis of its echoed function and so on. The 'gags' essentially emerge from the exploitation of incongruous pictorial similarities in the mise-en-scène and the collapse of the historically determined social functions of objects as they are understood in the 'modern' world. Arguably, this in some senses distracts from the quasi-hegemonic project being played out in *The Flintstones*, which is later foregrounded and self-consciously parodied in *The Simpsons*. The playfulness of the narrative context and the exploitation of a basic 'cartoonalness', most notably in the caricaturial paradigms and 'fantastic' juxtapositions, are less important than the linguistic aspects of the programme in which verbal puns and language-based sight gags are predicated on a tenuous relationship to rocks, stones, pebbles and so on. This centrality of the visual pun is in many senses the best equivalent that the Hanna Barbera aesthetic offers of the disparity between 'narrative' and 'text', but it is rarely critical or subversive. Hollywood actor Tony Curtis inevitably becomes Stoney Curtis; Leonard Bernstein becomes Leonard Bernstone and so on. Popular culture is drawn upon as the vehicle by which to secure adult identification, a strategy adopted much earlier, for example by Warner Bros. in the 1930s and 1940s, whose cartoons parodied their own live-action artists. This level of identification tends to heighten the comic elements of the cartoon while demoting some of the overt situational tensions about class and social aspiration, which become more readily understood as 'sentimental' issues.

Children, visually literate in the modes of graphic caricature as a result of their engagement with a range of illustrative tropes in children's literature, and, indeed, well-versed in their engagement with various modes of 'the cartoon' (rarely subject to any sense of variousness or distinction within the form or across styles by adult audiences, even in spite of the obvious difference between Disney and Warner Bros. shorts, for example), readily engage with the aesthetic space of *The Flintstones* and its contingent familiarity. This, after all, is an imaginative reconstruction of the family, the domestic environment and contemporary culture, but one enjoyed from the safe position of both displacement from its apparent historical context – the Stone Age – and the fact of its recognisable status as cartoonal artifice. It is in this aspect that children as an audience have

often been misrepresented, in the sense that they have always constituted a more sophisticated audience than is sometimes acknowledged. A recent study undertaken by the ITC in Britain confirmed once more that children could distinguish between 'reality' and its cartoonal representation, and recognised that the artifice of the graphic space contextualised the characters, situations and experience that they were viewing.[61] Though, unsurprisingly, boys and girls viewed differently and displayed different levels of investment identification, it was clear that cartoonal 'behaviours' exemplified in certain characters emerged as a consequence of their status as 'cartoon' characters, and not 'real' people. This enables children to accept conflict and confrontation in shows like *The Flintstones* as being intrinsically different from their representation in a live-action situation comedy or soap opera. In being an art of the 'unreal', animation, in however a basic a form, uses the fissure between 'text' and 'social context' to convert physical and material 'contexts' into mutable and ephemeral 'texts'. Children, therefore, readily perceive cartoon violence as slapstick; understand cartoon conflict as the vehicle for humour; and enjoy cartoon confrontation as a mode in which opposing 'forces' seem to symbolise an abstract tension between different ideas and issues. There is no great distance in this *perception* of the cartoon from that which governed the principles of synaesthetic cinema in promoting the use of the animated medium as a vehicle to project more primal 'forces and energies' which are the underlying imperatives of human existence and endeavour. Arguably, the 'scaled down' premises of much children's cartooning works in this spirit, offering a less sophisticated, but nevertheless affecting, code of difference and otherness which speaks to the evolving emotional agendas of the child viewer. Children may engage with the moral and ethical framework of the 'narrative', but they may actually be the very audience who distanciate it from the 'text'. It is they who, in their innocence, re-interpret the texts in a spirit of transcendence; a response *not* predicated on the intended perception of the cartoon as a reconciliation of popular culture or commerce for adults, but as a different way of seeing the world; a different way of *perceiving* the world. It is likely that this level of engagement will work predominantly at the personal and potentially idiosyncratic levels, but in this it echoes the individuation and liberation of progressive synaesthetic forms.

It is inevitable that adults viewing the same texts will in many senses be watching something entirely different. The scale of adult socialisation distanciates the cartoon from 'reality' in another way. The 'cartoon' is

not regarded as different because it represents an intrinsic artifice, or a mode of transcendence, but because it is a thing of another time and place, a childhood 'text', now watched in a spirit of 'pastness' and possibly nostalgia, but, most importantly, with an adult sensibility. The adult viewer watches differently, articulating sub-texts and other levels of meaning, noting the reference points and participating in a way that acknowledges the capacity for, and possibility of, the animation medium to use graphic artifice for the purposes of offering alternative perspectives about the material world. This means that on the one hand, for example, when Fred tries to surprise Wilma with a tenth wedding anniversary gift of a 'Stoneway' piano, purchased for fifty dollars from streetside shyster '88 Fingers Louis' this can degenerate into a set of 'runaway' piano gags in the spirit of Laurel and Hardy's *The Music Box* (1932), while on the other hand, it can include a gag where Wilma believes she witnesses a piano passing by, but is reassured by Fred with the words, 'A piano? It's merely a manifestation of your sub-conscious clashing with your conscious, which in turn is a logical outgrowth of a possible musical frustration, coupled with the cucumbers you had for dinner!' An 'everyday' scenario of a well-intended anniversary surprise demonstrates Fred's aspiration, naivety, integrity and foolhardiness, but it also signals the 'knowingness' of the creators of *The Flintstones* in foregrounding a parody of psychoanalytic explanation for a 'dream', which had in effect been a surreal moment of 'actuality' in the narrative. This one example signals a self-conscious knowledge of the parameters of the animated terrain, simultaneously illustrating its capacity for over-fictive excess (essentially the capability to represent the impossible, the exaggerated, the unreal) and its orthodoxy in referencing the *received* knowledges which attempt to shape the consensual frame of lived experience.

This occurs almost uniformly in animated films, but is especially pronounced in *The Flintstones* because it has a representational reference point in the American sit-com and its configuration of suburbanite normality. Though nominally based on 'blue-collar' culture, the context embraces the variousness of 'middle-classness'. By this I mean that the capacity (and commercial necessity) for animation to represent the widest range of 'imagined' perspectives and possibilities, *inevitably* liberates Fred, Wilma, Barney and Betty from the economic constraints that would otherwise inhibit their existence and which would locate them representationally within a class coding intrinsically linked to 'realist'

aesthetics. Again, as with Felperin's example of the Simpsons' marriage, too close a representation and reflection of the actual modes of experience lived by a particular social demographic collapses the narrative and textual premises of the form. Though Fred and Barney nominally seek 'the good life', they remain within their blue-collar culture, nevertheless enjoying a variety of experiences legitimised by the aesthetic possibility in which they are represented, rather than the context and circumstances in which they supposedly live. Wilma suggests 'Fred's a diamond in the rough, but even diamonds can stand a polish'. In one episode, a concussed Fred is transformed into an upper-class Englishman 'Frederick', who notes 'I've heard *Ode to a Lark* so many times, I could build a nest and lay eggs', and comments when listening to an operatic aria, 'the tonal counterpoint is too pianissimo', while also criticising his beloved bowling as 'truly monotonous'. Fred is hit by a rock, of course, and returns to his irascible, Barney-patronising, bowling-loving self, fully endorsed by a relieved Wilma. Though a clichéd narrative device, the concussion liberates Fred, and the cartoon itself, into aspirant narratives that rejoice in their 'difference' but celebrate their return to comforting orthodoxies. Whether at Stoneyside Country Club, or at the Order of the Dinosaurs, or on the boss's yacht, Fred is given the opportunity to 'perform' a new social identity, for example as a musician, a golfer and so on, but is ultimately returned to the site of his consensually accepted social place. Animation enables the 'fantasy' of difference to gain an ontological equivalence to the more 'realistic' premises of each episode and, consequently, facilitates less of a space between the modes of existence that are seemingly played out. This sense of continuity within the text in spite of its contextual flux further enables both children and adults to participate in the realisation of a 'parallel', and potentially alternative, world, constructed entirely upon its own terms and conditions, while also recognising their own place within it and outside it.

The Flintstones effectively establishes a paradigm which is much drawn upon by *The Simpsons*; the essential difference being that Matt Groening and his fellow artists, in making *The Simpsons*, are not content merely to reference the received knowledges of their social space but aim to challenge them. The passage of time has also modified the interpretation of *The Flintstones* as a mode of 'classic' animation in its own right; subversive by virtue of its very presence in prime-time mainstream television. This reconfigures *The Flintstones* as a model of work in which the overall conviction of a basic 'cartoonalness' remains its prevailing

'message' in its own right. Seemingly, both the audience and the artists who now recollect, still watch, and claim reference to these previous modes of television animation remember the subversiveness of their graphic style and representation rather than the prevailing codes of reference to the supposedly 'familiar', or the ideological or commercial claims associated with it. Groening and the makers of *The Simpsons* essentially insist upon the recovery of this overt, and ideologically inconsistent or incoherent text as a progressive form of work within the television context, which in the light of a more postmodern relativist 'social context' accommodates more open discourses which challenge established orthodoxies. Once more, it is Matt Groening's counterculture credentials which underpin *The Simpsons* and encourage scepticism and mistrust in the received models of social order. The emergence and establishing premise of *The Simpsons*, for example, was highly charged in its resistance to the more right-wing agenda of its immediate rival in the schedules, *The Cosby Show*. The 'inner-directed' and 'other-directed' pitted directly against a reactionary model of live-action 'tradition-directedness'. Mainstream 'synaesthesia' challenging sit-com sentience.

Bill Cosby, long an advocate of the positive pedagogic possibilities of television, and highly invested in creating morally sound and socially responsible programmes which seek to influence and affect family unity, was critical of the approach adopted by *The Simpsons*. Cosby argued that Bart was attractive to children from lower socio-economic backgrounds because his aggression was a signal that he knew he was marginalised, unfocused and without direction, but apparently triumphed over this because he didn't care.[62] Cosby identified this as a learning difficulty that the programme had a responsibility to address, showing the social infra-structure as a potentially enabling system, rather than one perpetuating failure, disillusionment and 'smart-arse' cynicism. Producer of *The Simpsons* James L. Brooks, in reply to this observation, noted that to make a programme which sought to provide role models was inherently dangerous, suggesting that 'My role model may not be somebody else's role model', but, more importantly, that such an approach was 'so nakedly anti-art and pro-propaganda' that it was unacceptable to the artists making the programme. Brooks and Groening were concerned about writing the characters, taking into account the variability in the character; the vicissitudes of everyday experience and the flux of ideologically charged tensions, rather than offering a version of experience determined by one ideological preference. Even if this had been their intention, it

would have been difficult to sustain in the light of the variables inherent in the animated form. As I have already suggested, even a text determined by limited animation, like *The Flintstones*, becomes a more open text when these credentials are properly acknowledged; the heightened self-consciousness of *The Simpsons* merely exacerbates this.

Most notable in this regard is the show's cartoon-within-a-cartoon, 'The Itchy and Scratchy Show', initially the subject of Marge Simpson's concern about the influence of the programme on her children's violent behaviour. Suddenly a key media figure in her condemnation of cartoon violence, winning the support of other viewers and advocacy groups, her recommendations to the producers of 'The Itchy and Scratchy Show' sanitise the cartoon, prompting hordes of previously invested children to stop watching the show and engage in interactive play and idyllic socially acceptable behaviour. There is some irony here, in the sense that this was actually the fate of the late *Tom and Jerry* cartoons under different circumstances. Chuck Jones' more literate and lyrical style essentially removed the speed and conflict from the cartoons, in effect sentimentalising the relationship between the two characters and removing much of the kinetic appeal of their narratives. Marge, however, while gaining considerable kudos for standing up to cartoon 'content' is ultimately undone by the recognition of 'aesthetics'. The arrival of Michaelangelo's 'David' at the Springfield Museum prompts a campaign against full-frontal nudity, and once more, appearing on 'Smartline', a local current affairs magazine programme, Marge has to concede that in spite of hating cartoons and their possible effects she supports the principle of freedom of expression, as 'David' is clearly a work of art. *The Simpsons* reflexivity about the ideological currency of its own animated aesthetic is the key to its success, and, ultimately, to its profile as a politically engaged programme. Further, it is the key factor in reconnecting with the 'Democratic' spirit underpinning the project of synaesthetic cinema. Groening's 'post-styling' of reality, fundamentally an erudite critique of the hypocrisy at the heart of American populism, is subversively doing this in a popular form. Sanjiv Battacharya notes, 'no sooner had George Bush Senior famously declared in 1992 that "The nation needs to be closer to the Waltons than the Simpsons," than Homer had the President in a headlock, wrestled him in a sewer and the Democrats won the next election'.[63]

The focus of this political engagement and the key site of both aesthetic and comic issues in *The Simpsons* is 'the body' and anxiety

about 'cerebral' achievement. 'Discouraging the airy humanistic conceit of our species', notes Peter Conrad, '*The Simpsons* tugs us back to earth by confronting us with the paterfamilias, Homer ...'[64] and the nihilism of his near animality. His scale of consumption and level of ambivalence are reminders of the absurdity and indifference of contemporary American culture, and, in this context, a comment upon the radical change in the response to material culture as it was evidenced and celebrated in *The Flintstones*. Further, it is a recovery of the more inchoate 'wild systems', excised from the representation of even animals themselves within the Disney universe. Fred and Barney's sense of aspiration, energy and ability has been replaced by a considerable scepticism about the value and purpose of particular kinds of attainment, especially with regard to the view that 'knowledge' and the cultivation of an 'intellect' will directly advance advantageous social re-location. Homer's brain literally floats away and collapses when he is bored by neighbour Ned Flanders; Bart cries in utter frustration when, even after considerable effort, he fails his history examination, only to pass by default when he cites the circumstance of George Washington's surrender to the French in 1754 as a point of empathy, and is granted extra marks for 'applied knowledge'; and Lisa's gifts are all but ignored in the context from which they emerge. This articulation of 'underachievement' is played out, however, through the extraordinary literateness and aesthetic ingenuity of Groening and his team. Conrad again notes how the programme consistently references the myth of Prometheus in recognition of its own self-conscious act of bringing characters to life and, ultimately, creating its own 'populist' context for metaphysical enquiry.[65] Crucially, though,

> for all of Homer's animated freedoms – the dream sequences, the conversations with his brain, the car crashes and trips to hell, all the things a live-action character simply can't do – the kernel of his character has remained intact from the first show.[66]

The Simpsons foregrounds Homer as the vehicle by which 'physical' experience is recovered in order to provoke metaphysical enquiry. The animation is crucial in this, in that it is used to overcome the seemingly taboo aspects of this mode of representation, and to make explicit the show's concern with the oppressive effects of consumerism and its seemingly symbiotic relationship with television itself. Unlike the Flintstones and the Rubbles, the Simpson family cannot escape the limits of their cultural conditioning, and this is used both to exemplify the 'wit' of

Groening *et al* in exposing the illusion of stability and contentment in relation to an assumed ideological orthodoxy within consumer capitalism and to literally illustrate this through the use of the intrinsic flux of the animated image and the confluence of often conflicting and random cultural resources mobilised to create its text.

The adult engagement with the sophistication of *The Simpsons* may be assumed, but it is important to consider once again what children may draw from this agenda. Phil Hogan has argued that children 'love the novelty of an adult with the appetites and impulses of a child', but laugh at Homer not because he is intrinsically offensive, or in some instances fundamentally 'wrong', but because he is 'funny'[67] – the incongruity at the heart of the character, heightened again by the caricatural excess of animation, merely exacerbates the comic potential of the imagery rather than the socio-cultural function of the 'parent'. Even if such depictions serve as a potential representation of human flaws, these may be more readily understood and accepted by children as 'foibles' rather than as something which may be viewed as intrinsically unacceptable. After all, the unconditional acceptance of those we love and admire is as much about the acceptance of their flaws and self-delusion as it is their particular qualities and attractiveness. The episode concerning 'Lisa's Wedding' is a great exemplar of this, in that Hugh, the English aristocrat she is foretold that she will marry, rejects Homer's offer of pig-shaped cufflinks for his wedding attire, and in doing so loses Lisa also. The episode concludes with Lisa listening intently, and with great pride, as Homer describes his attempt to eat a whole pig. Further, recognition of these seemingly complex emotions may be a significant contribution to the maturing process by which children try to bridge their own understanding of the text with that of their parents or other adults. In this respect, cartoonal caricature foregrounds its agenda in the exaggerated expression of its critical tropes, and in doing so creates a possible space for laughing at, and with, the characters, and a place by which these may be distinguished for explanatory and exploratory purposes. The questioning process which often arises when children seek to enhance their already established enjoyment of the programme and its 'cartoonal attractions' may be the most effective educational vehicle, and one which transcends the dominant discourse of the assumed harm that may be caused by representing 'dysfunctionality', though under these circumstances such a term is highly contentious and questionable, and effectively

collapses if the audience is viewed and, indeed, 'views' in a different light. I wish to pursue the term 'cartoonal attractions' a little further in this respect. Tom Gunning has posited a view of early cinema which is predicated on what he calls a 'cinema of attractions'; essentially a reworking of a conception of film construction 'less as a way of telling stories than as a way of presenting a series of views to an audience, fascinating because of their illusory power ... and exoticism'.[68] 'Cartoonal attractions' also forfeit the determinants of narrative to foreground the distinctive vocabulary of graphic visualisation in motion, and its non-objective, non-linear aesthetic as the carrier of complex personal symbolic and/or ideologically charged meanings. It is this that ultimately relates to the concept of synaesthetic cinema in that it encourages empathy, yet raises consciousness through offering alternative perspectives suggested by the distinctive aesthetic determinacy of the image. It is this which is the currency of all animation for children and adults.

Notes

* Some aspects of this discussion are also explored in P. Wells, ' "Tell Me About Your Id when you were a kid, yah!"': Animation and Children's Television Culture' in D. Buckingham (ed.), *Small Screens: Children's Television* (London: Continuum, 2001).

1. G. Youngblood, *Expanded Cinema* (New York: E. P. Dutton, 1970).
2. Ibid., p. 41.
3. Ibid., p. 68.
4. Ibid., p. 97.
5. Ibid., p. 97.
6. D. Crafton, *Before Mickey: The Animated Film 1989-1928* (Chicago and London: University of Chicago Press, 1993), p. 11.
7. M. Furniss, *Art in Motion* (London and Montrouge: John Libbey, 1998), p. 169.
8. G. Youngblood, *Expanded Cinema* (New York: E. P. Dutton, 1970), p. 105.
9. B. Orna, 'Magoo Has A Sennett Touch', *Films and Filming*, Vol. 2, No. 5, February 1956, p. 29.
10. R. Stephenson, *Animation in the Cinema* (London and New York: Zwemmer, 1967), p. 47.
11. D. Riesman, *The Lonely Crowd* (New Haven and London: Yale University Press, 1969), pp. 5–30.
12. Ibid., p. 32–6.
13. Ibid., p. 86.
14. Ibid., p. 126.
15. Ibid., p. 167.
16. R. Schickel, *The Disney Version* (London: Michael Joseph, 1986), p. 157.
17. D. Fisher, 'Two Premières: Disney and UPA' in D. Peary and G. Peary (eds), *The American Animated Cartoon* (New York: E. P. Dutton, 1980), p. 182.
18. M. Eliot, *Walt Disney: Hollywood's Dark Prince* (London: André Deutsch, 1994), p. 218.

19. J. D. Ford, 'An Interview with John and Faith Hubley' in D. Peary and G. Peary (eds), *The American Animated Cartoon* (New York: E. P. Dutton, 1980), p. 188.

20. 'Faith Hubley: an interview with Pat McGilligan', in J. Pilling (ed.), *Women and Animation* (London: BFI, 1992), p. 24.

21. See R. Allan, *Walt Disney and Europe* (London and Montrouge: John Libbey, 1999).

22. Quoted in Schickel, *The Disney Version* (London: Michale Joseph, 1986), p. 190.

23. Faith Hubley, in J. Pilling (ed.), *Women and Animation* (London: BFI, 1992), p. 25.

24. P. Adams Sitney, *Visionary Film: The American Avant-Garde 1943-1978* (New York: OUP, 1979), p. 232.

25. Ibid., p. 255.

26. Quoted in R. Russett and C. Starr, *Experimental Animation: Origins of a New Art* (New York: Da Capo, 1976), p. 155.

27. J. Pilling (ed.), *Women and Animation* (London: BFI, 1992), p. 48.

28. See P. Wells, *Understanding Animation* (London and New York: Routledge, 1998), pp. 201–3.

29. J. Hoberman, 'The Quazy World of Sally Cruikshank', in J. Pilling (ed.), *Women and Animation* (London: BFI, 1992), p. 51.

30. R. Schickel, *The Disney Version* (London: Michael Joseph, 1986), p. 205.

31. See 'John Kricfalusi: Profile and Interview' in P. Brophy (ed), *Kaboom!: Explosive Animation from America and Japan* (Sydney: Museum of Contemporary Art/Power, 1994), p. 100.

32. M. Eisner, *Work in Progress* (London and New York: Penguin, 1999), p. 148.

33. S. Stark, *Glued to the Set* (New York: Simon and Schuster, 1997), p. 19.

34. B. Putterman, 'A Short Critical History of Warner Bros. Cartoons' in B. Sandler (ed.), *Reading the Rabbit: Explorations in Warner Bros. Animation* (New Brunswick, New Jersey and London: Rutgers University Press, 1998), p. 35.

35. D. Gifford, 'William Hanna' (Obituary)', *The Guardian*, 24 March 2001, p. 22.

36. J. Adamson, 'Chuck Jones Interviewed' in G. Peary and D. Peary (eds), *The American Animated Cartoon* (New York: E. P. Dutton, 1980), pp. 140–1.

37. See P. Brophy, 'The Animation of Sound' in A. Cholodenko (ed.), *The Illusion of Life: Essays on Animation* (Sydney: Power/AFC, 1991), pp. 67–112.

38. See M. E. Shapiro, *Television Network Weekend Programming 1959–1990* (Jefferson, North Carolina and London: McFarland & Company Inc, 1992).

39. S. Kanfer, *Serious Business: The Art and Commerce of Animation in America from Betty Boop to* Toy Story (New York: Scribner, 1997), p. 183.

40. Quoted in M. Frierson, *Clay Animation* (New York: Twayne, 1994), p. 122.

41. M. Furniss, *Art in Motion* (London and Montrouge: John Libbey, 1998), p. 235.

42. Quoted in M. Frierson, *Clay Animation* (New York: Twayne, 1994), p. 122.

43. See A. Horrox and V. Nyberg, 'Square Eyes' in P. Simpson (ed.), *Parents Talking Television* (London: Comedia, 1987), pp. 26–30.

44. S. Kanfer, 1997, *Serious Business: The Art and Commerce of Animation in America from Betty Boop to* Toy Story (New York: Scribner, 1997), pp. 194–5.

45. D. Fratz, Quoted in J. Javna (ed.), *The Best of Science Fiction TV* (London: Titan, 1988), p. 130.

46. Quoted in S. Kanfer, *Serious Business: The Art and Commerce of Animation in America from Betty Boop to* Toy Story (New York: Scribner, 1997), p. 209.

47. See L. Maltin, *Of Mice and Magic: A History of Animated Cartoons* (New York: Plume 1987), pp. 154–5.

48. J. Korkis and J. Cawley, *The Encyclopaedia of Cartoon Superstars* (Las Vegas: Pioneer, 1990), p. 137.

49. H. Ellison, *The Glass Teat* (Manchester: Savoy, 1968), pp. 53–5.

50. B. Crawford, 'Saturday Morning Fever' in A. Cholodenko (ed.), *The Illusion of Life: Essays on Animation* (Sydney: Power/AFC, 1991), p. 113.

51. B. Crawford in A. Cholodenko (ed.), *The Illusion of Life: Essays on Animation* (Sydney: Power/AFC, 1991), p. 114.

52. See D. Kellner, *'Beavis and Butthead*: No Future For Postmodern Youth' in S. Steinberg and J. Kincheloe (eds), *Kinderculture: The Corporate Construction of Childhood* (Boulder and Oxford: Westview Press, 1997), pp. 85–103.

53. L. Felperin, 'Blue Hair Days', *The Guardian*, 10 August 2000, G2, p. 6.

54. See A. Siegal, 'Film-mediated Fantasy Aggression and Strength of Aggressive Drive', in *Child Development*, No. 27, 1956, pp. 365–78.

55. See A. Bandura, D. Ross and S. Ross, 'Imitation of Film-mediated Aggressive Models', *Journal of Abnormal and Social Psychology*, No. 66, 1963, pp. 3–11.

56. Originally from *Film Comment* 1975; quoted in E. Slafer, 'A Conversation with Bill Hanna' from D. Peary and G. Peary (eds), *The American Animated Cartoon* (New York: E. P. Dutton, 1980), p. 255.

57. W. Hanna, *A Cast of Friends* (Dallas: Taylor Publishing Co, 1996), p. 105.

58. See T. Sennett, *The Art of Hanna Barbera* (New York and London: Viking Penguin, 1989), pp. 83–4.

59. R. Butsch, 'Ralph, Fred, Archie and Homer: Why Television Keeps Recreating the White, Male, Working Class Buffoon' in G. Dines and J. M. Humez (eds), *Gender, Race and Class in Media: A Text Reader* (London, New Delhi and Thousand Oaks: Sage, 1995), pp. 403–12.

60. See R. Delmar and G. Nowell-Smith , 'Watching "teszelin"' in P. Simpson (ed.), *Parents Talking Television* (London: Comedia, 1987), pp. 11–18.

61. See S. Chambers, N. Karet and N. Sampson (Broadcast Research Ltd) and J. Sancho-Aldridge (ITC), *Cartoon Crazy?: Children's Perception of 'Action' Cartoons* (London: ITC, March 1998).

62. See D. Bianculli, *Teleliteracy* (New York and London: Simon and Schuster, 1994), pp. 174–83.

63. S. Bhattacharya, 'Homer's Odyssey', *The Observer Magazine*, 6 August 2000, p. 18.

64. P. Conrad, 'They've got Yellow skin and not enough fingers. Still, they're only human...', *The Observer Review*, 31 May 1998, pp. 2–3.

65. Ibid., p. 3.

66. S. Bhattacharya, 'Homer's Odyssey', *The Observer Magazine*, 6 August 2000, p. 19.

67. P. Hogan, 'Actually, I Tell My Kids that it's like Jacobean Theatre', *The Observer Review*, 31 May 1998, p. 3.

68. See T. Gunning 'The Cinema of Attractions: Early Film, Its Spectators and the Avant Garde', in T. Elsaesser (ed.), *Early Cinema: Space, Frame, Narrative* (London: BFI, 1990), p. 57.

New Disney, Old Stories?

If the efforts of the 'inner-directed' and the 'other-directed' had provided animation with an American 'oppositional' tendency and a bona fide avant garde, it was perhaps inevitable that Disney, throughout its own business and artistic traumas, would retain its 'tradition-directed' agenda. Arguably, this has not changed since Riesman identified these concepts in the 1950s, and consequently has left Disney as the quintessential embodiment of reactionary stability in the midst of a changing American culture. Its 'Classic Disney' style was revived in the mid 1980s as both the embodiment of the company and as a mode of intrinsic Americanism in the midst of Reaganite populism. This has inevitably provoked anxiety, particularly in leftist critics, who while acknowledging the 'art' in Disney's output, do not believe that there has been sufficient modernisation in its content. Henry Giroux has argued that 'the boundaries between entertainment, education and commercialisation collapse through the sheer omnipotence of Disney's reach into diverse spheres of everyday life',[1] and this has resulted in a naturalisation of the ideological agendas imbued in the Disney texts becoming a political and cultural orthodoxy that the United States has readily embraced. Little of the tradition or the work addressed in Chapter 3 has changed this, and, indeed, it can be seen purely as an oppositional or marginal challenge to the centrist populism of Disney's work, and its acceptance by the general public both historically and contemporaneously. This extraordinary scale of national and global penetration is accompanied by what Bell, Haas and Sells have suggested is 'the "trademark" of Disney innocence that masks the personal, historical and material relationship between Disney film and politics'.[2] Disney himself never perceived the studio's films as having a political imperative of any sort, arguing 'We have but one thought, and that is for good entertainment. We like to have a point to our stories, not an obvious moral but a worthwhile theme. Our most important aim is to develop definite personalities in our cartoon characters ...We invest

them with life by endowing them with human weaknesses which we exaggerate in a humorous way. Rather than a caricature of individuals, our work is a caricature of life'.[3] This caricaturial style and conviction, imbued with its 'worthwhile theme' may be viewed as an archetypal, mythically determined narrative, or conversely as a story produced within, reflective of, and affective in relation to, contemporary United States culture. Richard Schickel has argued,

> One thinks of Disney's Americanism, of the kind of clean, moral, simple and innocent stories he most often chose to present on screen, of the right wing politics of the later years, of his broad gag-oriented sense of humour, containing no elements of social or self-satire, as entirely typical of the tastes of the region that formed him. The geographic center of the nation is also, broadly speaking, the most passionately American of the American regions.[4]

Recent criticism of this mode of 'Americanness' – a model which by and large has not self-consciously embraced the wider cultural imperatives and inclusiveness of the independent and avant-garde artists – has identified a catalogue of ideological offences including, among the most easily evidenced, sexism, racism, nationalist jingoism and quasi-cultural imperialism. The reactionary nature of Disney's WASP orientations is completely naturalised within Disney texts to the extent where, contradictorily, it is both self-evident and invisible. As I have suggested throughout my discussion, this is the consequence of the ways in which the Disney aesthetic has been culturally positioned historically, but is also concerned with the codes and conditions of the animated form itself and the methods of its construction. While artists as various as Avery, Smith, Pitt and Cruikshank can use the self-enunciating 'difference' and 'otherness' of animation for subversive effects, Disney can subsume 'difference' and 'otherness' in a way that uses the particular language and material conditions of 'animation' to repress representational differences through a homogeneity of 'style'.

Throughout I have suggested that 'Disney' is a particular aesthetic and ideological orthodoxy of quasi-Republican, tradition-directed stability, but in the contemporary context it is important to expand this perspective. Usually 'Disney' is understood either as 'Walt Disney', the entrepreneurial animation pioneer – 'the controlling editor',[5] 'the charismatic leader',[6] 'chief designer'[7] and 'the spark plug of production';[8] or the

'studio' and its output; or the 'brand' which is the ideological and com-
mercial imprimatur on a range of cultural artefacts from films to theme
parks.⁹ 'Disney', echoing Faith Hubley's earlier recognition of the
differences between the craft orientation of the work and the authorial
power in its determination and assembly, should now be understood as a
metonym for *an authorially complex, hierarchical industrial process, which
organises and executes selective practices within the vocabularies of animated
film*. Consequently, this definition privileges the mode of production as
the context in which the 'generality' of Disney's own perspective stated
earlier has been not merely preserved but enshrined as an apparently
innocent approach to story-telling, which through its very organisation
resists the kind of individual signature of synaesthetic animation, and the
leftist or genuinely apolitical stances that goes with it. The 'ambivalence'
that is characteristic in the process is its outcome in the form. Arguably,
this challenges the assumptions of an ideological critique which suggests
'Disney' offers a coherent position by virtue of any one text being con-
figured within the received framework of its supposedly transparent right-
wing orthodoxies.

 If antithetical 'inner-directed' or 'other-directed' animation essenti-
ally modernises, adopts a quasi-Democratic interrogation in the spirit of
interventionist change and overtly prompts a view of cultural enhance-
ment through spiritual elevation or social pragmatism, then Disney's
'tradition-directed' view suggests that 'contentment' resides in a recogni-
tion that a utopian view of an un-reconstructed populist past can still
exist in the present. It is worthwhile addressing the construction of the
assumed 'happiness', both within the text and its reception, which accrues
around the Disney cartoons, that Susan Miller and Greg Rode argue 'is a
membrane assuring their coherence as vital organs of cultural continu-
ity'.¹⁰ The maintenance of this mode of reassurance and the promotion of
'joy' is strictly allied to conservative infrastructures of story-telling,
which Robert McKee has identified in recent Disney animation as being
intrinsically linked to the use of the 'maturation plot' – essentially the
'coming of age' story – to the targeted audience who are embracing its
emotional trajectories.¹¹ The assumption here is that there is a homo-
geneity of responses in the reception of such texts, but this is based on the
view that the audience is accepting and endorsing 'happy endings' which
have seemingly resolved the problems and issues raised by the main
protagonist in what is largely a 'classical' narrative, played out in the most
conservative of animated forms. The 'Disney' ethos is well understood,

but its individual texts evolve their own socio-political orientation through the assimilation of *cultural resources*[12] within a limited frame of representational appropriation, determined more by the industrialised aesthetic tradition at Disney and its stylistic inhibitions, rather than by political sensitivities. 'Technique' subsumes 'Narrative', which in turn overwhelms the substantive implications and possibilities of the 'Text'. This is not to suggest, though, that 'cultural resources', however mobilised, are ideologically innocent, but rather that once subjected to the multiple regulatory codes and artistic conventions expressed by numerous authorial hands within both the animation process itself and the Disney approach as it has evolved into a 'tradition', the symbolic import of these resources has significantly changed. Hubley's observation about Disney's grasp of this point is crucial, in the sense that this is what is actually most 'political' about Disney's texts, both before and after he died. Simply, the power over the process itself, identified a seemingly static 'brand', unchallenged by any other artistic or authorial imperatives.[13]

Disney has evolved a production paradigm that in effect renders contemporary ideological and political 'specificity' subordinate to the assumptions of Disney's own moral, ethical, cultural and, most importantly, *aesthetic* archetypes. The dominant aspects of this paradigm are encoded caricatural 'norms' signifying simplistic and overdetermined notions of good/evil; serious/funny; effective/ineffective etc., which undermine, dilute and resist readings of characters and events at a *significantly specific* politicised and ideological level. Disney has also created a mode of 'fairytale', which echoes and uses, but does not necessarily draw on, a literary fairytale tradition, which significantly re-locates 'contemporary' agendas in a less explicitly verifiable social space and time, but nevertheless speaks to contemporary idioms. This mode of storytelling which allies the 'maturation plot' to a sometimes more improvisatory, sequence-orientated approach offers the *maximum* degree of suggestion from the *minimum* limits of representational inclusion and selectivity in graphic forms. This also has the effect of legitimising non-linear, inconsequential and often undeveloped aspects of narrational and character-driven events to operate as substantive models of 'image-based' versatility, but *without* an obligation to representational 'responsibility'. Crucially and deterministically, contemporary Disney texts use songs and choreography from a utopian musical tradition that prioritise the use of *spectacle as narrative*, and contextualise, filter and/or resist quasi-political messages

and meanings within the parameters of 'romantic yearning'. Disney historian, Brian Sibley suggests,

> Walt Disney was essentially a Utopian. He once said – and it is quint-essentially a utopian view – 'I can't believe that there are any heights that can't be scaled by a man who knows the secret of making dreams come true'. It suggests that in real life man is infinitely perfectable – just like the art of animation; just like Mickey Mouse. The world can be made a better place simply by projecting upon it a better environment. If you build a better environment, if you give people the educational tools they will necessarily lead better lives.[14]

Leaving aside what constitutes 'a better environment', whose 'educational tools' and, indeed, whose 'dreams', this perspective is important because it is intrinsically based on the trajectories of the MGM musicals of the 1950s, and sustains itself as a model of resolution and elevation. It is the coherence of this creative paradigm, and not its 'content', that on the one hand results in cultural critics like Byrne and McQuillan[15] being able to mount sophisticated, ideologically grounded, deconstructionist readings of Disney texts, while on the other, encourages the 'mass' audience to persist in its understanding of the 'innocence' of animated spectacle, and, more importantly, note and *only* acknowledge the ritualised components of the traditionally determined 'cultural resource' now named as 'Disney'. This has major political implications, in the sense that at one and the same time Disney may be seen to be endorsing some of the dominant 'myths' of American political culture – most notably 'populism', with its prevailing tropes of an inclusive political economy and an intrinsic trust in the political infrastructure – while actually *representing* a socially excluding 'reality' where power resides only with the centrist authoritarianism of an established conservative élite.

Richard Schickel has noted, though, that in regard to Mickey Mouse during the late 1930s and early 1940s, 'the political passions occasionally stirred by The Mouse during this decade indicate the folly of overinterpreting essentially innocent popular culture material in the light of any ideology – political, psychological, religious or even literary.'[16] This is largely because Mickey had been interpreted in such a variety of historically specific ways in a host of politically diverse nations that his identity lacked any of the cogency required for a coherent ideologically charged interpretation that could sustain itself beyond the context within which it occurred. This is not to deny Mickey, or any other Disney

character or film, political significance or importance, but to suggest that the Disney aesthetic readily challenges any apparently self-evident 'meaning' bestowed upon it by cultural critics. It is also to note that the films thus operate as significantly politicised texts within what may be termed a 'veiled' aesthetic which simultaneously denies this import. It may be the case that Disney, more than anyone else, in determining the predominant aesthetic for animation doomed the form to this fate, the outcome of which on the one hand, is to render animation as an eternally 'invisible' medium, on the other to liberate it as a form which is, as I have suggested, in a certain sense unregulated, or unregulatable.

It is clear that the framing of 'Disney' as a seemingly sinister corporate oppressor, constantly celebrating in Giroux's words, 'deeply anti-democratic social relations',[17] does not, however, seem to sit with the reception of the films. Audiences seem to embrace the satisfactions of the 'maturation' plot and its utopian tropes rather than see Disney as anything from being a perpetrator of stories in which 'children are taught that cultural differences that do not bear the imprint of white, middle-class ethnicity are deviant, inferior, ignorant, and a threat to overcome'[18] right through to being an organisation with an ethos that 'promotes escapism from the indeterminacy of "wild systems" through denial of process and difference'.[19] Problematically, this leaves the Disney oeuvre and, perhaps, animation in general in an ambivalent cultural bind; again, at one level capable of complex and substantive representation and the articulation of 'states of consciousness', all open to sophisticated inter-pretation; at another, a fixed model of narrativisation, innocuousness and cliché. Martin Barker has sceptically suggested that ideological inter-pretation 'is only worth doing if someone, somewhere might be con-ceived to be in receipt of the thus-discovered plague of reactionary forms' and argues that more work needs to be done on 'why and how people *enjoy* Disney films'.[20] My own work in this area suggests that audiences recognise and participate in the *difference* afforded by the animated form, and particularise the dominant tendencies of their res-ponse, most notably in relation to their emotional reaction to the films, locating the representational tendencies of the films in personal rather than political ways.[21] In many senses, this is to de-politicise the texts on the assumption that they work only as emotive entertainments somehow distanciated from the socio-cultural or, more importantly, national context in which they were produced. In locating the importance of the

films back in their 'felt' experience, rather than their cerebrally deter-
mined outcomes, they ironically share some purchase with the use of the
medium itself as a particular mode of elevation or transcendence, made
self-conscious and transparent within more overtly 'cartoonal' or avant-
garde animation. Ironically, Disney's mode of 'transcendence' is escapist
in its truest sense, since it points up 'difference' in order not to context-
ualise itself within modes of assimilation that would hold it to account for
its representational and ideological imperatives. The 'transcendence'
insisted upon by the 'Unicorns' is in a spirit of critique, drawing attention
to those very issues.

 This process has a long established history. Writing in his intro-
duction to one of the most significant leftist critiques of the Disney
perspective – Ariel Dorfman and Armand Mattelart's *How to Read Donald
Duck* (1975)[22] – David Kunzle suggests,

> If important sectors of the intelligentsia in the United States have
> been lulled into silent complicity with Disney, it can only be because
> they share his basic values and see the broad public as enjoying the
> same cultural privileges. But this complicity becomes positively
> criminal when their common ideology is imposed on noncapitalist,
> underdeveloped countries with no regard to the grotesque disparity
> between the Disney dream of wealth and leisure, and the *real* needs of
> the Third World.[23]

Dorfman and Mattelart's work, in mounting a damning critique of
Disney's imperialist assumptions from a Chilean perspective, prompted
a 'wake-up call' which in turn re-interrogated Disney's WASP capitalist
agenda within the wider parameters of an 'Americanisation' or a 'Global-
isation' thesis which, for example, re-engaged with Disney's work as part
of the 'Good Neighbour Policy' in Latin America during the war, where
the company were responsible for '[Reiterative] narratives of conquest in
which the patriarchal unconscious and imperial unconscious insidiously
overlap'.[23] This kind of reading of the Disney text places the company
and its products within a frame of critical reference which essentially
removes it from a national context and locates it within the boundaries of
multi-national corporate agenda that *inevitably* creates ideological con-
flict through the inequality of market economies. This ideological
imperative, however, still does not seemingly characterise the critical
response to the 'animation' itself, nor the story-telling modes it facilitates.
These reactionary, sometimes 'politically incorrect', sometimes culturally

inappropriate 'messages' do not become the dominant currency of the films and, instead, a kind of quasi-ideological optimism, innocence and security accrues and endures around the texts even in spite of the post-Dorfman and Mattelart critiques. Arguably, this is the prevailing effect of a politics of pleasure, where 'emotional' determinacy and agency characterises human ambition and need rather than intellectual or political clarity. This links with postmodern agendas which suggest that authoritarian, utilitarian and even democratic discourses are in demise within an increasingly de-historicised and sceptical version of socio-political understanding in western cultures.

Norman Denzin has suggested that the development of the cinematic form from the early primitive cinema phase right through to the postmodern era has served ideological purposes correspondent to the development of twentieth-century capitalism from its local to its multi-national condition, noting,

> Primitive realist cinema introduced the cinematic gaze and the screen voyeur into American culture. Modernist cinema kept the camera's gaze alive, but distanced it from everyday life. Under late modernism this gaze was parodied. With postmodernism the gaze is openly acknowledged, and its presence everywhere, including in the living room, is treated as commonplace.[24]

Denzin's perspective is enabling in the sense that it locates ideology as an inherent part of the development of commodity culture and consumer practice, and that this in turn is intrinsically related to the modes of construction in the cinematic apparatus which privilege the codes and conditions that determine 'ways of seeing'. What this once again pays no attention to is the specificity of animation as a form and as a mode of production within the same periods of development. The perpetual 'modernity' of the animated form consistently resisted, and continues to resist, a consensual version of the 'cinematic gaze', and refutes any clear model of ideological particularity that is not questionable in relation to the ways that animation as a form itself offers a multiplicity of perspectives through the overt 'plasticity' of its artifice. Arguably, Disney films, with the clear exception of *Aladdin* (1992), and increasingly in the post-*Hercules* (1997) period, acknowledge and embrace the 'gaze' in the way that cartoons have predominantly done since their inception, having only previously predicated their texts as classical narratives which

preserve the 'fourth wall' which insists upon the coherent integrity of the fiction observed in its own right, while providing a framework by which the observer determines its own model of spectatorial participation and effect. The 'loosening' of the Disney text is in a certain sense an acknowledgement of the increasing prominence of the cartoonal form and a greater trust in the public's ability to embrace its intrinsic vocabulary. It little mattered, for example, that children would not understand the popular culture references in the Genie's performance in *Aladdin*, as the film was clearly borrowing Warneresque tropes as one of the conditions of its approach. Embracing rapid metamorphoses, narrative condensation and associative relations, the film was much more invested in the 'primal' roots of the form, and re-asserted its 'modernity' accordingly, especially in relation to the defining and anticipated aspects of the Disney canon. Long before the determination of a concept of 'postmodernism' or a period of 'postmodernity', the animated form inherently embraced the self-figurative, self-reflexive, self-enunciating characteristics that supposedly characterise the collapse of previously constructed views of 'modernity', and the social and ideological practices associated with it. The 'ways of looking' at animation have always been re-determined with each approach to the form; its own 'modernity' sometimes echoing but largely irradicating the nexus of outcomes suggested in the movement from primitive to modern to postmodern forms. These 'modes' have arguably worked in parallel in animation; a sustained re-mediation of its own terrain; a flux of 'reactionary' and 'radical' forms determined *by its own* conditions rather than those imposed from without, or in relation to the dominance of live-action cinema. Consequently, the nature of the 'gaze' is a constantly questionable one; the ideological meaning uncertain; and the status of any one animated text in flux. This may further explain why the 'Disney' text may still retain its currency of 'difference' yet reassurance, while falling foul of cultural critiques which remain coherent on the basis of normative practices, but in themselves do not sufficiently allow for the ways animation re-constructs the 'gaze' and its concomitant variabilities in promoting new modes of perception and understanding, and, indeed, pleasure – again, a facility embraced by the 'unicorns' as politically and socially enabling, but merely embraced by Disney as a taken-for-granted mode of creative production.

Simplistically, if the 'reactionary' currencies are obvious, clear and affecting in the Disney texts, the Disney audience, however configured, either wilfully misreads, ignores or resists the messages of the text. This

serves to maintain the view that animation is *inevitably* an innocent medium, predominant in children's entertainment, and 'abstract'only by virtue of its status as drawing, painting, model-manipulation and so on. As Miller and Rode have rightly suggested, though, a culture is composed of *actual* people, who organise and make sense of their experience on their own terms and conditions, using '[Remembered] images' as the 'seeds of cultural formation'.[26] This act of memory and re-configuration is important, but the mode of 'cultural formation' that may result from it is questionable. Animation in the American context is unique in the sense that 'the cartoon' may be understood as one of its intrinsic creations, and with that comes a currency of memory which is not merely allied predominantly to childhood reminiscence and pleasure, but to the importance of a text as a 'marker' of individual experience within a cultural and national context. There is a mode of 'Americanness' imbued in the art-form which is grounded in a range of assumptions about its production that serve as signifiers to its essence as an 'American art-form'. Arguably, this encourages a *primary* reading, where it is more important, for example, to endorse the principle of 'freedom' rather than its implications; where it is more satisfying to enjoy the 'playing out' of the protagonists' progress towards fulfilment; and where it is reassuring to believe that notions of 'goodness', 'right', 'truth' and so on may still exist, *even if* there is a full understanding and tacit acceptance of the potentially illusory, contradictory or misrepresentative elements of the text in place. This 'American' supra-narrative is vindicated in Disney's adoption of the 'maturation plot', and the maintenance of the key regimes of American popular cinema from Capra to Spielberg. Any *secondary* reading which interrogates the Disney texts inevitably reads more complexly, and just as inevitably, finds the Disney text open to more critical questions than its conception and execution can support or answer.

Stefan Kanfer notes, for example,

> [*The Lion King* (1994)] reflected some social concerns about the discredited male in society; it had a strong paternal figure ... an Iago figure ... and a wide-eyed young lion who must one day replace his murdered father ... It also contained a group of goose-stepping hyenas, portrayed in a strange pastiche of Leni Riefenstahl's Nazi film *Triumph of the Will*. Probably less than 5 per cent of the audience had any understanding of the reference, but no matter. Disney was convinced it could do anything, including a politically incorrect movie, and make it pay.[27]

This statement is representative of the kinds of ambivalence and complexity these texts can provoke. When the ideological perspective or thematic is obvious – 'the social concerns about the discredited male in society' – the textual coherence is clear; when the form facilitates imagery which apparently (although, in my view inexplicably, in this case) problematises the ideological and textual consistency, this is some-how 'politically incorrect' and apparently in the service of the corporate oppressor once more. The *primary* reading here would suggest that Scar and the hyenas are being *graphically* determined as the epitome of 'evil', and the use of the suggestive, and culturally well-known *iconography* of oppressive regimes deployed to reinforce this *symbolic* construction. This is the capacity of the animated form on display in its most explicit form. As Kanfer himself acknowledges, the mainstream audience may not know that *Triumph of the Will* is (arguably) the referent for this scene, and consequently understands the imagery in a *primary*, arche-typal, rather than culturally specific, way. Knowledge of the referent would only enrich the *secondary* reading by calling into the discourse the long-held debate about *Triumph of the Will* as unacceptable propaganda, or state-of-the-art 'film form'. The latter aspect would be of more relevance to the animators making the film as it is clear that the deter-minist nature of the design and execution of 'industrial' animated texts is of greater significance than the potential complexities of the ideological discourses that may result. The *iconic* value of 'goose-stepping' soldiers is more important than its ideological imperatives; one dominant level of meaning prioritised over something more substantive and contradictory. The use of the imagery is not politically incorrect, but it may be politically naive. The facilitation of the animation, and its subsequent 'openness' as a textual form, challenges the version of coherence Kanfer wishes to embrace through the dominant theme of 'the maturation plot' – Simba's 'rite of passage' and process of redemption.

Animation is obviously 'artificial'; its characters 'unreal'; its politics subordinate to the assumption that the medium in its conventional forms promotes 'entertainment' before education or propaganda. Henry Giroux suggests, however, that Disney is 'profoundly pedagogical in its attempt to produce specific knowledge, values and desires'.[28] While the Disney text may have an underlying educative purpose, it is unclear that 'specific' kinds of knowledge, values and desires can be privileged as the overdetermined outcome. *Primary* reading is seemingly more 'open'; grounded more in 'emotional' matters; and 'aspirant' rather than

constrained. Disney, in prioritising 'utopian' *principles* as a thematic norm, and maintaining the 'tradition-directed' sensibility intrinsic to, and inscribed within, its own aesthetic, distanciates itself from the actual *meanings* implicit in the representational conventions consistently deployed. The *spectacle* of archetypal themes and emotions prevails over a cerebral engagement with *ideas*. This is not to suggest that ideas are not present, but they are not made transparent through the medium in the way that 'cartoonal' and 'avant-garde' practice insists upon. Orthodox animation in the Disney style retains an apolitical veneer, even when potentially highly politically charged. Ironically, this legitimises acts of representational subversion *and* reactionary consistency because the specificity of the technique in making the film still subsumes the process of storytelling. The Western Union, it seems, is still the best place to send messages.

Arguably, though, the very 'openness', 'emotionality' and 'aspiration' which are imbued in the Disney text may be viewed as politically liberating. This is a point confirmed by different (ironically, almost oppositional) means in Byrne and McQuillan's discussion of *The Little Mermaid* (1988) where they suggest '[The] endless readability of [the] film ... demonstrates the ways in which the Disney text carries within itself a radical ambivalence to the Disney narrative'.[29] In differentiating the 'text' and 'narrative' (though only partially exploring its implications) Byrne and McQuillan identify the way in which the Disney 'text' may become overdetermined in its possibilities, while the Disney 'narrative' carries with it a degree of enunciative specificity that appeals to openness, emotional response and aspiration *before* it may be grounded in quasi-political discourses. The overdetermined nature of the Disney 'text' is the result of the process of animation which accommodates 'authorial' excess even within strict aesthetic regimes, while the Disney 'narrative' is grounded in the particular modes of archetypal and aesthetic expression that speak to the known variables and antitheses of an un-reconstructed, or, more likely, un-complex view of right/wrong; good/evil; attractive/ugly; civilised/barbaric and so on. In some senses, it is possible to suggest that 'narrative' and 'text' effectively evolve separately in hierarchical, industrially determined animation production.

The animated film, within the quasi-Fordist industrial paradigm created by the Disney organisation, is constructed in stages, often beginning with an initial story idea that is normally drawn from established literary, graphic or historio-mythic sources. This idea is then developed

into a scene-by-scene script detailing the key events, context, character exchanges and projected shooting ideas, although in many instances this remains a highly fluid text through the processes of visual and character development. Even these initial stages are informed by collective suggestion ∪nd negotiation among the assigned creative teams in order to refine the principal storyline. The pre-production period, thereafter, involves the key personnel – producer, director, designer and art-director – defining the proposed 'style' of the film, and determining the nature of the characters, their personalities and design, and possible voice-casting options. At this stage, lead animators are assigned major characters and/or proposed sequences, and are responsible for model sheets of the character showing the dominant physical, gestural and emotive characteristics of the figure. This is a critical stage in the sense that the supervising or lead animation directors, and the voice artists, often major Hollywood stars, are the 'actors' who 'work through' the visual personality of the character as well as its performance elements. In a process where a film is made frame-by-frame this 'visual' criterion is crucial because the emphasis of the narrative and textual events is very much (over)determined by how things might *look* and *move*, rather than by what they may *mean* in themselves, or, ultimately, contextually in relation to other characters or events in the film.

This idea may be reinforced by addressing what may be viewed as an atypical example – the influence of British satiric caricaturist Gerald Scarfe on *Hercules* (1997). His forty inspirational designs, which are all pervasive in the film, were primarily driven by Scarfe's concerns with anatomy, graphic economy and the sense of a spontaneous line, before they were seen as representational images which may harbour a range of potentially challenging (political) meanings or connotations. Conse-quently, the key issue becomes the creative tension which took place between Scarfe's 'brutalist' immediacy in design, and the prevailing imperatives in the Disney personnel to re-create established and tradi-tional visual codings of iconic 'cuteness', and their attempts to ensure a clarity of shape and form in the designs to facilitate ease in the industrial process of *animating*. It is this which becomes the key *ideological* struggle in the film, and not the 'political' implications that less specifically emerge out of the final narrative/text. The result in *Hercules* was a compromise which is half-Scarfe, half-Disney where the 'elegant grotes-que' becomes part of the Disney image vocabulary, but carries with it little of Scarfe's anticipated satirical bias. Further, and more importantly,

nothing in his designs was retained, or found a place in the film, if it could not be made 'simple' enough to facilitate 'complex' choreography in the animation – form necessarily prevailing over content.

The key personnel in the production process are essentially 'evolving' the film through a number of parallel approaches. While it is clear that the Disney approach has often been understood as a strictly hierarchical construct, Michael Eisner, CEO of the Walt Disney Company, has suggested that the creative process in contemporary Disney films is informed by a higher degree of democratic involvement; citing Tom Schumacher's term, he notes that this is a form of 'Cultural Darwinism' in which an idea is embraced from *anyone* working on the project, which is essentially tested for its validity by its ability to survive a process of challenge, scrutiny and re-working over several years of production.[30] Traditional processes still inform this approach, however. Storyboard artists begin preparing the key drawings which illustrate the provisionally determined aspects of the script, picturing the stage-by-stage visual narration of the action sequences. These artists effectively construct the initial mise-en-scène of the film and an implicit editorial regime for executing the main events of the story, and often must persuade the director, producer, designer and art-director of the appropriateness and effectiveness of the suggested storyboard. If approved, these storyboards are shot on film to create a provisional 'plot' reel, which may be subject to considerable re-editing, re-ordering and the addition of material. Once the 'action reel' is approved, individual sequences can be sent to 'layout', where the composition of each shot is provisionally decided and cinematographic decisions are made concerning the most effective expression of narrative concepts in purely visual terms. Again, this stress upon 'technique' and the clarity with which the events of the story take place, becomes of greater importance than some of the implications of the design or the proposed plot. The 'clarification' process that both facilitates technique and insists upon ease in understanding 'the story' allows for little nuance or complexity in the semiotic inflections of the visual narrative. 'Cultural resources' become the material of technical and story-telling processes first and foremost, and not the material of an ideologically charged concept-led aesthetic. The multiple 'authors' of the Disney text deploy 'cultural resources' in their own work as part of an ever-evolving conception where the Disney 'style' and its concomitant mode of 'fairytale-ing' marshals 'narrative' ideologically through aesthetic decisions, but neglects the ramifications of the 'text'. This is

largely the outcome of the 'openness' of the pre-production process, which arguably ultimately creates an openness in the text, which in turn invites layers of interpretation.

The pivotal moment in the pre-production process, sometimes called the 'workbook' phase, is critical in this, in the sense that this is when the key personnel decide upon a shot-by-shot breakdown of the film, taking into account all the detail of the mise-en-scène, and determining lighting, camera angles and effects – essentially all visual phenomena which is not 'character' animation. Decisions are also made about the camera moves for each scene, and the first dialogue recordings are made to establish provisional timings and begin the process by which all aspects of the soundtrack are delineated. The value and importance of 'sound' and 'voice' in animation cannot be underestimated, and in recent years have been highly significant in the ideological readings of Disney films. The casting of Whoopi Goldberg, for example, as a villainous hyena in *The Lion King* (1994) was read as another element in the 'racist' discourse of the film – allied to Kanfer's suggestion that the film is 'politically incorrect' – where Goldberg's 'blackness' was read into the schemata of the role and function of the character. This kind of interpretation in some senses fundamentally ignores the visual text altogether, and merely casts 'the actor' as the condition of reading. As Brad Bird, director of many *Simpsons* episodes and the full-length feature, *The Iron Giant* (1999), notes,

> When an animated character breaks through and becomes part of the cultural landscape, the voice actor – not the animator – is credited, because people understand what a voice actor does. What is typically lost in discussions about animation is the fact that when you watch an animated film, the performance you are seeing is the one that the animator is giving you.[31]

Bird sounds an important note of caution in that to over-determine the meaning of a character through vocal casting is to both ignore the primacy of the animation, and interprets the character through the 'known' performance persona of the 'stars' who may be cast in those roles. This immediately neglects those *not* taken into account; i.e. those vocal performances by unknown or less known actors. This can raise serious issues but is ultimately misleading – Phil Harris and Louis Prima, white performers, voice the nominally 'black' troped characters of Baloo the bear and King Louie the ape in *The Jungle Book* (1967), but how far this informs and extends a 'racist' discourse is certainly open to question.

However viewed, it is clear that, if addressed, vocal performance only becomes part of a 'textual' reading when it is allied to a 'star', and essentially remains a 'narrative' discourse otherwise, especially as the creative choices about vocal performance are necessarily made on aesthetic grounds rather than those which supposedly predetermine the character ideologically.

The production initiative takes a long time to actually arrive at the stage of 'text' or 'narrative', but rather moves forward as a process of accumulative preparation. Lead and supervising animation directors work with animating teams on each scene, using 'model sheets' with key poses for the characters; establishing the nature of the action and movement and reviewing the dialogue for performance information. Key drawings of a sequence and an exposure sheet showing frame-by-frame information about the proposed animation are prepared, and teams work on before-and-after sequences, over-lapping action, and the in-between drawings of the main poses in the action sequences. Rough line-drawings are animated and shot for evaluation and correction, and a whole range of decisions may be made in relation to the work before it proceeds to 'final-line' animation or 'clean-up'. Consistency in the design and detailed execution of a character is fundamental to the continuity of narrative events in the film, and must work well within the designated background context. Numerous checks are made before all work is scanned onto computer for the key personnel to create a composite of all the scenes, modify colour, movement, sound and so on, and eventually create a text for camera and the final completion of the film. In recent years the impact of CAPS – the Computer Application Production System – has enabled animators

> to digitize hand drawn images into the computer, which [gives] them the power to manipulate and three-dimensionalise characters and scenes in entirely new ways. It also dramatically enriched the colour palette. In a short time, CAPS technologically and artistically revolutionised the archaic method by which animated movies had been made since *Snow White*.[32]

The inevitable outcome of such a complex 'authorial' process, however hierarchically organised, efficiently executed, or culturally Darwinised, is a text which foregrounds its aesthetic and technical achievement, and radically 'simplifies' its ideological project. This 'simplification' has become a 'tradition-directed' technical, aesthetic and textual norm, and a

seemingly regulated 'site' which presupposes its own orthodoxies as the conditions of its creativity and political position.

Fundamentally, the Disney 'site' may be viewed within the parameters of Richard Dyer's model of utopian entertainment,[33] once more recalling Disney's affiliations with the parameters of the 1950s MGM musical, and viewed in a spirit where the *public* and political may be identified with the 'text' while the *personal* and the political may be identified with the 'narrative'. In many senses this is to imply that 'cartoonal' and 'avant-garde' forms are intrinsically textual, and there is some veracity in this even when such films have a narrative structure and proposition. These conditions overlap and, inevitably, create the ambivalence and contra-diction which characterise and define the animated form. The onto-logical equivalence intrinsic to animated texts compounds this issue, and speaks further to the difficulties of properly assessing political inscription within Disney films. Dyer's conceptions of 'energy' (activity as human potential and power); 'abundance' (material well-being for many); 'intensity' (authentic depictions of affective emotion); 'transparency' (clarity of relationships between the protagonists themselves, and in relation to the audience) and 'community' (networks of communication and 'togetherness') in the musical are enabling in determining how the creation of the Disney text, in deploying 'cultural resources' as part of its aesthetic and narrational process, merely uses them as agents of meta-phorical allusion to the thematic and personalised aspects of cultural events, rather than the specificity of cultural politics.

Recent Disney animation has seemingly reflected some key social, cultural and national events – *The Little Mermaid* (1989) (the fall of the Berlin Wall and the end of the Cold War); *Beauty and the Beast* (1991) (the opening of EuroDisney); *Aladdin* (1992) (The Gulf War); *The Lion King* (1994) (the first democratic elections in South Africa); *Pocahontas* (1995) (Clinton era 'human rights' processes in, for example, Palestine and Ulster); *Toy Story* (1995) (re-defining 'Frontier' myths in the light of a 'New World Order'); *The Hunchback of Notre Dame* (1996) ('Ethnic cleansing' in the Balkan War); *Hercules* (1997) (re-asserting American 'heroism' as a Kennedy/Clinton-esque mediated phenomenon); and *Mulan* (1998) (Disney's corporate expansion into Chinese markets).[34] All these Disney films serve as examples of the ways in which Disney creates 'narrative' and 'text' as politicised entities, where 'narrative' and 'text' may be understood entirely separately from each other, inter-relatedly or, indeed, oppositionally, but importantly, all embrace Dyer's

utopian paradigm as an 'archetypal veil' which overlays deep themes and disguises the intricacies of political 'metaphor' as they may be (obviously) read through these stories. At one level, these films use their central protagonist (Ariel, Belle, Aladdin, Simba, Pocahontas, Woody, Quasimodo, Hercules and Mulan) *only* as a vehicle to express stasis, frustration, alienation and oppression in the light of a range of oppositional forces mainly concerned with established traditions and seemingly preordained social structures. Each literally 'embodies' social and romantic 'yearning' for change, and are nominally configured as 'good' in their desire to gain what is normally constructed as a self-evident reward for enduring their current predicament or 'lack'. All are thrust into 'public' circumstances which enable them to act upon the cultural and/or environmental infrastructure and challenge the oppositional forces, which, inevitably, are configured as 'bad'/'evil', even if they too may be subject to more complex readings, or act as part of a higher redemptive scheme for all the characters involved. Ultimately, all succeed in 'revising', 'reconstructing' or 're-determining' their social circumstances, but crucial to their progress has been the mobilisation and absorption of 'otherness' (both in the characters and, arguably, in the viewing audience) into a consensual drive towards a known resolution akin to Dyer's utopian ideal.

These central figures are the 'energy' of the narrative, galvanising the affective 'action', which is normally a challenge mounted to either maintain or question established power relations and cultural norms. Initially, it is almost always about a longing for something, or the responsibility to *have* to achieve something at the individual level. In achieving 'abundance' – material well-being for many – these protagonists create 'community' as part of their personal need and ambition, accommodating 'otherness' as 'togetherness'. This is where the 'design' orthodoxies in Disney animation become crucial. The anthropomorphisation of animals and objects; the caricatural norms of comic 'cute'; villainous 'angularity' and romantic 'curvaceousness' and the mood-determining detail of 'real' environments and psychological/emotional contexts all retain an ontological equivalence within the *materiality* and *flexibility* of the animated text to the point where 'difference' is only evaluated through the terms and conditions of the animated form, and *not* at the social level. The central protagonists are the same as the 'others' they align with or oppose. Those who are marked *narrationally* as 'good', 'right', 'true' and so on and those who may be punished, redeemed or eliminated in the same scheme,

become part of a view which is effectively assuming a model of socio-cultural 'accommodation', rather than an active comment upon 'differentiation'. The whole premise of the 'inner-directed' or 'other-directed' 'cartoonal' or 'avant-garde' work is entirely about establishing modes of differentiation which critique any notion of 'accommodation' which assumes 'sameness'. The animated text/form in the Disney style legitimises this process because *its* creative orthodoxies don't change, while social mores *do*. In consistently promoting the 'magical' properties of animation – essentially its *procedural* and *technological* difference from live-action (though some would argue that the impact of animation in live action is once more making this line in distinguishable) – Disney represents what Bryan Appleyard has described as the 'super-normal'; a world which 'doesn't have to be as upsetting as the real one', and works as 'tradition-directed' myth which is 'an expression of a pristine moment in a great nation's life when its people really thought they would all live happily ever after'.[35]

The 'design' strategy described earlier is further reinforced through the 'transparency' of each individual as a cipher for a dominant trait, and the ease in identifying the bonding aspects of the relationships between romantic lovers; hero/heroine and allies; hero/heroine and villain and so on. This model is authenticated by the 'intensity' – overt depictions of affective emotion – in the songs and choreographic spectacle that underpin the narrative. Disney has created a 'fairy-tale' structure of its own, which it supports through *visual* orthodoxies, also of its own making, and which it advances through overdetermined utopian tropes in song and spectacle. 'Animation' itself is Disney's first defence here, in the sense that as a 'film form' in its own right, it refuses the ways of reading available to critics of live-action film. Byrne and McQuillan are almost surprised, for example, when they describe Ariel in *The Little Mermaid*: 'She looks up to the camera with doe eyes and enhanced breasts, which have more to do with animation than anatomy …'.[36] Arguably, this has more to do with the 'received' knowledges of Disney (indeed, classical cartoon) animation, and its need to create 'industrial' templates of stereotypical femininity by which archetypal veiling and utopian aspiration may take place. These strategies inevitably promote the primary reading cited earlier, and divert audiences from any apparent necessity for secondary reading. It is in the secondary reading, of course, that the highly charged political and ideological complexities may reside. Disney's trademark 'innocence' is a consequence of a particular manipulation of

technology and a specific approach to 'animation'. It remains, then, to explore what the *actual* political implications of this are.

In a recent review of *Fantasia 2000* (2000), John Patterson notes his loathing of Walt Disney's 'saccharine, utopianised Main Street', and 'his knee-jerk anti-semitism', commenting on '*Song of the South* ... which would probably make a great Ku Klux Klan double bill with *Birth of a Nation*', and concluding, 'I've stood on Walt Disney's grave many times. And if the place had been a little emptier I might have done a few more things on it, too'.[37] This level of vitriol, essentially directed at Walt Disney himself, has largely emerged as a consequence of the rejection of the Company-approved 'sanitised' biographical material about Disney written by Bob Thomas and Leonard Mosley;[38] the embrace of Marc Eliot's unauthorised and much more damning biography, *Walt Disney, Hollywood's Dark Prince*;[39] and the rise of persuasive deconstructive academic criticism, which fully delineates the issues concerning representation in Disney animated films over the last decade or so. This extratextual material has significantly coloured a negative response to the films themselves in critical quarters, but has done little to impinge upon the positive nature of the mass viewing audience worldwide. This may indicate that the viewing public has little interest in 'authorship' and 'cultural politics', and is opting to engage with and enjoy the 'supernormal' world of the animated form in a *primal* rather than *interrogative* or *contextual* way. The historical or institutional issues raised by 'Disney' (however defined, in this instance) have been subsumed into personal meta-narratives rather than cultural ones. Childhood experiences become adult memories, which in turn influence the next generation of childhood experiences, and so on. This continuity is based on an intrinsic trust in Disney's 'form' and the nature of the primary responses outlined earlier, and not on the re-positioning of 'Disney' within the contemporary sociocultural consciousness or political frame. The sense of 'timelessness' in the Disney animated form facilitates the ease with which this attitude about, and trust in, 'Disney' persists, although it is clear that on closer inspection all the texts are of their time, and readily reveal their cultural inflections. Even if the Muslims object to their portrayal in *Aladdin*; African-Americans find deep-rooted racism in *The Lion King*; the French oppose the presence of Disneyland, Paris; Christian fundamentalists rail against Disney's corporate identity and Virginians successfully resist the imposition of an American History Theme Park, the engagement with, and perpetuation of, the Disney myth prevails.

Crucially, it may be argued that this has been achieved because Disney was absolutely intrinsic to the emergence and acceptance of an authentic 'popular culture' in the post-war era. The politics of 'past-Art' and its associated pleasures have been so forcefully entwined in the fabric of legitimate socio-cultural materiality that they cannot be readily un-picked and re-contextualised within an alternative system of appraisal. This may come with time, and may be aided and abetted by the increas-ing scale of revelation about how the 'magic' is constructed. With each new *The Making Of* ... documentary and every associated 'technology' in toys, promotions and spin-offs, comes a gradual erosion of the 'mysti-fication' of creativity. While the 'wow' factor remains in place, and technological determinacy retains its awe and wonder, the Disney ethic of responsiveness and reassurance stays in place, but once this is a known quantity and one shared by other producers and the public alike, a closer address of the teller and the tale may take place. Disney's aesthetic, and its own meta-commentary on art and progress as illustrated in animated film, when immersed in popular and critical acclaim for over forty years, has in effect defined an acceptable, accessible and, crucially, archetypal 'Art' for mass consumption. This cannot be easily over-turned in the necessary attempt to draw key 'producers' into the realms of important critical debates. In many senses, the middle-class critical determinism in re-constructing and re-defining 'histories' is a comparatively recent phenomenon, and whilst fundamentally necessary in the reclamation of gender, race and class knowledges, it cannot immediately challenge both the *mythic* identity of Disney or the intrinsic *modernity* of the animated form. Disney 'history' is embedded as cultural history, and a key site for a 'populist' value system that seemed to be drawn from self-evident truths, and was rendered *visible* by an 'art-form' made out of artisanal imperatives and folk sensibilities. This 'visibility' has been retained and continues to be embraced because of the 'imagery' of that visibility has been maintained and re-invested in (American) culture. Its 'meaning' seemingly does not change in the public imagination, while the social and political context within which it finds itself has changed radically.

Again Giroux has argued, in recent Disney films,

> memory is removed from the historical, social and political context that defines it as a process of cultural production that opens rather than closes down history. It is precisely this pedagogical policing of memory that undercuts its possibility as a form of critical remembrance

that positions human agency against the restrictions and boundaries set by the historical past.[40]

Ironically, the Disney myth is propagated by an identification with its 'visible' ethos, embodied in a pictorial 'stasis', which even in spite of consistently shifting positions and adjustments of historical and cultural perspectives does not change in the public memory. While it is obvious that the Disney texts may be part of a personal meta-narrative that perceives only inclusion, justice and progress, these texts are part of a cultural environment that does not readily evidence these things. In essence the 'myth' endures above the specificities of representational responsibility because its claims are for a universality of *human* qualities rather than the particular recognition of geo-political variation. Its 'modernity' merely foregrounds the possible metaphors in which we can address a limited range of psychological and emotional variables rather than those about increasingly important issues concerning personal and cultural identity. It is no surprise, then, that Disney's design strategy is found to be irredeemably lacking in its cultural sensitivity, when its mythical ethos does not speak to the contemporary ideological discourses in the public domain.

While the audience watching *Aladdin* sees Jafar, cultural critics see Saddam Hussein; while some view *The Lion King*, others see an inept *Hamlet*, or, perhaps, a blatant copy of Osamu Tezuka's *Kimba the White Lion* (1965); some, too, may see *Mulan* as a story about a communist girl, loyal to state-soldiery *and* domesticity, while others may determine a discourse on cross-dressing and queer identity; and many may see Belle in *Beauty and the Beast* as a victim of oppressive masculinities and a patriarchal culture, while others, a reassuring fairy-tale of love conquering all. One inarguable fact to have emerged about Disney texts in the modern era is that they have attracted much more critical attention and have been subject to post-structuralist, post-colonial, (post-)feminist and post-modern interrogation. Arguably, these critical approaches reinforce the mythical centre and its ethos, and promote the reassurance of primary readings. It is much easier, after all, to 'wish upon a star' than to engage with the Clinton-chasing Kenneth Starr, and the 'Whole New World' offered by Disney in the comfort of cartoon is politically preferable to the one to which it refers.

Notes

* The issues explored in this chapter were first addressed in P. Davies and P. Wells (eds), *Cinema and Society in America* (Manchester and New York: MUP, 2001).

1. H. Giroux, 'Are Disney Movies Good for Your Kids?', in S. Steinberg and J. Kincheloe (eds), *Kinderculture: The Corporate Construction of Childhood* (Boulder and Oxford: Westview Press, 1997), p. 55.

2. E. Bell, L. Haas and L. Sells (eds), *From Mouse to Mermaid: The Politics of Film, Gender and Culture* (Bloomington and Indianapolis: Indiana University Press, 1995), p. 5.

3. Walt Disney, quoted in R. Schickel, *The Disney Version* (London: Michael Joseph, 1986), p. 174.

4. R. Schickel, *The Disney Version* (London: Michael Joseph, 1986), p. 72.

5. R. Allan, *Walt Disney and Europe* (London: John Libbey, 1999), p. 1.

6. A. Bryman, *Disney and his Worlds* (London and New York, 1995), pp. 14–15.

7. J. Zipes, 'Breaking the Disney Spell' in E. Bell, L. Haas and L. Sells (eds), *From Mouse to Mermaid: The Politics of Film, Gender and Culture* (Bloomington and Indianapolis: Indiana University Press, 1995), p. 29.

8. P. Hollister, 'Genius at Work: Walt Disney' in E. Smoodin (ed.), *Disney Discourse* (London and New York: Routledge, 1994), p. 38.

9. See J. Wasko, *Understanding Disney* (Cambridge: Polity Press, 2001).

10. S. Miller and G. Rode, 'The Movie You See, The Movie You Don't See' in E. Bell, L. Haas and L. Sells (eds), *From Mouse to Mermaid: The Politics of Film, Gender and Culture* (Bloomington and Indianapolis: Indiana University Press, 1995), p. 86.

11. R. McKee, *Story* (London: Methuen, 1998), pp. 81–5.

12. I am grateful to Martin Barker for introducing me to this concept.

13. See P. Wells, *Animation: Genre and Authorship* (London: Wallflower Press, (forthcoming)).

14. Brian Sibley: Personal Interview, 22 March 1988.

15. See E. Byrne and M. McQuillan, *Deconstructing Disney* (London and Sterling: Pluto Press, 1999).

16. R. Schickel, *The Disney Version* (London: Pavilion, 1986), p. 186.

17. H. Giroux in S. Steinberg and J. Kincheloe (eds), *Kinderculture: The Corporate Construction of Childhood* (Boulder and Oxford: Westview Press, 1997), p. 62.

18. Ibid., p. 62.

19. P. D. Murphy, 'The Whole Wide World was Scrubbed Clean: The Androcentric Animation of Denatured Disney' in E. Bell, L. Haas and L. Sells (eds), *From Mouse to Mermaid: The Politics of Film, Gender and Culture* (Bloomington and Indianapolis: Indiana University Press, 1995), p. 126.

20. M. Barker, *From* Antz *to* Titanic: *Reinventing Film Analysis* (London and Sterling: Pluto Press, 2000), p. 189.

21. See P. Wells, *Understanding Animation* (London and New York, 1998), pp. 222–42.

22. See A. Dorfman and A. Mattelart, *How to Read Donald Duck* (New York: International General, 1975).

23. D. Kunzle, 'Introduction to *How to Read Donald Duck*' in D. Lazere (ed), *American Media and Mass Culture* (Berkeley and Los Angeles: University of California Press, 1987), p. 516–7.

24. J. Burton-Carvajal, '"Surprise Package": Looking Southward with Disney' in E. Smoodin (ed.), *Disney Discourse* (London and New York: Routledge/AFI, 1994), p. 131.

25. N. Denzin, *The Cinematic Society* (London and Thousand Oaks: Sage, 1995), p. 9.

26. S. Miller and G. Rode in E. Bell, L. Haas and L. Sells (eds), *From Mouse to Mermaid: The Politics of Film, Gender and Culture* (Bloomington and Indianapolis: Indiana University Press, 1995), p. 87.

27. S. Kanfer, *Serious Business: The Art and Commerce of Animation in America from Betty Boop to* Toy Story (New York: Scribner, 1997), p. 221.

28. H. Giroux, 'Memory and Pedagogy in the "Wonderful World of Disney"' in E. Bell, L. Haas and L. Sells (eds), *From Mouse to Mermaid: The Politics of Film, Gender and Culture* (Bloomington and Indianapolis: Indiana University Press, 1995), p. 48.

29. E. Byrne and M. McQuillan, *Deconstructing Disney* (London and Sterling: Pluto Press, 1999), p. 35.

30. M. Eisner, *Work in Progress* (London and New York: Penguin, 1999), p. 180.

31. E. Hooks, *Acting For Animators* (Portsmouth: Heinemann, 2000), p. vi.

32. M. Eisner, *Work in Progress* (London and New York: Penguin, 1999), p. 180.

33. R. Dyer, 'Entertainment and Utopia', in *Only Entertainment* (London and New York: Routledge, 1992), pp. 17–35.

34. See E. Byrne and M. McQuillan, *Deconstructing Disney* (London and Sterling: Pluto Press, 1999).

35. B. Appleyard, 'Disney Family Values: The Triumph of Niceness', *The Sunday Times How Disney Makes Magic* Supplement, Week One: Creating Character, 1998, p. 8.

36. E. Byrne and M. McQuillan, *Deconstructing Disney* (London and Sterling: Pluto Press, 1999), p. 24.

37. J. Patterson, 'Hollywood Reporter', *The Guardian Review*, 31 December 1999, p. 8.

38. See L. Mosley, *The Real Walt Disney* (London: Grafton Books, 1985); B. Thomas, *Walt Disney* (London: W. H. Allen, 1976).

39. M. Eliot, *Walt Disney, Hollywood's Dark Prince* (London: André Deutch, 1993).

40. H. Giroux, 'Memory and Pedagogy in the "Wonderful World of Disney"' in E. Bell, L. Haas and L. Sells (eds), *From Mouse to Mermaid: The Politics of Film, Gender and Culture* (Bloomington and Indianapolis: Indiana University Press, 1995), p. 47.

New Animation *Auteurs*

Leonard Maltin, in his engaging history of animated cartoons in the United States, recognised that the television era had significantly changed the animation landscape, and though he saw that this was a potential opportunity, and a chance to recover aspects of the art form, he also noted that 'animation is not merely a trend or a product and those who treat it as such are likely to fail', suggesting that it would remain necessary 'to bridge the gulf between art and commerce', citing Richard Williams and Don Bluth, both torch-bearers for the Disney tradition, as the likely candidates in promoting art in the animated feature and encouraging quality in the television realm.[1] In many senses, this provides a useful starting place to look at the contemporary period and trace a number of issues, particularly in relation to what may be viewed as a new *auteurism*. Williams, for example, was responsible for the groundbreaking animation in *Who Framed Roger Rabbit?* (1988) and later *The Thief and the Cobbler* (1998), his masterpiece which was thirty years in the making and which became subject to the impositions of the Disney studio and distributors insisting upon the re-editing and alteration of the film for the direct-to-video market. *Who Framed Roger Rabbit?* was a self-conscious attempt to re-invigorate both interest in, and acknowledgement of, cartoonal history, but the film failed to draw into its frame the radical principles of its sources in awakening emotional empathy, and misrepresented its investment in the unique qualities of the animated aesthetic by down-playing the effect of those sources as a central tenet of film-making illusionism. This may ultimately be a consequence of being unable to reconcile the differing premises of the Disney, Warner Bros. and Fleischer cartoons brought together in the film, and the preoccupation with a convoluted narrative which remained ambivalent about the radical conditions which underpin cartoonal forms and their effects. On the one hand, *Who Framed Roger Rabbit?* celebrates the spontaneous, redemptive, quasi-spiritual influence of the cartoon characters, while on

the other it renders them uncertain of their 'meaning'. In a sense, the film's discourse is to question the meaning of cartoons, yet without validating their embrace of 'difference'. Dr Doom, for example, who effectively 'liquidates' cartoon forms, seems a highly conservative figure, oppressing the antic freedoms of the 'toons', representing corporate oppressiveness and social consensus. Ultimately, this represents the conservatism of late-Reaganism.

As the television era developed, a significant aspect of this was the prioritisation of 'process-driven' work and the demotion of the 'creator-driven' project. The preservation of a consensual orthodoxy marginalised the 'inner-directed' or 'other-directed' principles of more cartoonal and avant-garde films, and with it a lack of quality in mainstream animation vehicles. Individuals like George Griffin pondered this state in his work, lamenting a lack of reference to the nature of the art-form or the auteurist possibilities within it. *Lineage* (1979), in particular, reflects on the processes of the animated form while reflecting on the process of the artist, a perspective he took from the works of Robert Breer and Stan Vanderbeek, and which he argues were 'not particularly ideological, [but] they were revolutionary; perfect analogs for the defiant anarchism of the counterculture', and which ultimately led him to conclude 'as I learned more of the history of animation, I began to formulate a critical analysis of the studio system and recognised the need for another production model'.[2] *Frames* (1978) was a collaboration between Griffin and other New York artists like Kathy Rose and Victor Faccinto, and signalled the intention of breaking down the false distinction between abstract and cartoonal art – a premise which underpins the whole of my discussion here – and to encourage the embrace of all production contexts and broadcast outlets to promote a range of work and to challenge the assumed homogeneity in the form, largely determined by the high-profile work of the Disney studio. The recovery of the autobiographical, experimental, therapeutic and progressive aspects of animation was a necessity for Griffin, who published a polemic entitled 'Cartoon, Anti Cartoon', which championed the *auteurist* work of the pioneers, Messmer and McCay, and criticised the authorial limits of the studio process, singling out Richard Williams' *Raggedy Ann and Andy* (1977) as characterised by 'a shocking lack of personal vision', working as 'a presold product, not a work of art'.[3] It was this kind of work, seemingly also prevalent at the Disney studio, that Maltin's other 'great white hope', Don Bluth, objected to.

In a much publicised 'walk-out' from the Disney studios in 1979, Don Bluth effectively made a prescient statement about the decline of Disney's production values and outlook. Robin Allan, while acknowledging that this indeed was not the work of the 'Golden era', recognises, however, that the Disney Studios had in essence tried to carry on a tradition of progressiveness and experimentation in the form in the postwar period, but this had ultimately failed: 'the public was tired of the package films, the compilations and the mixtures of live action and animation, the experimental work of the middle forties, which had not done well at the box office'.[4] Though Disney tried to recover its reputation in a return to the single feature project in films as diverse as *Alice in Wonderland* (1950), *Peter Pan* (1963), *101 Dalmatians* (1961), *Mary Poppins* (1964), *The Jungle Book* (1967), *Bedknobs and Broomsticks* (1971) and *Robin Hood* (1973), the new generation of animators and Directors could not emulate their predecessors, though many of these films have distinctive and engaging elements. Arguably, the Studio's preoccupation with 'Englishness' and its associated aesthetic during this period both undermined the potential of the narrative and worked as a distanciation from the cultural destabilisation that escalated in the United States during the same decades. Disney had become detached from its own artistic credo and aspiration, and the socio-cultural context in which it was produced.

If the 'Golden era' was informed by Disney's personal investment artistically, strategically and entrepreneurially in the projects undertaken by the Studio, it is clear that this 'authorial' cachet, and the narrative of its construction and promotion was a specific factor in Disney's prominence as an intrinsically 'American' folk art, even in spite of many of its European aesthetic sources. Disney represented the very spirit of the 'populist' hero, and in the 'Golden era', the triumph of Modernism in the popular idiom. The Disney Studio's 'modernist' predilections, thereafter, did not sit easily with the paradigm that had been established by Disney, the man, and the extraordinary achievements of the Studio until 1941. While other studios – most notably, UPA – are often credited with re-injecting modernist art principles into animation in the post-war period, it is arguably the case that Disney also sought to be more progressive in its work only to have this received with disappointment and criticism. Simply, the Disney 'brand' and its visual identity were established in a way that refused change, which on the one hand produced work which was arguably 'more-of-the-same' in an attempt to recover it;

and on the other, work which seemed increasingly of a different cultural and aesthetic order. The 'Englishness' at the heart of the Disney canon during this period is essentially located in the 'literariness' of the texts and, arguably, works as a cipher for 'quality' stories, yet this sits at odds with the defining aesthetic of the 'Golden era'. While innovation, for example, may characterise the design principles of *101 Dalmations*, which borrows directly from the caricature of Ronald Searle to heighten its 'English' credentials, this is a long way removed from the cultural context of the United States.

Bluth and his colleagues, Gary Goldman and John Pomeroy, along with eleven others were left in dismay at the poor work which had characterised the studio's output since *Robin Hood* (1973). Having long abandoned the scale of investment and quality assurance championed in 'the Golden era', Disney only re-addressed these issues much later, when the Michael Eisner and Jeffrey Katzenberg era recognised that the 'Classical' animation tradition had all but disappeared, and Disney's fate as a company was intrinsically bound up in its resurrection and success. Eisner himself notes that the credo among the animation artists had become 'We may bore you, but we will never shock you'.[5] Bluth, having moved to Santa Monica with his family in 1954 and attended Brigham Young University, sent his portfolio of artwork to the Disney studios, and was hired immediately as an assistant animator on *Sleeping Beauty* (1959). Bluth's initial period at Disney was a brief one, however, as he left in 1957 to pursue spiritual interests for three years with the Mormon Church in Argentina, and then, working with his brother Fred, producing musical theatre in Culver City, California. Returning to the Disney studio, Bluth was an omnipresent part of the Disney animation unit during the 1970s, and he directed the animation sequences in *Pete's Dragon* (1977), a live-action feature, and *The Rescuers* (1977), as well as writing songs. He also directed *The Small One* (1978), the story of the little donkey who takes Mary to Bethlehem, while simultaneously working on his own short film, *Banjo, The Woodpile Cat* (1978). When Disney passed on its release, the film effectively became a showreel which won him a $6.5 million offer to direct his own feature. Having left Disney, he established an animation team at Studio City, before re-locating to Ireland to form the Sullivan Bluth Studio with Morris Sullivan in the early 1980s. The Disney 'tradition' was in effect first resurrected in the studio's initial film *The Secret of NIMH* (1982), based on Robert C.

O'Brien's book, *Mrs Frisby and the Rats of NIMH*, and later in the Steven Spielberg/Amblin funded *An American Tail* (1986). *An American Tail* in many senses suffers from the same difficulties as *Who Framed Roger Rabbit?* two years later, however, as the 'movie brat' influence of Steven Spielberg seeks to foreground an 'animatophilia' through the incompatible aspects of seeking to ally Warneresque speed and cynicism with Disney-style sentiment. The more hyper-realist, character-driven, tragicomedy of the authentic Disney formula was more fully played out in Bluth's next feature, *The Land Before Time* (1988), however, in which Bluth's commitment to quality animation in character movement and story-telling as an emotional journey completely reflects the Disney ethos, seemingly absent in the poorly designed, adult-oriented *Oliver and Company* (1988), released the same year. *The Land Before Time* may be viewed as a re-working of *Bambi* (1941), and tells the story of the fatherless Littlefoot, a baby dinosaur, who endures the barren plains, the loss of his mother, massive earthquakes and the 'sharp-tooth' T-Rex, before arriving at the lush Great Valley, having reconciled the differences between species among his friends, and finding his grandparents. An epic and optimistic, rather than sentimentalised, story, the film engages in the standard tropes of emotional provocation and unconscious anxiety inscribed in Disney texts, but, more importantly, recalls its 'artistic' credentials. Many viewers would no doubt have found Bluth's film indistinguishable from a Disney film, but it is clear Bluth sought a more retrospective aesthetic as a rejection of the minimalist styling of the contemporary Disney product, which proved an inconclusive 'modernity' at best. In many senses, like Griffin, he wanted to recall the *authenticity* of the 'Golden era', and re-imbue the form with the emotive and spiritual qualities intrinsic to the form when operating with a progressive integrity even in its most conservative of applications.

Bluth recognised that the studio would also have to establish itself with adult audiences, and made an altogether darker piece in *All Dogs Go to Heaven* (1990), an uneven hybrid of the musical adventure, gangster film and 'second-chance-on-Earth' fantasy. Charlie, a canine convict voiced by Burt Reynolds, breaks out of jail and seeks to resume his illegal gambling and rat-racing business venture with former partner Carface, voiced by Vic Tayback. Carface, however, kills Charlie, who ascends to heaven only to be given an opportunity of coming back to earth to redeem his mortal sins. He exposes Carface's rat-race fixing scam; protects those abused by him; endures nightmares of a descent into

hell (a tour-de-force of design) and, finally, fights Carface in a brutal climax. Critic Nick Digilio allied the directness and spirit of the film with the work of Ralph Bakshi, praising the ways in which mature themes were handled,[6] although this is in many ways an expression of a lack of a radical spirit which merely leaves Bluth's work as progressive by default, since while urbane and mature in its themes, it is not allied to social critique nor to elevating satire, both of which may be accorded to Bakshi's work. *Rock-A-Doodle* (1992), a rollicking musical, followed, but only consolidated the view that Bluth was a brilliant technician who could not aspire to such auteurial credentials. Ironically, having arguably provoked Disney's necessary improvement, Bluth's work became a victim in comparison to it. *A Troll in Central Park* (1994), about a non-conformist troll named Stanley, was a pleasant but ultimately unsatisfying diversion; while *Thumbelina* (1994), his adaptation of the Hans Christian Andersen story, pales in comparison to the intrinsic 'modernity' of Disney's *Aladdin* (1992), for example, by not fully exploiting the potential of CGI or embracing Warneresque 'knowingness' in its narrative style. While echoing Disney's newfound 'musical theatre' approach, *The Pebble and the Penguin* (1996), like *Thumbelina* using songs by Barry Manilow, also suffers, ironically, from the same kind of anonymity imitating the same unimaginative and clichéd 'Disney' of the 1970s of which Bluth had been so critical. The striving for the signature 'timelessness' of the Disney stories was resulting in a lack of contextual depth to facilitate more emotionally complex stories.

Bluth tried to remedy this by re-engaging the adult audience in creating a 'human' story which sought to compete with Disney's more mature levels of engagement, attempting to once again find 'authenticity' in using a historical source. *Anastasia* (1998), however, suffers from seeking to erase the political dimensions of its best-known historically grounded events. The Russian Revolution, for example, is provoked by the sorceror Rasputin, rather than by the rise of a disempowered proletariat, and is rendered absent in preference to the 'rags-to-riches' destiny narrative of the foundling, Anastasia, who ultimately attains her royal ascendence to the Romanov dynasty after years of amnesia and absence. She also ultimately finds her fullest contentment in the pursuit of romance, with the ever loyal (if contradictory and manipulative) Dimiti. It is clear that what had emerged in American animation was a singularity of purpose, not merely in Bluth's work, but in Disney feature animation, to preserve a highly sentimentalised and glibly romantic

account of human endeavour even in spite of the sometimes horrific and contradictory aspects of its narrative sources. The assassination of Tsar Nicholas and his family in 1918, which included a multiple stabbing of Anastasia and which was concluded by 'burial' in a mineshaft where sulphuric acid was poured over the faces of the family to prevent identification, self-evidently has no place in this schemata, and provides clear evidence for left-wing or radical critics who seek to expose the high degree of insensitivity in the depiction of other histories and cultures within such vehicles. The aesthetic high point of the film – Paris depicted through picturesque reference of its most renowned artists – merely reinforces the absence of ideological and political engagement, while maintaining the fissure between the narrative and the text identified as a clear currency of this kind of animation in Chapter Four. The film also spawned a sequel for one of its cute comic sidekicks, Bartok the bat, in *Bartok the Magnificent* (1999), and located the form back in its most 'tradition-directed' form, subject only to the view that animation was consigning itself to becoming a mainstream commercial entertainment no longer affiliated to its art, or the possibilities of its intrinsic vocabulary.

It is perhaps fortunate, then, that an act of fate placed three individuals in the same class at the California Institute of the Arts, who would ensure that the field of animation would progress on the terms and conditions which reconciled the codes and conventions of the 'classical' era and the determinants of synaesthetic cinema. John Lasseter would emerge as a key figure in the development of computer-generated animation; Henry Selick would insist upon the maintenance of stop-motion animation as a feature aesthetic in its own right and John Musker, later working with his partner Ron Clements would finally modernise the Disney aesthetic. Ron Clements and John Musker have become the most distinctive and successful working partnership in the new era of Disney animation. Their work on *Basil: the Great Mouse Detective* (1986), *The Little Mermaid* (1989), *Aladdin* (1992) and *Hercules* (1997) has been prominent in raising the quality of the animation at the Disney Studios after an acknowledged lull, in a spirit of echoing the 'Golden era' of the Disney Classics. More importantly, they are arguably responsible for re-inventing the Disney ethos for modern audiences.

Ron Clements immersed himself in cinema from an early age, making a short animated film called 'Shades of Sherlock Holmes' as a child, a story which he would re-visit later in his work on *Basil: The Great Mouse Detective*. He worked part-time at a local television station and produced

commercials for nearby businesses before taking a course in Life Drawing at the Art Centre in California. After working for a short time at Hanna Barbera, he undertook the Animation Training Development Programme at the Disney Studio, under the guidance of Frank Thomas, where he met John Musker. Clements worked his way through a range of production roles and is credited on *Winnie the Pooh and Tigger, Too* (1974), *The Rescuers* (1977), *Pete's Dragon* (1977), *The Fox and the Hound* (1981) and *The Black Cauldron* (1981). John Musker attended the Loyola Academy in Wilmette, Illinois, where he was a cartoonist for the Academy newspaper, honing his skills in caricature and demonstrating the significant influence of the artists at *Mad* magazine. He then went to Northwestern University in Evanston, majoring in English, and continued cartooning for the *Daily Northwestern* newspaper. He was rejected for direct entry at the Disney Studios in 1974, but won a partial scholarship to the California Institute of the Arts, in classes tutored by renowned experimental animator Jules Engel. In 1977, he finally joined Disney on the same Animation Training Development Programme as Clements, and after working under Don Bluth on *The Small One* (1978), he began work with Clements on storyboards for an adaptation of Eve Titus' book *Basil of Baker Street*, which was eventually given the go-ahead for production in 1984. Michael Eisner identified some issues early in the production of the film, which he perceived as endemic to the time:

> Much as I admired what I was shown, the movie still lacked a well-told story, with a beginning, a middle and an end. This was the area that Walt had handled almost single-handedly for thirty years. After he died, no one filled the void, and story had lost its priority in Disney's animated films.[7]

Eisner's insistence upon the development of a 'script', following the traditional live-action model, challenged some of the studio's long-established practices, and had the consequence of changing the design and sequence-led process of work into one which had to more formally acknowledge the structural aspects of screenwriting. Almost as a consequence, Disney's contemporary films have embraced more traditional plot structures – i.e. the 'rites of passage' maturation story cited earlier – and generic tendencies, which half-relate to the established conventions of traditional animation but, equally, half-relate to genre vehicles drawn from the live-action context.

Clements and Musker, both influenced by the aesthetic coherence of

Pinocchio (1940), sought in all their films to establish an overall design strategy which properly embraced the underpinning thematic and narrative clarity of the text, its approach to comic events – significantly different, for example, in *Basil* and *Aladdin*, and in relation to performance tropes. Clements has argued that 'the greatest challenge in animation is to create the relationship of characters through a picture that the audience believes in. To them these characters exist – they're real. It's tough enough to create one character that lives, but to get two or more interrelating – that is the impossible dream'.[8] This has been one of the significant achievements of the Clements–Musker partnership as the seamless interaction between design and dialogue has considerably facilitated the enhancement of performance and character-interaction, particularly in father/daughter; hero/villain; hero/heroine exchanges, and tour-de-force comic and confrontation sequences in *Aladdin* and *Hercules*. Perhaps most significant here, though, is Musker's less sentimental, more 'cartoonal' sensibility, which has influenced the stretching of the form beyond the standard Disney 'hyper-realism' in these texts, and has introduced a much stronger strand of self-reflexive irony to the work, an irony that also supports a view that, however relatively, a more 'inner-directed' sensibility is informing the process. Musker suggests, for example, that Princess Jasmine is a character that is

> rebelling against the social structure in choosing to marry someone of her own freewill, and rightfully so. We're with her on that one. She should follow her heart and not have her life dictated to her in any way by anyone above her or in authority over her. It should be her choice who she marries.[9]

While this may contravene the customs and culture of the ethnic characters Musker and Clements are actually dealing with, it nevertheless supports a notion of a more emphatic 'Americanism' in the text, which strives to support a more democratic openness and democratic interventionism. Inevitably, *Aladdin* provoked extensive criticism from the Muslim community, objecting to the representation of the Arab world, and the Disney studio were forced to change the lyrics of the opening song, 'Arabian Nights', and actively 'defend' their film in the light of the potential loss of a major market.[10] The film was seen as a thinly veiled parable about the Gulf War where 'Al', the Tom Cruise-lookalike and all-American guy, and his sideshow Genie, a compendium of American cultural iconography from Cab Calloway to Arnold Schwarzeneggar,

defeat the expansionist control freak, Jafar, a villain clearly in the mould of Saddam Hussein. Interestingly, though, rumours abound that Jafar was partly designed to look like Nancy Reagan, and ambiguity is further compounded by Jafar's use of two George Bush phrases, 'there's a new order now' and 'read my lips'. This sense of playfulness is enhanced, too, by Clements and Musker as they caricatured themselves, and former Disney executive, Jeffrey Katzenberg into the 'Prince Ali' number. Cultural, aesthetic and political contradictions abound in *Aladdin*, and make it Disney's most contentious, thought-provoking and entertaining film since the 'Golden era'. It is pertinent to suggest that in mobilising its cultural resources in creating textual over-determinacy and a model of 'incoherence', *Aladdin* embraces only the already naturalised conditions of its status as a story within the American context. Its 'text' is about America, and not the cultures it represents. In some senses it works with the same degree of appropriation that the avant-garde American artists used in embracing and re-defining Eastern philosophies and aesthetics within the countercultural thinking of the 1960s and 1970s. For Musker and Clements, the cultural appropriation is in the service of radicalising 'Disney', however, and in the general commitment to an overarching theme.

Clements and Musker argue that their chief interests were in creating a story that resisted the 'greed is good' ethos, then dominant in the United States, promoting instead a return to inner values, independent thought (especially embodied in the character of Jasmine) and the symbolic quest for personal fulfilment in the face of the cultural entrapments that could inhibit such growth.[11] Musker's 'cartoonier' sensibility also preferred a return to the style of animation of classic era artists, Fred Moore and Bill Tytla, and an overall design strategy that embraced the curvature and basic poses of Al Hirschfield caricatures, an ever-present feature of the *New York Times* for many years. The design strategy was also informed by the work of Rasoul Azadini, who returned to his native Ispahan in Iran before the Gulf War and took 1800 photographs of authentic Islamic architecture and interiors. The study of AD 100–1500 Persian miniatures, Arabic calligraphy, Erté costume design and previous cinematic and cartoonal representations of the Middle East also underpinned the approach to design, thus giving the text a pronounced bricolage that resists coherent address but facilitates comic incongruity.[12] It is clear, then, that a particular kind of 'inner-directed' transposition has taken place which, while resisting the 'tradition-directed' model from

which it comes, *does not* embrace the 'other-directed' sensibility that would fully respect the integrity of its sources, and aspires to create 'difference' in a more radically social way by *replacing* one set of socio-cultural practices with another. Musker and Clements do not wish to use the 'real politic' of Muslim cultures in their film to critique American political mores; they merely wish to use the aesthetic and cultural codings to 'modernise' Disney, with the consequence that there seems to be a high degree of cultural insensitivity at the level of representation. The very 'abstraction' of the form does not justify this, but merely explains the model of investment which seeks to prioritise the re-enunciation of the Disney aesthetic and create a more open 'text' which, ironically, invites this criticism by virtue of its self-consciousness.

This sense of 'progress' in the Disney text from within the Studio has not been seen as a step forward in some contexts.' *The Little Mermaid*, for example, may be viewed as an unflattering account of one girl's deep-rooted selfishness; a long way from the intention of the directors to tell a story about the necessity for parents to love and protect their children, but to let their children go and let them make their own mistakes. Deconstructionist critics Bynne and McQuillan found a metaphor for the fall of the Berlin Wall, and post-Cold War anxiety, played out in the relationship between the human and undersea worlds, and had concerns too, about the preoccupation with consumer durables and material culture in the whole gamut of post-1989 texts, noting that

> the magic kingdom which lies beyond the 'untranscendable horizon' of the mer world (or Belle's 'provincial life', Princess Jasmine's palace, Simba's troubles, Pochahontas' village, Quasimodo's bell-tower, Hercules' farm, and Mulan's chores) is, unsurprisingly, Disney itself – a place which matches personal freedom with consumerist bounty and the pursuit of happiness.[13]

More than this, the magic kingdom is a still a utopian version of America itself, and one which is bound up with a set of mythic democratic principles rather than those grounded in the specificity of political life. This extends to embracing an over-determined view of the United States as a profoundly inclusive nation, which nevertheless struggles with profound issues of social inequality. It is the 'democracy' of hope and nostalgic longing; not the democracy of the ballot box, and representa-tional equanimity. Arguably, the desire to create an 'American myth' in the industrial mode only heightens the problematic space between the

necessarily 'generalist' themes and intentions that drive the industrial process which produces the Disney narrative, and the 'specific' outcomes which are the substance of the texts addressed by critics. As I have suggested, this also explains why the mass audience essentially accept and enjoy the sameness of the 'brand' and the utopian view of a WASP America it offers, while cultural critics fiercely challenge the representational agenda. For the directors, the concerns are artistic and thematic; for the studio, the preoccupations are commercial; for most audiences, the needs are for pleasure and entertainment; and for the critics, the desire is for cultural enlightenment and progress. These agendas are sometimes, seemingly incompatible, especially as the animated form in itself is complicit with openness and de-regulation.

These issues are not confined to the Disney canon. Dreamworks SKG's *Prince of Egypt* (1998) also became subject to a complex model of criticism. Simon Wells and his co-directors, Brenda Chapman and Steve Hickner, though once more reacting to the newly established 'musical theatre' animation created by Disney as the defining model of feature animation in the 1990s, made a full commitment to the adult-orientation of the material by resisting the conventions of animal characters, ironic gags and songs of romantic yearning. The film does not retreat from the pivotal narrative moment when Moses kills the guard who is marshalling the brutalities of Hebrew slavery. Portraying this, in itself, is crucial in setting a tone for the film, which ultimately embraces murder, plague and exodus. This creative decision, along with the contrivance that Moses, voiced by Val Kilmer, and Rameses, voiced by Ralph Fiennes, play out a sibling rivalry than may be read as a tension between Jewish and Egyptian imperatives are, however, at the heart of the criticism levelled at the film. Jeffrey Katzenberg, the executive producer of the film, in light of the debates that previously surrounded *Aladdin* (1992), anticipated potential difficulties, and consulted the Reverend Jesse Jackson; preacher, Billy Graham; Rabbi Marvin Hier of the Simon Wiesenthal Centre and Michel Shehadeh of the Anti-American Anti-Discrimination Centre, the latter of whom pronounced the film as 'a human rights film against repression'. Katzenberg also showed the film to seventy-five cardinals at the Vatican and gained the approval of the Jewish intellectual magazine *Tikkun*, when Rabbi Michael Lerner pronounced the film as 'an outstanding contribution to the task of reintroducing Torah to the world'. All to no avail, alas, as leading Egyptian journalists like Adel Hammouda of the *al Ahram* accused Dreamworks SKG of making a Jewish revisionist

history of ancient Egypt by implying Moses ruled Egypt, was the archi-
tect of its civilisation and that the people were punished after the Jewish
exodus, in essence, because they were left with no value or worth.
Egyptian film-director Hani Lashin also called it 'poison-laced chocolate'
– 'It is very nice and we are hungry, but we must tell the people not to eat
it', implying that the film was technically brilliant but sent an inappropri-
ate and, indeed, potentially unacceptable message to its most inevitably
sensitive audience. On this basis, Malaysia and the Maldives also banned
the film as offensive to Muslims.[13]

Hercules, however, may be viewed as a response to the concerns of
cultural critics, in more overtly grounding the story-telling mode in
American mores, and the 'openness' and transmutability of myth. Michael
Grant has suggested that

> twentieth-century writers, from tragic theatre to comic strip, have con-
> tinued to employ the archetypes with renewed vigour ... The atmos-
> phere to which they translate us is life enhancing; for it gives us fresh
> strength by providing a route of escape ... Yet this is not the escapism
> of any ordinary kind ... these myths generate and throw off potent,
> almost violent, flashes of inextinguishable, universal truths.[14]

Further, Robert Graves notes,

> True myth may be defined as the reduction to narrative shorthand of
> ritual mime performed on public festivals, and in many cases recorded
> pictorially on temple walls, vases, seals, bowls, mirrors, chests, shields,
> tapestries and the like', and which must be distinguished from forms
> like 'philosophical allegory', 'sentimental fable', 'political propaganda',
> 'heroic saga' and 'realistic fiction' or 'satire'.[15]

In many senses, the latter formulation is an enabling description of a
method which directly echoes the animation process in privileging the
pictorial, iconographic recording of socially grounded rituals of presence
and celebration, which is directly taken up in *Hercules* when characters
are literally rendered and liberated from their status as images on vases
and so on. Once more, Clements and Musker prioritise a coherent design
strategy but move away from the reinforcement of the Disney tradition
of 'cute' by adding to the iconographic vocabulary drawn from Greek
models, by adopting the freer, harsher and more fluid styling of English
satirist and caricaturist Gerald Scarfe. Further, they enhance the more

ironic and self-reflexive elements of the text – thus moving away from 'true myth' – to comment upon the representational and commercial agendas, so often the currency of Disney criticism, within the narrative itself. The mode of 'escapism' offered in *Hercules* is one which offers a revelation about the creators of the text, and the recognition that those creative personnel are aware of the social and critical context within which they work. The central character of Hercules is simultaneously an example of 'masculinity in crisis' – and a marketable 'action figure'; the Greek myths are hollowed out to make way for 'high-school' narratives but are maintained as archetypes of human challenge and moral myth-making; Scarfe's design legitimises a crueller, more sceptical sensibility to sit alongside, and caution sentimentality and romantic endeavour. There is a recognition that America is a nation debilitated by the realities of its past but the necessary commitment to the ethos of its previous endeavours as the substantive requirement for progress. This contradiction sits right at the heart of contemporary animated narratives which address the American hero. Byrne and McQuillan ally Hercules, for example, to figures like Luke Skywalker and Superman, but also to President Clinton himself; Hercules' odyssey of self-discovery is a 'campaign trail', featuring the threat of sexually aggressive women, the assimilation of black-racial determinacy and the reconciliation of political process, finally offering 'hope' about the maintenance of 'democratic' principles in a de-stabilised, mass-mediated political context.[17] Even if this metaphor remains unpersuasive, it is clear that Hercules becomes a hero by mythic default; a set of happy accidents and good intentions, arguably, 'downsizing' the mythic import of the text to accommodate a view of everyday success or failure, and the good humour with which it must be endured given that a lack of security about the past and a de-stabilised and possibly dysfunctional sense of the present leaves 'the hero' in American art and culture at a social impasse. This partly echoes the strategies of *Toy Story* (1995) (see Chapter Six) and, later, *Small Soldiers* (1998).

Joe Dante, a champion of stop-motion animation, though ostensibly a live-action director, embraces this ambivalent view of American heroism through his re-working of 'exploitation' and 'trash' aesthetics as a vehicle by which to engage with a more localised and less mythic view of urban, consumerist America. Dante has constantly critiqued the hypocrisies of 'Reaganite' small-town American populism, but most notably in this context in his segment in the Spielberg-produced *Twilight Zone:The*

Movie (1983), 'It's a Good Life'. This highlighted Dante's recognition of the absurdist ambivalence of the cartoon sensibility and his gift for choreographing the surreal brutalities of cartoon violence. An implied critique of 'Uncle Walt' and the sentimentality of the Disney canon, this pre-figures Dante's work in *Gremlins* (1984) and *Gremlins 2: The New Batch* (1990), which turns Disneyesque 'sweetness' and WASP suburban security into a nightmare of technological failure, while also satirising the complicity of the media and the complacency of consumerist expectation and indifference. This combination of the 'cartoonal' avant garde and social satire reaches its culmination in Dante's work on the part-animated *Small Soldiers* (1998), an anti-*Toy Story* vehicle, which shows the brutality of gung-ho action figures as they take on their sworn enemies, the essentially peace-loving and fun-seeking Gorgonites, and along the way trash the middle-American liberal ethos as outmoded and naive. In some senses, Dante critiques both the 'tradition-directed' right-wing sensibilities of the 'Disney' ethos and the limitations of the quasi-spiritual agenda of the 'inner-directed', demonstrating that the orchestration of power relations in American culture are contextual and not mythic. Dante plays out an ambivalence in the appeal of the far-right agenda through the figures of Chip Hazard (voiced by Tommy Lee Jones) and his Commando Elite (voiced by the surviving actors from *The Dirty Dozen*). Dante condemns the violence of the US military as self-evidently 'wrong' and lampoons the heroic glorification of soldiery in war movies, but the wit, ingenuity and selfless commitment of the soldiers remains exciting and persuasive, set against its opposition. Dante's witty parodies of, among many, *Patten* (1970) – 'Think not of what your country can do for you, but be sad that you only have one life to give' – and *Apocalypse Now* (1989) – 'I love the smell of polyurethane in the morning' – merely enhance the credentials of the 'right' in the face of the ineptitudes and nostalgia of the 'centre'. The very parameters of 'action' define heroic achievement, but here such action, played out literally through nuclear-enhanced action-figure toys, substantially undermines the mythic purchase of their status. This is not the American military of the World War Two movie or the 'Vietnam' sub-genre; it is a sanitised version of the myth, made laughable by the incongruity of the size of the soldiers and the limits of their achievement set against their bravura desires to achieve. Though Dante critiques Globotech's corporate abuse of merchandising opportunities and communications technologies – 'you put munitions chips in toys!?!?' – this, ultimately, only

highlights generational anxiety in the light of late capitalism. The baby-boomer generation is both disempowered at the socio-economic level and, more importantly, out of touch with the context in which their children live – a context informed by a vast ideological and ethical vacuum which the less scrupulous are eager to exploit. Though the small soldiers are ultimately defeated by the enterprising youngster Alan, his girlfriend Christie, and a combination of geeks and suburban bumblers, Globotech, the makers of the Commando Elite toys, merely pay off the inconvenienced at the end of the film, and still perceive a use for the toys in rebel guerilla warfare elsewhere. Though the surviving Gorgonites sail off in pursuit of their mythical home, Dante does not let sentiment interfere with the radicalism that comes from the recognition that the ruling power élites maintain their power through sustaining ideological continuity even in spite of the changing aspects of the social and economic context. Disney as a company is but one example of this. At another level, Dante suggests that the consumerist agenda of late capitalism *only* represents the 'tradition-directed' and seeks to oppress the 'inner-directed' or 'other-directed' models of existence.

As I have suggested throughout my discussion, however, the survival of the 'inner-directed' and 'other-directed' has been predicated on animated aesthetics imbued with a 'modernity' that at once recalls its sources and their meanings, and simultaneously revises and enhances new terrains of expression and representational possibility. In this sense, Henry Selick is an important and distinctive figure in contemporary film, championing and perpetuating the art of stop-motion animation in the feature-length form. Resisting traditional cel animation and the predominant aesthetic of the high-gloss dynamics of computer-generated imagery, Selick's work represents enhancement and continuity in a field stretching back as far as the pioneering 'trick' films of J. Stuart Blackton and Albert E. Smith at the turn of the nineteenth century; Ladeslaw Starewich's experiments with insect and animal characters; Willis O'Brien's ground-breaking work in *Creation* (1929) and *King Kong* (1933);[18] George Pal's famous 'Puppetoons'; Ray Harryhausen's celebrated special effects in 1950s 'B' movies like *The Beast from 20,000 Fathoms* (1952) and fantasy epics like *Jason and the Argonauts* (1963), with its noted 'skeleton' fight sequence;[19] and in the subsequent work of Art Clokey, Will Vinton and Nick Park. Arguably, Selick has created the context in which a film like *Chicken Run* (2000) could be made, privileging model animation as a bearer of a satisfying aesthetic distinctiveness,

and re-kindling the relationship between puppets, automata and human beings, drawing upon the ambiguity of three-dimensional 'artificial' forms existing within the paradigmatic space that constitutes a 'live-action' context.

Selick's collaboration with Tim Burton, *Nightmare Before Christmas* (1992), which in featuring Jack Skellington, a skeletal hero, references Harryhausen's work, effectively re-established stop-motion animation as a 'low-tech' approach to film-making practice, promoting the use of the technique to carry the complete narrative of a film, rather than merely using it in effects sequences. The distinctive style and movement which characterise stop-motion animation and which some believed were becoming obsolete, added to the sense of surreal beauty and super-natural eccentricity at the heart of the film. Burton's original poem, designs and ideas underpin the story, but it is the under-acknowledged Selick's direction and aesthetic sense which inform the expressionist ambiguities of the final piece. Drawing upon influences as diverse as Fred Astaire, Francis Bacon, Dr Seuss, Edward Gorey, Mario Bava and F. W. Murnau, Selick conjures an elegance and sophistication in the work that has the hallucinatory spirit of dream and the heightened and sometimes perverse energy of celebration. Its almost Brechtian operatic quality foregrounds tour-de-force sequences of black humour – Jack's Christmas delivery of a severed head and Sally's seduction of Dr Finkle-stein by separating her stitched-together body parts – that far outweigh any nominal redemption in Disneyesque sentimentality. This is an 'inner-directed' and 'other-directed' sensibility privileging the gothic and surreal as a fissure to insert challenging European art sources in the re-definition both of the 'consumerist' Christmas, but a form of 'Disney' animation which was synonymous with it.

Selick, an Art major at Syracuse University, also trained at the St. Martin's School of Art in London and was a graduate of the California Institute of the Arts. Joining Disney, he worked on *The Fox and the Hound* (1981) title characters; created alien creatures for *Watcher in the Woods* (1981) and made an influential pilot film called *Slow Bob in the Lower Dimensions* (1990), a collage work featuring dancing scissors. Other significant work includes his 'as filmed' storyboards for the clay-mation sequences of Walter Murch's *Return to Oz* (1985) and challenging MTV inserts. He also made his own short film, *Seepage* (1979), using life-size stop-motion figures, which is executed in a 'modernist' style, recalling cubism and expressionism and which reveals the influence of

Lotte Reiniger's silhouette cut-out animation and the fantastical incon-
gruities of the Fleischer Bros. black-and-white 'Betty Boop' cartoons.
Selick constantly stresses the need for animation to enunciate itself in a
way that once more recalls self-figuration; as he suggests,

> I'd rather go back to a more crude approach, and show wires, and
> show rods, and almost get back to the bunraku puppetry of Japan.
> Because I really feel that once the human hand is too far removed, and
> it is too easily done, then anyone can do it. Anyone can buy a program
> to morph, and look at how its value has plummeted. It was like the
> Holy Grail of animation, for years and years. And in just a couple of
> years, it's in every car commercial. It has no impact.[20]

This return to a more individual, artisanal approach recognises the
aesthetic tendencies in animation as their intrinsic language of expression
and meaning. In returning to the process of drawing attention to the
auteurial investment in metamorphosis, Selick successfully reclaims the
process by which the characters and their effects are specific and pur-
posive. This in itself re-aligns the aesthetic with the freedoms of dance
and music as the catalyst for the progress of the narrative and the
enrichment of the text. The process insists upon a resistance to the deter-
minants of the traditional screenplay preferred by Eisner as the under-
pinning structure of an animated story, and privileges the 'anti-cartoon'
sensibility championed by Griffin.

Selick's most significant achievement is *James and the Giant Peach*
(1995), which combines stop-motion animation with computer-generated
material; hand-painted backgrounds and effects and 'bookends' of live-
action performance. Sensitively re-writing Roald Dahl's popular story
and using children's illustrator Lane Smith's Paul Klee-influenced
design, Selick sought to use the extended animated sequence in the
middle of the film, contextualised by live-action, to achieve an Oz-like
transition into a colourful and exciting fantasy world. In many senses,
Selick wanted to move away from what he ultimately felt was the over-
orchestrated aspects of *Nightmare Before Christmas* (1992) to more fully
authenticate the material environment of stop-motion animation and to
create a coherent fictional world based on the specific theatrical
limitations of the set, i.e. the peach. Selick notes

> For much of the film, we were travelling on top of the peach and there
> is a limited space for staging. And at the same time, there are a lot

more lead characters who are interacting much more of the time. All these characters except for James have extra limbs. We didn't want our bugs to be like Jiminy Cricket, who they made into a little man without insect appendages.[21]

This sense of 'property' and 'blocking' in the mise-en-scène suits the theatricality of the main insect characters as they perform on the literally limited 'stage' of the peach; the extraordinariness of the multi-limbed figures engaged in multiple character interaction is an exemplary example of the distinctive aesthetic achievable with this technique. Selick's tour-de-force underwater sequence featuring a cameo by Jack Skellington is another direct homage to Harryhausen's skeleton fight and also to the 'marionette' sequence, and Albert Hurter and Gustaf Tenggren's design work in Disney's *Pinocchio* (1940). Crucially, Selick is constantly attempting to create a visual context which suggests more than its literal form, engaging with the idea that the iconography may once more recall the notion of a dream-state or a stream of consciousness populated by unusual creatures and based in imagined environments. Like *Nightmare*, the film insinuates that this may be viewed not merely as the outcome of the 'inner-directed' but as a picture of the 'inner-directed' itself, characterised by a tension between the satisfactions of creativity and problem-solving; pragmatism and pleasure and the deep-rooted anxieties and fears that prompt our very continuum towards resolution and redemption.

Selick's *Monkey Bone* (2000) progresses this work further, stretching the boundaries of the psychological, emotional, geographical and supernatural environments the freedoms of his technique can embrace. Based on the Canadian comic book written by Kaja Blackley and illustrated by Vanessa Chong, the story, scripted by Sam Hamm, concerns a man trapped in a coma, given twelve hours to find a way out of the labyrinth of his own dreams and nightmares before he eventually dies. In wanting to resist categories and promote 'difference', Selick's achievement and influence should not be undervalued as they represent both a continuity in the form and the maintenance of a predominantly European aesthetic tradition, and, consequently, demonstrable 'art', in feature-length Hollywood 'products'. While it has often been the case that American artists have sought to refresh their own canvasses through the re-working and re-positioning of European art sources, some of the most important work in challenging both the centrality of the Disney aesthetic and in re-defining a view of America itself has resided with iconoclasts

who use and exaggerate the principles of popular idioms in order to expose the conservative agenda which informs the 'private', and arguably repressed cultures, of American life.

Bill Plympton and his self-styled 'Plymptoons' have earned a significant place in the American cartoonal tradition, both for their deadpan auteurist signature style, and their means of production. His short works for MTV established his place as a cult figure, renowned for his surreal address of human obsessions and the grotesque but playful brutalism in his representation of the body. Describing his own work as 'like an animated David Lynch',[22] Plympton combines the physical excesses of Tex Avery cartoons; the Daliesque incongruities of form; the sense of absence and presence in the work of René Magritte; the 'trip' sensibility of Robert Crumb and the independent off-centre preoccupations of Jim Jarmusch. His place as a bona fide *auteur* is secure in the sense that he writes, produces, directs and animates all his own work. After leaving Portland State University, Plympton joined the National Guard in 1967 to avoid the draft to Vietnam. His five years in the National Guard were followed by a move to New York and a year's study at the School of Visual Arts. Plympton became a graphic designer, illustrator and cartoonist, creating material for publications as diverse as *Vogue*, *Penthouse* and the *New York Times*. His move to New York in 1968 proved particularly important in the sense that the incongruities and brutalities of urban politics, the emergence of the counter culture and the surreality seemingly imbued in everyday life were to be highly influential on his style and outlook. In 1975 he created a political cartoon strip entitled 'Plympton' for *The Soho Weekly News* which was syndicated by Universal to more than twenty newspapers nationwide. Plympton's later, self-taught animation reflects this experience, as he simply removes the logic of the assumptions and consensual habits which are the stabilising elements of contemporary life and replaces them with an alternative set of perspectives and alternatives which collapse existence into a chaotic and arbitrary state of mind. The human form is particularly vulnerable in the Plympton universe; the body a site for sadistic and surreal re-definition. Figures inhale each other; are decapitated; crushed; electrocuted, exploded and imploded; all in the spirit of extending the traditions of artifice in cartoon violence and foregrounding the vulnerability of the human body as it seeks to transcend its own boundaries. Arguably, there is a great deal of male anxiety about the female form in Plympton's work, but whether configuring breasts as

malleable balloon animals or wall-smashing globes serves as a site to evidence this, or merely serves as the fervent associative invention of an uninhibited comic mind, is open to question.

It is Plympton's prolific draughtmanship, though, that impresses yet more, crea.ing the significant milestone of *The Tune* (1992), a ninety-minute feature animated by one person, in which Del, his leading character, is given forty-seven minutes to find a hit for his boss, Mr Mega. Funded partly by selling segments of the final film as individual shorts to MTV and partly by commercial work on the *Trivial Pursuit* and *Sugar Delight* campaigns, the film was made on a comparatively minimal budget. His technique – loosely drawn animated sequences on paper, transferred to cel and re-coloured and detailed – makes for a spontaneous, active mise-en-scène, even when seemingly at its most static and barren. His craving for creative freedom and independence, following in the footsteps of mentor, George Griffin, has also led to him becoming his own distributor and heightening his profile through putting his material on a web-site. Despite a long career in the graphic arts, Plympton did not make his first animation until 1977 with a cut-out film, *Lucas the Ear of Corn* (1977) and a second cartoon, until he collaborated on *Boomtown* (1985), a visualisation of a Jules Feiffer song sung by the Android sisters, implicitly critiquing American foreign policy and defence spending. *Your Face* (1987), his first 'signature' film, a musical short featuring a slowed-down vocal performance from country singer Maureen McElheron and animation of an ever-contorting face, won an Oscar nomination. Interestingly, in 1990, Plympton was sought by Disney to animate the fast metamamorphoses of the genie in their projected feature *Aladdin*, but Plympton declined on the basis that he could continue to work independently, having established an international reputation with *One of Those Days* (1988), a viewer's point-of-view compendium of accidents; *How to Kiss* (1989), a bizarre guide to kissing; *25 Ways to Quit Smoking* (1989), an inventive inventory of smoking cures; *Plymptoons* (1989), animated versions of his most notable print cartoons; *Dig my Do* (1990), featuring an animated Elvis dog and *The Wiseman* (1990). *Push Comes to Shove* (1991) plays out a slowhand Laurel-and-Hardyesque escalation of petty yet excessive brutality, while *Nosehair* (1994) engages in the epic struggle between one man and a hair dangling from his nostril, essentially an animated *tour de force* in what can be achieved with a single line.

Plympton's second feature, *I Married a Strange Person* (1997), includes only one previous short, *How to Make Love to a Woman*, but readily echoes the 'B' movie, *I Married a Monster From Outer Space* (1958) in its device of a husband, Grant Boyer, being changed by radiation emitted from a satellite dish, which enables him to make his sexual and violent fantasies 'real'. More to the point, this enables Plympton to make these 'realities' yet more excessive and comically implausible. Opening the film by citing Picasso's idea that 'taste is the enemy of creativity', and supporting it, provocatively, with Hermann Goering's view that 'when I hear the word culture, I reach for my pistol', Plympton then proceeds through a catalogue of surreal riffs – bird orgasm; amoeba wrestling; dialogues between tongue and teeth; a comedian who tears himself up and throws himself to the audience; the formation of navel 'fluff'; aggressive nipples – it is all here; the body endlessly at war with itself, other people, the media – 'the Smile Corps' – institutionalism and the environment. The film's set-piece sexual preoccupations are also echoed in *Sex and Violence* (1997) and *More Sex and Violence* (1998) which effectively show the absurdity of sexual practice and the excesses of violent acts in order to parody and critique the titillatory limits of representation of sex and violence in live-action cinema. Interestingly, the imagery embraces an erotica of its own in illustrating quasi-pornographic behaviour or uninhibited physical expression. Plympton's essential subjects, though, are vanity and hypocrisy, revealed, for example, in his 'people with confused priorities' gags in which, for instance, a woman who has broken down in her car on a train track with an express train approaching, stops to pluck an eyelash, or a man falling from the sky in a parachute that will not open prioritising tying his shoelaces, or, again, a man in the midst of frenzied sex stopping to floss when he feels a piece of cabbage stuck in his teeth. Icons like Elvis are also parodied; Elvis eats and eats, even consuming cars and skyscrapers, then goes to the toilet, ready for an MC to announce 'ladies and Gentleman, the building has left Elvis'. Blow-up dolls are used as car air-bags prompting deliberate car-crashes for sexual gratification; shoes are designed with spring-open mirrors to reveal a crotch beneath a dress; a new act at Aqualand sees a mermaid spring from the water to fellate a lifeguard on a springboard and in a dark perspective on the old proverb, 'he who laughs last, laughs longest', Plympton depicts a tittering torso, mutilated after a crash. Plympton's self-consciousness about his comic imagery is reflected in his work on 'why we laugh', which features an academic commentary on

gag structures while a man slips on a banana skin, is elevated high in the air and lands to devastating effect with all his internal organs flowing over the floor. Plympton refuses any notion of political correctness in his works, and uses the 'inner-directed' and 'other-directed' currencies of the 'cartoonal' form to question the polite and unrepresentative representations of American lifestyle, and to undermine the conservative veneer which seeks to inhibit, shape and oppress liberal outlooks and imperatives. Plympton challenges the last American taboos, and is in the forefront of a mode of work which has characterised a populist avant garde in American animation.

In 1991, Craig Decker and Mike Gribble created the 'All Sick and Twisted Festival' which continues to debut new works which extend the parameters of representation in animated forms, and, consequently, challenge the mainstream animated orthodoxy. One of the first key directors to emerge from the festival was Mike Judge, with his film *In Bred Jed's Cartoon* (1991) and, later, the first Beavis and Butthead cartoons, *Frog Baseball* (1992) and *Peace, Love and Understanding* (1993). Further, Joel S. Bacher's Blackchair Productions has promoted screenings of independent work which have included innovative animations like Laurence Arcadias' Terry Gilliam-influenced gothic tale *The Donor Party* (1996). This important personal work maintains a view that there are still 'unicorns in the garden', but the contemporary period, however, has been characterised more by the film industry's embrace of animation as a lifeblood in both film and television, and this has raised issues of its own. Harvey Deneroff writes,

> [2000–2001] was a period of transition for animated movies, as well as somewhat of a disappointment at the box office. Hollywood seemed to be moving aggressively away from the Disney style in hopes of finding something new, which usually meant computer or even stop-motion animation. Studios' efforts to explore different styles and techniques were part of the attempt to differentiate themselves in an increasingly crowded field. At the same time, the Academy of Motion Picture Arts and Sciences announced a brand-new Oscar category for Best Animated Feature Film, which could conceivably encourage the growth of a true independent sector.[22]

Once more, there is clear recognition of the need to move away from the Disney 'tradition-directed' orthodoxy – the self-evident benchmark by which to create 'difference' in the field since the 1920s – and to embrace

independent 'inner-directed' or 'other-directed' work as the expression *not* of an individual vision, but as a 'branding' agent for a studio house-style. Further, the announcement of a separate Oscar category is at one level a confirmation that animation is big business and back on the agenda, but on another, it potentially creates a ghetto in which animation may yet remain marginalised, working in the spirit of 'Hollywood' live-action cinema and not exploring and developing its distinctive creden-tials. Even here there remain complications. The initial criterion for the Oscar is that the animation should be 'more than seventy minutes in length', and, contentiously, 'primarily animated'. This complicates an already complex agenda about what an animated film actually is, and how animation will be viewed in relation to its place within the effects tradition. *The Phantom Menace* (1999) or *Stuart Little* (1999), for example, may immediately have as many claims as *Chicken Run* (2000) or *Shrek* (2001). It is clear that the 'mainstreaming' of animation will once again activate all the questions addressed in this discussion so far in the sense that at the very moment when animation seems to have achieved the recognition it deserves as an art-form, there remain concerns about how animation will announce its distinctive aesthetic vocabulary and privilege innovative visions. Arguably, animation as a form is being commercially coerced into being 'tradition-directed', yet it is clear that the very speci-ficity of animation as an art-form does not relinquish its enunciative or self-figurative potential. It is this that John Lasseter recognised in his work with computer-generated animation, but more, he recognised that if an intrinsically American art-form was to speak to its own history, its own progress and its own place within contemporary Hollywood, it would once more have to speak to the dilemmas at the heart of American culture. In *Toy Story* (1995) and its sequel, Lasster revolutionised a form, but also gave it back its voice in reconciling the seemingly antithetical and com-plex aspects of expression I have defined throughout this piece. It is with an analysis of Lasseter's work that I wish to conclude this discussion.

Notes

1. L. Maltin, *Of Mice and Magic: A History of Animated Cartoons* (New York: Plume 1987), p. 352.
2. A. Philippon, 'An Interview with George Griffin', *Animation World Magazine*, Issue 1. 12, March 1997.
3. G. Griffin, 'Cartoon, Anti-Cartoon', in D. Peary and G. Peary (eds), *The American Animated Cartoon* (New York: E. P. Dutton, 1980), pp 261–8.

4. R. Allan, *Walt Disney and Europe* (London: John Libbey, 1999), p. 205.
5. M. Eisner, *Work in Progress* (London and New York: Penguin, 1999), p. 172.
6. N. Digilio, 'All Dogs Go to Heaven', in (ed. unknown), *The Motion Picture Annual* (Evanston: Cinebooks, 1990), p. 21.
7. M. Eisner, *Work in Progress* (London and New York: Penguin, 1999), p. 173.
8. Quoted in J. Culhane, *Disney's Aladdin: The Making of an Animated Film* (New York: Hyperion, 1992), p. 28.
9. Ibid., p. 16.
10. See L. Felperin, 'The Thief of Buena Vista: Disney's *Aladdin* and Orientalism' in J. Pilling (ed.), *A Reader in Animation Studies* (London: John Libbey, 1997), pp. 137–42; E. Byrne and M. McQuillan, *Deconstructing Disney* (London and Sterling: Pluto Press, 1999), p. 73–82.
11. J. Culhane, *Disney's Aladdin: The Making of an Animated Film* (New York: Hyperion, 1992), p. 16.
12. Ibid., pp. 55–6.
13. E. Byrne and M. McQuillan, *Deconstructing Disney* (London and Sterling: Pluto Press, 1999), pp. 24–5.
14. See M. Eltahawy, 'Egyptians disown celluloid Prince', *The Guardian*, 17 April 1999.
15. M. Grant, *The Myths of the Greeks and Romans* (New York and Ontario: New American Library, 1962), p. xviii.
16. R. Graves, *The Greek Myths* (London and New York: Penguin, 1978), p. 12.
17. E. Byrne and M. McQuillan, *Deconstructing Disney* (London and Sterling: Pluto Press, 1999), pp. 152–9.
18. See O. Goldner and G. E. Turner, *The Making of King Kong* (New York: Ballantine Books, 1975).
19. See R. Harryhausen, *Film Fantasy Scrapbook* (London: Titan Books, 1989).
20. G. Solman, 'Bringing Things to Life by Hand: an Interview with Henry Selick' in J. Boorman and W. Donohue (eds), *Projections 5* (London and Boston: Faber & Faber, 1996), p. 112.
21. Quoted in *James and the Giant Peach* Promotional Production Booklet, Disney Enterprises, 1996, p. 5.
22. See M. Segall, 'Plympton's Metamorphoses', *Animation World Network*, 1996; see also plymptoons@aol.com
23. H. Deneroff, 'Line of Sight', *The Hollywood Reporter*, January 2001, p. 3.

CHAPTER 6

United States of the Art

In evaluating the contemporary period, both in relation to the ways that animation has progressed, and as a model by which the very aesthetics of the animated form have become imbued with socio-cultural meaning and currency, it is clear that John Lasseter's *Toy Story* is a significant milestone. *Toy Story* represents a major achievement in the field as being the first full-length computer-generated film, although, as I will explore later, this is perhaps one of the least significant of its credentials. Made over four years, it is composed of 1,560 shots and uses over 400 mathematically derived models and backgrounds.¹ Further, it embodies the first major pinnacle in the work of the PIXAR studio and its director, John Lasseter, who in CGI works from the early Lucas film *The Adventures of André and Wally B* (1984); the first Academy Award-nominated CGI film, *Luxo Jnr* (1986); *Tin Toy* (1988), the forerunner to *Toy Story*, and *Knick Knack* (1989) has explored the interaction between cartoonal aesthetics and the new potentialities of the computer-generated interface in a way that fully exploits the material nature of the objects which serve as characters in the films and the geometric space and synthetic gloss of the graphic environment.² Lasseter and PIXAR have defined the terrain where animators and technicians impacted upon the new resources made available through computers. PIXAR developed 'MENV', a 'Modelling Environment' program which could create 3D computer models with articulation controls for every aspect of a figure in motion, which in itself revolutionised the process of frame-by-frame animation. They also created 'RenderMan', a programme including all the information to create a 3D animated environment, and collaborated with the Disney Studio in the development of a Computer-Assisted Production System (CAPS) for executing the digital colouring of hand-drawn 2D animation. This featured in, and partially changed, the aesthetic style of Disney features from *The Rescuers Down Under* (1989) onward, but ultimately it remained important that this was in a spirit of assisting with the recovery

of the 'Classic Disney' aesthetic and production values of the 'Golden era'. If Kricfalusi, Selick, Lasseter *et al* sought to maintain the 'cartoonal' sensibility of the 1930s and 1940s, then it was Clements and Musker, and others like Glen Keane and Gary Trousdale, who were set the task in the contemporary era of retaining the homogenous hyper-realist styling of classic-era Disney, but of modifying it through the application of some aspect of post-styling, either in design or, more often, in the 'modernity' of the narrative. It must be stressed immediately, however, that this degree of 'modernity' was merely comparative, measured only against the previous conservatism of Disney's approach before 1989. Lasseter's ambition was much greater than this, though, and *Toy Story* and its sequel are the outcome of a desire to use 'a new pencil', but also address the ways in which American popular cultural artefacts have become the focus of a significant meta-commentary on American consumer values and social identity.

Toy Story began its narrative gestation as a 'tin soldier lost' story, but evolved into a 'toyroom-come-to-life' story, which has a rich tradition, both in children's literature and in animated films, a tradition which was particularly prevalent at the Warner Bros. studio in the 1930s, and which includes *A Great Big Bunch of You* (1932), *Three's A Crowd* (1933), *I Like Mountain Music* (1933), *We're In the Money* (1933) and *Beauty and the Beast* (1934). This kind of cartoon precedes the more character-centred and urban cartoons of the late 1930s, and work as cartoons innocently drawing upon a storehouse of literary and popular culture reference points which define the terms and conditions of their thematic and conceptual playfulness. Disney, too, as early as *Midnight in a Toy Shop* (1930), *Mother Goose Melodies* (1931) and *The Clock Store* (1931) embraced the genre, stressing the ambivalent pleasures and anxieties of the 'inanimate' suddenly taking on life, a core issue explored in *Toy Story* in the ways that Andy and Sid, the boy-child owners of the toys, engage with and act upon them.

The *Toy Story* films are profoundly significant within the terrain of American animation, though, because they usefully interrogate the status and impact of the cartoonal 'text'; the mode of production and technological enhancement of animated films within 'institutional' frameworks and the cultural work necessary for the 'implied audience' to understand the films as a commentary on the United States in transition, in search of a new meaning for the 'frontier'. The role of Woody, the pullstring cowboy, and Buzz, the gadget-laden electronic astronaut, the film's 'stars',

becomes pivotal to the perception of an America in the midst of socio-
cultural 'flux', coming to terms not merely with a de-mythologised and
often de-historicised past, which has prompted political scepticism, but
also with the collapse of a previously stable view of 'populist' principles.
Woody and Buzz's status as socially-integrated characters within the
critically neglected terrain of animated films and, relatedly, the condi-
tions of 'authenticity' that underpin their possible meanings and effects,
have provided a new symbolic agenda which at one and the same time
addresses the implications of late industrial capitalism while being
produced through its most advanced aesthetic, technological and com-
munications infrastructure. Their status as 'stars' becomes an instru-
mental vehicle by which to engage with this phenomenon. In many
senses, the notion of the 'star' in this context operates as a confluence for
the 'transcendence' both of the animated form as an art, and as an
acknowledgement of the prominence of synaesthetic cinema within
mainstream film-making. The 'inner-directed' and the 'other-directed'
are now playing out a formal tension with the 'tradition-directed' and
playing it out through the new technological infrastructures of contem-
porary American animation, but through the characters themselves. The
debate that I have argued as having characterised the very evolution of
the animated form in all its stages of competing 'modernity' is being
overtly expressed in *Toy Story*. Woody and Buzz as 'stars' serve to arti-
culate the discourses played out through this discussion.

Christine Gledhill suggests,

> The star challenges analysis in the way it crosses disciplinary bound-
> aries: a product of mass culture, but retaining theatrical concerns with
> acting, performance and art; an industrial marketing device, but a
> signifying element in films; a social sign, carrying cultural meanings
> and ideological values, which expresses the intimacies of individual
> personality, inviting desire and identification; an emblem of national
> celebrity, founded on body, fashion and personal style; a product of
> capitalism and the ideology of individualism, yet a site of contest by
> marginalised groups; a figure consumed for his or her personal life,
> who competes for allegiance with statesman and politicians.[3]

This useful summary merely points up the issues raised in relation to
Woody and Buzz as intrinsically artificial characters, but as characters
charged with a symbolic *langue* specifically related to their contradictory
and ambivalent status as 'people'. Though clearly a product of mass

culture, and raising issues concerning acting, performance and art, the disciplinary boundary that they cross – existing as synaesthetic animated characters rather than live-action figures – changes the nature not merely of the ways in which they act, perform and reconfigure 'art', but also how their CGI aesthetic and environment re-determines the 'realist' premise which normally underpins supposedly more persuasive or convincing analyses of social metaphor. The *Toy Story* films herald a reworking of populist myths in a domestic and recognisably social space, drawing upon the specific vocabulary of animation as a meta-narrative, which I have explored throughout my discussion, to support the speculative engagement with the cultural moment. Simply, the aesthetic possibilties afforded by CGI both recall and enhance the 'openness' of the language of animation as an interrogative tool in a quasi-realist context. While this has always been the function of animation in principle, it is given special purchase in the *Toy Story* films by its narrative preoccupation with changing definitions of 'Americana' as it is expressed through objects and memories. The modes of signification and social identity embodied in Woody and Buzz are intrinsically bound up with this aesthetic terrain and its distinctive industrial and commercial context. While carrying cultural meanings and values and provoking emotional reactions, Woody and Buzz operate in a different 'fictional' category wherein their complete 'artifice' challenges the nature of the extra-textual connotations associated with the character, and the idea of 'individualism' as an ideological, and specifically 'American', currency. Consequently, Woody and Buzz in being animated characters intrinsically interrogate the boundaries of 'star' paradigms, generic expectation and realist narratives predicated on codes and conventions which ultimately only ambivalently embrace them.

Woody and Buzz are social phenomena, images and signs within a mode of integration which is both suggestive of its sources and cognisant of its effects, as an animated film and as late capitalist industrial process. The *Toy Story* films become a vindication of the transmutation of aesthetic virtuality into socio-cultural actuality. The mode of synaesthetic cinema as 'cartoonal' or 'avant-garde' principle is being drawn into the 'virtual' project, and is consequently used as a vehicle to re-determine 'tradition-directed' models of work. 'The lunatics', as it were, 'have taken over the asylum'; the abnegation of all mental law is the very site of aesthetic and social interrogation. Ironically, central to this transition is a process of authentication which fully recognises the animated form as a

mature context which simultaneously enunciates its style, technique and approach, while promoting its credentials as a pertinent, *contemporary* story-telling vehicle. The 'animated film' as I have suggested in the previous two chapters both embodies and reflects the psychological, emotional and material conditions of contemporary American life; its very artifice is capable of embracing the ambivalence and contradiction of changing notions of 'reality'. Richard Dyer's work on 'authenticity' in relation to 'stars' usefully engages with some of the principles of this transition, and may be helpfully employed here. As Dyer suggests, 'authenticity is both a quality necessary to the star phenomenon to make it work, and also the quality that guarantees the authenticity of the other particular values the star embodies ... [It] is this effect of authenticating authenticity that gives the star charisma'.[4] Woody and Buzz claim their 'charisma' from the hybridity of their values as bona fide 'Americana' and their hyper-presence as examples of a CGI aesthetic intrinsically related to its synaesthetic forbears. This, combined with new forms of extra-textual discourse and dissemination, presents Woody and Buzz as a multiple metaphor not merely for 'animation' as the single most important aspect of contemporary film production *per se*, but as icons for an America caught between innocence and experience; expectation and fulfilment; instability and reassurance. Thomas Dumm has suggested that these issues accrue into 'an allegory about white-collar unemployment' and, ultimately, 'the constitution of identity', where 'Buzz embraces his inauthenticity as his reality principle', and all the toys must accept their 'diminished circumstance in a post-productive corporate order'.[5] Dumm also argues that *Toy Story* is a 'meditation on the authenticity of the inauthentic, told through the means of cartoon animation, a medium that announces its inauthenticity in every frame of film'.[6] While this observation has a persuasive ring, it renders animation as 'inauthentic' because it measures the form as intrinsically more artificial than live-action realism, and thus misses its key capacity to play out 'difference' and 'otherness'. Further, while Dumm is equally astute in his perception of the film as a metaphor about a necessary, inevitable and consensual capitulation to corporate ideology and social positioning, he insufficiently credits the medium and its message in offering an ironic take on 'falling with style', Woody and Buzz's in-joke about Buzz's acceptance that he cannot actually fly. Woody and Buzz embrace the vicissitudes of their political economy like anyone else, and their resistance to the apparently inevitable facilitation of corporate culture is played out further in *Toy Story 2*.

Crudely, Woody and Buzz are literally and metaphorically pheno-mena of production. The production process of an animated film and, in this case, a post-photographic, computer-generated film becomes of clear significance in addressing 'difference' and 'otherness', and the radical credentials of the synaesthetic 'post-styling' of 'reality'. For example, at the technical level, Woody and Buzz are the consequence of the elision of the physical presence of the 'actor' within the animated construction of the character. While the vocal performances of Tom Hanks (Woody) and Tim Allen (Buzz) may carry with them aural signifiers of their pre-established film and television personae, this is significantly counter-pointed by the graphic signifiers of the moving, visualised figures. I noted this anomaly earlier through the protestations of Brad Bird, who rightly insists upon recognition for the animator's presence as the intrinsic performer of the character. It is the iconographic purchase and modernity of the image which enables a transcendence in the characters' ultimate scheme of suggestion and association. Woody and Buzz 'exist' in their own right because they have been configured within a domestic America, both looking inward for spiritual comfort while looking outward to socio-commercial orthodoxy in crisis. Woody and Buzz are figures which embody traditional conceptions of the comic book 'cowboy' and 'astronaut' while re-defining both their very presence in animated forms as computer generated phenomena, and their identities as carriers of mytho-historic, cultural 'baggage'. Equally, they are the bearers of the discourse between the 'cartoonal' and 'avant-garde' parameters of the inner-directed and other-directed, proto-democratic sensibility, and the conservative orthodoxies of the 'tradition-directed' centre.

The 'actor' – here, Hanks or Allen, is usurped by the potency of the discourses played out through the iconography. The nature of the design of Woody and Buzz and the manufacture of their motion call into question their status as 'actors', in the sense that they should be viewed not merely as 'cartoonal' forms which re-define the body and its identi-ficatory principles in the same way as other animated characters, but also as figures that recall and comment upon material culture, not merely socially and experiencially, but *as it has been previously represented in animated forms*. They are representations of 'toys'; material objects which they actually become in the extra-textual 'real-world' environment. Woody and Buzz are predicated *only* through modes of artifice; they exist *as* their iconic form, but their potency transcends their non-human status. Woody and Buzz vindicate the virtual. In this sense, it may be

useful to remember veteran Warner Bros. animator Chuck Jones' anecdote about his meeting with a young Bugs Bunny fan. Introduced to the little boy as 'the man who drew Bugs Bunny', he found himself corrected as 'the man who drew pictures of Bugs Bunny'.[7] Bugs had transcended his status as a cartoon character, and in doing so, made invisible both his author and the production process that had created him. Woody and Buzz in embodying a technological 'shock of the new' simultaneously veil their authorial source and mask their technical creation, yet advance both through their more socially grounded virtual status, and its *self-evident* condition in progressing new definitions of animation as a creative medium. Their animated aesthetic – the century-long process of foregrounding the distinctive vocabulary of plasticity – has afforded them the distinctiveness of their socio-cultural role and function. It has taken an inordinate amount of time to suggest and evidence the view that animation works as a singular and distinctive vocabulary outside the parameters of live-action film-making. When acknowledged, 'animation' has largely been viewed as 'cartoonal' at its most populist, and 'avant-garde' at its most experimental; and most significantly, in the context of this discussion, a form which has time and again been absorbed into an 'effects' tradition, a pre- and post-production phenomenon made invisible within the remit of live-action cinema.

It is a useful digression to look at this area in relation to the *Toy Story* films as it only enhances their significance in relation to their place as formative cultural texts, and speaks to the achievements of the film-makers addressed in the previous chapter in sustaining the form outside this insistent context of 'invisibility'. Martin Barker sees Dreamworks SKG's *Antz* (1998), for example, as a 'special effects movie', 'one long special effect'; a film which has 'special effects within an effects film'.[8] Consequently, its whole vocabulary, intrinsically drawn from the 2D graphic and 3D stop-motion modes of animation is marginalised as the film's overwhelming signifier in preference to reading its extra-textual reference points – its self-conscious, cinematic, storytelling conventions, star-voice casting, quotation from live-action film and so on – when its currencies, as I have implicitly demonstrated throughout my discussion, lie in the history and aesthetics of the Disney, Warner Bros. and Fleischer Bros. cartoons, which manipulate graphic space, perspective, scale and representational style at will. *Antz*, like *Toy Story*, is the epitome of synaesthetic, post-styling cinema, reworking the conditions of 'animation' as the currency for its metaphoric inscription of 'reality' and social simile.

Antz is grounded in a tradition of 'insect' animation which includes Starewich's *The Cameraman's Revenge* (1911); Warner Bros.' *Honeymoon Hotel* (1934); Disney's *Pinocchio* (1940); the Fleischers' *Mr Bug Goes To Town* (1941); Reiniger's *The Grasshopper and the Ant* (1953) and De Patie-Freleng's series *The Ant and the Aardvark* of the early 1960s. These aspects of production make a significant difference in the ways that the film has been created, and also make a difference to the way in which the phenomena of the animated feature may be understood. *Antz* works as affecting social metaphor about individuality in the midst of conformist culture and oppressive social hierarchies. Like the *Toy Story* films, its aesthetic is intrinsically bound up with offering overt and perceptible codes of resistance which challenge quasi-political orthodoxies by adopting new aesthetic geographic conventions. At one level, these are the 'effects', but they are also the uniform practices of animation which advance different paradigms and models of narrative, genre, representation, 'stars' etc. *Antz* recalls its own tradition to advance and enhance it, and to more clearly promote its metaphoric credentials in the midst of the homogenous products of live-action populist film-making in Hollywood. Like *Toy Story*, it plays upon the expectations of its aesthetic and its narrative implications to collapse the anticipated conditions of 'the social' as it is determined within corporate infrastructures. At one and the same time, it can offer a critique of Clintonesque complacency; power-broking in Congress and so on while promoting its own alternative fairy-tale agenda which plays out issues about social inclusion and marginalisation. Interestingly, this is still bound up with resisting the orthodoxies of the Disney canon in the sense that *Antz* is liberated into the context of a 'socio-cultural' interpretation because it refutes the reactionary aesthetics of 'Classic Disney' and, indeed, live-action cinema. Like *Toy Story*, it finally signifies a proper recognition of the animated form to embrace 'meaning' beyond that which has been encultured as 'invisible' or 'innocent' in the dominant paradigm of the Disney form.

Barker further suggests that instances of 'extra-special effects' in *Antz* offer shifts in modality, taking the narrative and thematic concerns to another level. This may be so, but this is a characteristic of *most* animated cartoons and not a consequence of heightened manipulations of CGI. What has led to this misconception is the prominence of sequences in traditional 2D animated features, which have foregrounded the freedoms of 3D environments – the ballroom dance sequence in *Beauty and the Beast* (1989), for example, or the magic carpet ride in *Aladdin* (1992)

– where the effect is conspicuous, yet ultimately undermines the *particularity* of animation as a versatile and variable language which depicts figures and forms on its own terms and conditions and *in its own right*. Instead of being viewed as another 'pencil', these technologies and techniques are somehow viewed as different – an 'effect'. This has done much to discredit the specificities of animation and consequently has seen the form consistently ignored or drawn into comparative discussions about live-action cinema, instead of critical debates which reinforce its distinctiveness. As I have suggested earlier, so preoccupied, for example, are Byrne and McQuillan in their highly illuminating deconstruction of Disney's late 1990s canon, that no consideration is given to their status as animated films, nor why the ideological insensitivities and brutalities they suggest characterise Disney films seem to go unnoticed by the millions of viewers worldwide who enjoy them. I noted some potential answers to that question earlier, but in this context I merely wish to reiterate the view that by locking such films into a supposedly coherent ideologically determined framework, this ignores animation's self-evident capacity not merely to resist such harnessing, but to be altogether separate, creating and determining its own frames of reference. These often have related and transparent social codings which are recognisable as such, but they are always subverted by the aesthetic which prioritises its own terms and conditions as its mode of myth-making and means of construction.

When animated figures and forms constitute the main claims to narrative imperative and the enhancement of spectacle, they in essence become iconography in motion, intrinsically and fundamentally related to the new graphic terrain of the visual cultures of the late twentieth and early twenty-first century. These are prosthetic phenomena that embrace all the credentials of performance, persona and proto-meaning and *transcend* the context which produced them, operating in a comparatively new cultural space which allies them with the virtual automata of computer games and cyber-worlds.[9] Woody and Buzz in the *Toy Story* movies must be aligned *not* with a phenomenology of 'Hanks' or 'Allen', or what may be termed the traditional mode of 'star' defined by the economic, artistic and socio-cultural factors discussed by Dyer and Gledhill, but to the phenomenology of Lara Croft and the burgeoning conception of the 'cyborg'. Further, the environment that Woody and Buzz inhabit must be viewed as both a hyperworld and a cyberspace; simultaneously social and material, yet subject to physical and imagined

innovation and progress. They encourage the view that they inhabit a space which is no longer stable, either at the social and aesthetic 'textual' level or at the technological 'extra-textual' level and, consequently, they are mediations of the bridge between the textual and extra-textual where Woody and Buzz are no longer configured as fictional and passive, but as part of a culture that views and understands them, which embraces the interactive and the 'virtually' experiencial. This becomes clearer in the case of Lara Croft, but Woody and Buzz are clearly the pioneering figures in both representing identifiable notions of a domesticised America while signifying the premises of how it might be represented radically and differently. It is perhaps ironic that this transition is mediated through the 'toy' – a plaything, a concept, a conceit – but one which points back to childhood and innocence, and forward to 'non-human' formulations which heighten fresh perceptions of what it is to be 'human' in these new creative and cultural contexts. In this particular case, it is but a little removed to suggest that this also demonstrates what it might be to be an American in the late millennial period.

Toy Story and *Toy Story 2* are interrogations of what it is to be a 'toy', played out by toys in a way that invests them with an understanding of their own mechanism, market and mortality. Further, the self-conscious recognition of the materiality of 'toys' is allied to the self-reflexive understanding of the 'technology' as a space by which to acknowledge the current place of animation as *the* intrinsic language not merely of film, but all contemporary visual, communications and design cultures. Woody and Buzz speak to new modes of visual literacy and, most importantly, *interactivity*. For adults and children, the films foreground the notion of 'play'; issues of ownership and control and, most significantly, the *emotional* investment in bringing identity to the technological *difference* that now underpins notions of creativity, whether in the realm of 'play' within the text, interacting with a text or in the act of constructing texts. These factors amount to a version of Woody and Buzz as 'post-human' reconstructions which speak to the generational orthodoxies of cinematic personae, but more importantly relate to the interactive accessibilities and identities emerging from new communications and entertainment technologies. They are but another version of animated characters prompting 'empathy' at the very moment when they enunciate change, empower alternative models of perception and embody different cultural positions. In this, once more, it is important to stress that they are the logical outcome of the radical principles of

synaesthetic cinema, even though this may in itself prompt a new avant garde.

In the pre-war era of cartooning, Felix the Cat, Mickey Mouse, Donald Duck, Betty Boop, Bugs Bunny and Popeye all transcended their status as animated drawings to become bona fide cultural figures. As now, this was considerably enhanced by the proliferation of merchandising associated with the characters and the increasing presence of the characters at film premieres, social functions, store openings and so on as live personae – people dressed up in character costumes. As Richard deCordova remarks, 'From the late 1920s to the mid 1930s there was an intensification and rationalisation of the process through which films were linked to consumer goods' and notes that Disney in particular embraced toy production, and the Charlotte Clark-dressed presence of 'Mickey Mouse' in live contexts as a mode of advertising.[10] In the public imagination, the characters represented a curious mix of 'fantasy' and 'reality', in which the people could recognise human traits in what for the most part were *drawn* animal figures, but which were nevertheless recognisable as fictional constructs performing acts outside the human capacity and sometimes beyond the social frame. These included 'gags' that could only be executed as graphic phenomena; 'titillatory' imagery which challenged the parameters of the body and social behaviour; and interaction which had no parallel in cultural contexts. The 'symbolic' identity of the characters was well understood – Mickey as 'John Doe'; Donald as 'the average irascible American'; Betty as the sexually-harrassed 'flapper' and Bugs as a 'wise-ass victor' – and this, in effect, was part of their currency as 'stars', and figures who gained some cultural purchase. Their dominant traits represented something clear and meaningful in their own fictional context, and this transposed to the broader cultural realm – perhaps best evidenced during the war when their propaganda value was pronounced because of their already established identities. Donald Duck was Disney's most popular character, and featured in much of the studio's wartime output on the basis that the American public would more identify with his anxiety, irritability and defiance as necessary requirements in the fight against the axis powers.[11] Bugs Bunny was similarly employed by Warner Bros. as he was already established as a character who would only respond when provoked, and then humiliate always inferior opposition.[12] Betty Boop, of course, had to clean up her act much earlier. The Hays Code significantly curtailed her raunchy reputation, and her re-design – no garter, no cleavage,

longer skirts, no innuendous songs – changed her cultural coding and reduced her commercial and social significance.[13] Though invested with social meaning within particular cultural contexts, however, this did not 'fix' the aesthetic and material premises of these characters, who all embraced a flux of meaning in different times and places, and still facilitate contemporary recovery and revisionism, particularly in relation to their sexual politics and cultural identity, a point noted throughout my discussion.

In recent years, the phenomenology of characters has increased with the two-fold development of theme parks and studio stores specialising in any number of toys and costume paraphernalia which enhance the 'three-dimensionality' of two-dimensional figures. While 'dolls' have always been a significant part of a child's play environment, their specificity in relation to other media texts is an escalating aspect of their production. Significantly, Disney's strategy of proliferating a diverse range of Mickey Mouse merchandising in the early 1930s was instrumental in moving the 'toy' away from its seasonal emphasis as a Christmas phenomenon, using the regularity of Mickey's presence in everyday movie-going to promote year-long interest in the toys and other accessories produced by the George Borgfeldt Company. What becomes interesting here, however, is the contemporary status of the 'toy' amidst the competing attractions of other mediated forms. It is becoming increasingly difficult for toy manufacturers and retailers to secure profitable margins purely in the market of traditional toys, which are being significantly challenged by the impact of computer games and PC applications. Major retailers, FAO Schwarz and Toys 'R' Us have seen rapid decline in 'toy' earnings, and have had to embrace the phenomenon now well known in the industry as 'kids getting older younger', and the consequent abandonment of toys by children at a much younger age.[14] Industry figures assume that any child over the age of eight years old will have already moved into the competing arenas of fashion, personal accessorising, and new media entertainments, only to re-activate an interest in their childhood interests at seventeen, and sometimes enduringly throughout adulthood. Consequently, producers, manufacturers and marketeers have a vested interest in creating artefacts which both move across platforms and have an appeal which reaches across ages and interests.

It is this phenomenon which characterises Woody and Buzz and is so self-consciously interrogated in the *Toy Story* films. Woody and Buzz

stretch across the digital divide into reality, embracing the computer-game aesthetic and sensibility and the substantiveness of an enduring identity predicated on the sense of a 'historicised' emotional investment in their bonds and environment both within the films and in relation to the empathy they prompt in audiences. Jimmy Hunter, Chairman of the British Toy and Hobby Association, suggests,

> As an industry we've never been very good at standing up and shouting about what an important role toys play in a child's life. It's by playing with toys that children learn how to do things, how to build things, how to cooperate. It helps them find their place in society. Computers can't help them do that.[15]

Demonstrably, through figures like Woody and Buzz, they can. The characters use their 'post-human' status to recall the values and purpose of their representative forms as toys, while promoting the aesthetic and interactive aspects of their role as animated action figures in the new entertainment environment. Their prominence, and claim to cultural effect is the fact that they carry traditional values into the virtual 'modernity' of the new graphic space and represent the vanguard of a perception of 'toys' as material *and* conceptual phenomena. This is what makes Woody and Buzz intrinsically different from all other toy/game/film tie-ins. They embody an interrogation of their own 'reality' and the 'experience' which gives them their identity from the multiple point of view of those who create them, market them, watch them, play with them and invest in them. Barry King has described this 'cyborg'-like identity as 'a state of self-sufficient knowing or textuality', arguing that such figures operate at 'a new level of representation in which textuality [is] triumphantly divorced from context'.[16]

Crucially, Woody and Buzz only half-embrace this definition. Woody and Buzz always retain a sense of 'context' because they have re-defined modes of 'authenticity'. Dyer argues that 'authenticity' is predicated on a notion of 'truthfulness', and points out that the central tenets of Marxism, behaviourism, psychoanalysis, linguistics and modernism have been to expose the contexts in which they operate as intrinsically masking and disguising their essential but invisible 'truths'.[17] He goes on to say that 'stars' – arguably, in this context, the cultural phenomena embodied by Woody and Buzz – may be perceived as the focus of 'genuine' meaning because they expose their points of reference within and outside of

'texts', thus simultaneously speaking to the textual, sub-textual and extra-textual agendas they carry at all times – essentially this multiplicity of authentications carries with it a guarantor of a discursive but perpetually anchored discourse. He notes that 'The basic paradigm is just this – that what is behind or below the surface is, unquestionably and virtually by definition, the truth'.[18] Woody and Buzz problematise this paradigm, because their artificial status as animated figures designates them as 'surface' phenomena, embodying their own truth only as 'textual events', transcribed into their existence as iconic phenomena *and* toys. The intrinsic modernity of the animated form, and the modernity of their own aesthetic, however, refuses the post-modern delineation of Woody and Buzz's 'surface' articulation, and claims the high modernist position of embodying spiritual and emotional values by their refusal of being an 'object' that may only be absorbed within consumer culture and, instead, being a 'subject' which encourages and provokes a range of emotional, intellectual and physical responses and investments both in their fictional and extra-fictional contexts. It is intrinsically related to the 'spiritual' and 'radical' agenda of the synaesthetic, and is an important example of the way that the 'inner-directed' and 'other-directed' sensibility challenges the absorption of the 'tradition-directed' into consumer culture. Dyer, of course, recognises the instability of his paradigm, and addresses the 'rhetoric of authenticity' in which the tensions between the manufactured aspects of the 'star' *persona* and the revelatory modes which expose the real, uninhibited, un-policeable aspects of *being* define the 'authentic' and 'truthful'. Woody and Buzz in *not* being characterised by these tensions, and being wholly defined by the clarity, specificity and modernity of their 'manufacture', invests them with a sincerity, genuineness and emotiveness that speak to a contemporary sensibility which embraces the needs and premises of the *text*. Further, and importantly, their characters do not speak to the pursuit of an inappropriate and corporately determined *sub-text*; or the requirements of the *narrative* in closing the fissure between text and narrative so readily cleaved in traditional Disney texts. It is crucial to suggest, therefore, that Disney finally embraces a different model of 'modernity' not through its own dominant aesthetic but in the affiliation with PIXAR as a related but ultimately different form. Some might argue that this merely 'absorbs' the difference within Disney's corporate enterprise, but, crucially, such an enterprise cannot contain, regulate or re-determine the currency of the animated aesthetic created by PIXAR, which embraces the progressive

history of its own creation and the socio-historical premises of the material cultures which have formed it. Lasseter, the director of the *Toy Story* films, locates the intensity of the aesthetic, social, historical and corporate discourses in his principal characters, and it is the way that the films cue and prompt these discourses that delineates a new model of 'stardom' but, more importantly, the use of the 'stars' as a proper recognition of animation as the facilitator of *significant* social discourses and as a rejection of the previous dismissal of the form.

Woody and Buzz are essentially 'stars' because they prompt a form of 'emotional work' which overcomes their non-human, modern, computer-animated status. While audiences may feel that they immediately comprehend Woody and Buzz, their most fundamental meanings and effects may only be recognised once it is realised that the conditions of their construction and being have been accorded the distinction of transcending the aesthetic context from which they emerge. Though this is not the modern art of disorientation, offensiveness or shock, it is nevertheless the modern art of difference, which like all art-forms has its sources and antecedents, but works as a challenge to the assumed superficialities or transience of animated forms. The challenge here is not grounded in provocation or in breaking taboos, but in the meditation upon what it is to love; what is fundamentally human and what intrinsic values underpin our mortality. This is a return to the spirituality that underpins radical modernism in the cartoonal and avant-garde form. Viewed in this way, Dumm's reading of *Toy Story* as an ideologically grounded allegory, while substantive, pales against the idea that the very questions he believes the film raises in relation to political economy are actually those about human value, mortality and the value of 'feeling' above commodity. Arguably, these are essentially increasingly marginalised, neglected or self-consciously embraced ideas, which only the most connective and substantial of (modern) art-forms can encapsulate and provoke in those who observe them.

Woody and Buzz are central to an understanding of *Toy Story* and *Toy Story 2* as forms of modern art which are at one and the same time about preservation and conservation, and yet concerned with an understanding of new kinds of personal investment intrinsically related to mediated cultural knowledge and new media applications. This is crucial to the understanding of Woody and Buzz, because they operate as a meta-narrative about the impact of new information and entertainment technologies, while embodying deeply primal imperatives about human

survival and reproduction. *Toy Story* and *Toy Story 2* are effectively stories about toys resisting their own obsolescence; about their own desire to live; about their need to love and be loved. In *Toy Story*, the toys are consumed with anxiety every birthday and Christmas in fear of being replaced by newer, more up to date toys. Woody, erstwhile his owner's favourite toy, desperately tries not to be usurped by the claims of Buzz to Andy's affections, having to conquer his jealousy and sense of inadequacy along the way. The toys mobilise to protect themselves from destruction and the extremist wing of creative play – arguably progressive in its own way – in the hands of Andy's neighbour, Sid, who makes hybridised toys and specialises in an adolescent theatre of cruelty with inanimate objects. Woody's whole imperative is to save Buzz from the fate of living outside the safety of the domestic bedroom, but also to know more about his own imperatives and to achieve his own sense of salvation. As film director, Rowan Woods has noted,

> the whole premise of the central characters is that they are toys with no power beyond the fact that they are toys. In a sense they're like real people as opposed to action heroes, or ordinary toys as opposed to action toys which can do anything, perform any function.[19]

This observation usefully summarises a view of the human condition which notes its powerlessness and relativity, and which recognises the intensity of effort to know what is human in the face of a context that rarely enables its fulfilment.

In *Toy Story 2*, some toys are 'shelved' and sold in a yard sale because they are broken or no longer used – Woody's attempt to save the 'voiceless' Weezy, the penguin, results in his own abduction by the villainous Al, owner of the 'Toybarn', who recognises Woody as a 'collectible'. This clever conceit adds another dimension to the idea of the 'shelf-life' of toys, and their contemporary status as collectible items or cultural artefacts, their value ironically resting in the idea that they have never been used as playthings. Here the commercial context and the corporate agenda are used as a context for Woody's resolve. He is, in effect, given the choice of embracing lived experience and its vicissitudes or embracing immortality. Far from being a Faustian pact, this creates the central tension in the film, which in defining the 'meaning' of a toy, offers a philosophical perspective on the conduct of life itself. In *Toy Story 2*, Woody is given the dilemma of remaining Andy's long-cherished toy,

or joining up with Jessie, Bullseye and Stinky Pete, the prospector, other toy characters from Woody's 1950s children's television show, *Woody's Roundup*, and going on display in a Japanese toy museum. This is effectively a choice between the temporary pleasures of being loved, played with and ultimately abandoned by a child – a story heart-rendingly played out through Jessie the cowgirl's torch song – and the immortality of preservation without use. Woody is seduced by his previously unknown identity as a national icon who features on the cover of *Time* magazine, and on all manner of collectible merchandising from yo-yos to record players, but he ultimately refuses to relinquish his real function and identity as Andy's toy. This is a neat reversal of Buzz's narrative in *Toy Story*, in which he has to come to terms with the 'artifice' of his role as a 'space ranger' and accept that he is a toy, essentially given meaning by his owner – a revelation he most fully comes to terms with when he is cast by Sid's sister as 'Mrs Nesbit' at a play tea party. All delusions of heroic grandeur are absent here, reinforcing Buzz's function as a toy, but are partially recovered in the stunning 'computer game' opening of *Toy Story 2* and, indeed, in the spin-off 2D animated television series, *Buzz Lightyear of Star Command*, where Buzz is given back his role as a space ranger battling it out across the Universe with Emperor Zurg, and all self-reflexive 'toying' with different levels of reality and identity is removed. More importantly, the status of Woody and Buzz as authenticated, virtual characters, representative of their art, their science, and their 'felt' historiography has been established and accepted. Woody and Buzz seamlessly move across platforms, taking with them their range of narrative, aesthetic and integrated meanings. Most importantly, though, there is nothing reductive about these transitions – they merely add to the on-going re-construction of 'context', and another level of emotional work which is related to their non-human fate as 'technologies' and 'art', and their human fate as carriers of explicit feelings.

If Buzz has to learn that he cannot really fly, but can engineer 'falling with style', then Woody must transcend his own nightmare of being ripped, thrown away, stolen, sold or lost. In *Toy Story 2*, his self-consciousness about this leads him to counsel Buzz about the need to rotate the toys at the bottom of the chest so that as many get remembered and played with as possible; that new batteries are placed in toys and that toy parts must not be misplaced. Both films show the material culture of the toys as it is experienced and in doing so demonstrate to the children watching aspects of their own behaviour, the value they place on things

and the emotional investment they bring to the objects of play and amusement. Woody and Buzz implicitly encourage the child and, indeed, the adult, in the emotional work that preserves their status as visual icons and physical artefacts by virtue of presenting what those visual icons and physical artefacts mean and represent to them. It is this construction of 'affinity' which most underpins Woody and Buzz's claim to stardom; to the terms and conditions of modern art and to a progressive and trans-itional place in the history of animation.

For adults, this is played out in a number of ways. The vocal per-formances of Tom Hanks, a less contradictory latter-day James Stewart in films as diverse as *Forrest Gump* (1997) and *Saving Private Ryan* (1999) and Tim Allen, with his bluff machismo persona from the sit-com *Home Improvement*, may have some resonance, but this is merely in support of the personae of the American 'cowboy' and 'astronaut', each potent symbols of the construction of the 'frontier'. As the embittered Stinky Pete, 'in the box that has never been opened', remarks in *Toy Story 2*, with the launch of Sputnik 'children only wanted to play with space toys', to which Woody ruefully replies, 'I know how that feels'. The tension between Woody and Buzz is ultimately a recognition, however, that the frontier is no longer about an implied communality or consensu-ality in pursuit of the way west or the conquering of the Universe, but the management of identity and purpose in a world fragmented by the proliferation of new communications technologies. Progress cannot be measured in a grand narrative; only in the transience of the local and the success in sustaining individual purpose and achievement. Both children and adults recognise that Woody and Buzz transcend their 'post-human' agendas as toys; as a cowboy and an astronaut; as animated characters, to re-engage the viewer with the necessity of human bonding and affection in the light of this unstable and fluid context. Adults recognise that their toys carry with them memories of the relationships with them, and the largely unconditional affection accorded to them. This is more than 'nostalgia'; it is an intrinsic landmark in personal development. The *Toy Story* films feature Mr Potato Head (1952), Slinky (1953), Barbie (1959) and GI Joe (1964) as poignant reminders of that emotional work and its longevity and effect. This 'encultures' the space in which Woody and Buzz take their place, and contributes to what Mike Featherstone has called the process of 'instantiation'[20] in which pleasure arises immedi-ately from the artefacts or virtual objects which are subject to contem-plation. Again, I would argue that this is an attribute of a high Modernist

agenda at the heart of popular cultural forms. Woody and Buzz elevate their specific fate on to a universal plane.

Arguably, this immediacy of cultural immersion also characterises children in the contemporary era, as their playthings in being predicated on transience, technology and modes of interactive practice are configured in a way that provokes short-term intimacies. Again, Woody and Buzz transcend this temporal function and identity by virtue of their iconic value as embodiments of the technologies and socio-cultural infrastructures that produce them. Their theme tune – 'You've got a friend in me' – moves beyond the 'buddy' sensibility and offers itself as an anthem for the emotional work and symbolic maintenance of 'affinity' in the pairing of Woody and Buzz; and, crucially, their 'mediation' of the space between character and animated CGI forms; character and toy; character and historically determined icon and character and sense memory. They have cultural effects because they anchor and represent the highest quality representation of the transition from the culture of the camera to the dynamics of the digital and the machinations of the mercantile, while encompassing the most important characteristics of each. John Lasseter's art is to make this modernity so human.

The post-photographic film may become the dominant mode of image production in the future, but at present is intrinsically bound up with the free-play of animated forms, which in themselves have never been entirely free of childhood associations. At any one stage in the development of the moving image, the emergence of new technology has always prompted fears of technological determinism; that somehow the purposes and outcomes of creativity would be overwhelmed by the impact of technological capability in itself. An allied issue has always been the idea that such technological capability is intrinsically bound up with the principles of display and spectacle in its own right, beyond the import of narrative or text – a cinema of attractions – which privileges visual effects and relationships, and which as I have suggested here, may be re-configured as 'cartoonal attractions', the self-enunciating variables of modernity grounded in socio-historical creative investment in the form. Interestingly, computer-generated imagery, especially in relation to *Toy Story* and its sequel, has embraced its 'determinism' in relation to what may be viewed as a 'technological instrumentalism' which maintains, reveals and enhances the generic potentialities of animation as a distinctive aesthetic and cultural form. Woody and Buzz are associated, therefore, with a range of contemporary cultural resources that at the

level of character and technical achievement promote identification and progress, and which signify a mode of resolution and affirmation in 'emotional work' as the cornerstone of human values and continuum. Woody and Buzz allay the age-old anxiety concerning technological and social change because they embody an 'authenticity' which is *about* this very change, and the powerful feelings that are associated with it. Woody and Buzz may constitute a 'downsizing' of what it is to be a 'star', but an 'upgrading' of their value and effect in a contemporary era where visual and social communication is in transition, and subject to new forms of understanding. Woody and Buzz are the most substantive metaphor for change and human endeavour in American culture and the animated art-form. It is perhaps no accident that with the return to a more conservative America, anxious about change, that Disney made *Dinosaur* (2000), the first work from its own newly configured CGI team,[21] at once a state-of-the-art combination of computer-generated three-dimensional creatures within a live-action environment, but also a retreat to the standard 'emotional odyssey' of the standard Disney story, and highly reminiscent of Don Bluth's *The Land Before Time*. While this may recall a whole tradition of animated dinosaurs, from Winsor McCay's *Gertie the Dinosaur* to Willis O'Brien's work in *The Lost World* to Ray Harryhausen's extraordinary stop-motion animation in *The Valley of Gwangi* (1968) to Phil Tippett's achievements in *Dragonslayer* (1981) and *Jurassic Park* (1993),[22] *Dinosaur* has none of the inner-directed or other-directed spirit of its forbears. It is clear that the animated form has come a long way, however, reconciling its reactionary and radical tendencies; finding its aesthetic capabilities at the heart of contemporary visual culture. It is clear, too, that animation in the United States is wholly inscribed with the multiple currents and contradictions of the nation that produced it; sometimes a dis-united state, sometimes an America of conservatism and conformity. Animation may be truly understood, though, as a language which has properly embraced its nation's conscience and consciousness; an aesthetic insistent on its own modernity in the attention to the populist, pragmatic and progressive conditions of the most inherently contradictory country in the world.

Notes

1. B. Snider, 'The Toy Story Story', *Wired* Archive 3. 12, Dec 1995: http://www. wired. com/wired/archive/3.12/toy. story_pr. html, p. 1.
2. See P. Wells, *Understanding Animation* (London and New York, 1998), pp. 180–2.

3. C. Gledhill (ed.), *Stardom: Industry of Desire* (London and New York: Routledge, 1991), p. xiii.

4. R. Dyer, '*A Star is Born* and the construction of authenticity' in C. Gledhill (ed.), *Stardom: Industry of Desire* (London and New York: Routledge, 1991), p. 133.

5. T. Dumm, 'Toy Stories: Downsizing American Masculinity', Vol. 1 No. 1, 1997), pp. 90–2.

6. Ibid., p. 92.

7. A. Cholodenko (ed.), *The Illusion of Life: Essays on Animation* (Sydney: Power Press, 1991), p. 59.

8. M. Barker, *From Antz to Titanic: Reinventing Film Analysis* (London and Stirling: Pluto Press, 2000), p. 79.

9. I have written elsewhere about the relationship between the computer-generated television series, *Roughnecks: Starship Troopers Chronicles*, new configurations of 'realism' and computer games aesthetics. See P. Wells, '*Roughnecks:* Reality, Recumbancy, and Radical Aesthetics', *Point* 11, Spring/Summer 2001, pp. 48–55.

10. R. de Cordova, 'The Mickey in Macy's Window: Childhood, Consumerism and Disney Animation' in E. Smoodin (ed.), *Disney Discourse: Producing the Magic Kingdom* (London and New York: Routledge, 1994), pp. 204–5.

11. R. Holliss and B. Sibley, *The Disney Studio Story* (London and New York: Crown, 1988), pp. 46–54.

12. S. Dalton, 'Bugs and Daffy Go To War' in D. Peary and G. Peary (eds), *The American Animated Cartoon* (New York: E. P. Dutton, 1980), pp. 158–62.

13. L. Cabarga, *The Fleischer Story* (New York: Da Capo, 1988), pp. 53–81.

14. R. Gray, 'Toy Tactics', *Livewire*, Oct–Nov 2000, London: Artisan Press, pp. 22–6.

15. Ibid., p. 23.

16. B. King, 'The Burden of Headroom', *Screen*, 1–2, p. 122.

17. R. Dyer in C. Gledhill (ed.), *Stardom: Industry of Desire* (London and New York: Routledge, 1991), p. 134.

18. Ibid., p. 136.

19. R. Woods, 'To Infinity … and Beyond', *Sight and Sound*, Vol. 9, Issue 1 (NS), January 1999, p. 62.

20. See M. Featherstone, *Consumer Culture and Postmodernism* (London: Sage, 1991).

21. See M. Cotta Vaz, 'Engendered Species', *Cinefex*, No. 82, July 2000, pp. 68–93.

22. P. Tippett, 'Working on the Threshold of Animation', in J. Boorman and W. Donohue (eds), *Projections 8* (London and Boston: Faber & Faber, 1998), pp. 327–43.

Filmography

A Great Big Bunch of You (1932)
A Troll in Central Park (1994)
Abstronic (1954)
Adventures of an * (1957)
Adventures of André and Wally B (1984)
Aladdin (1992)
Alice in Wonderland (1950)
Alice in Wonderland [TV] (1951)
All Dogs Go to Heaven (1990)
All My Relations (1990)
An American Tail (1986)
Anastasia (1998)
Antz (1998)
Apocalypse Now (1989)
Archies, The (1969)
Asparagus (1978)
Baby Puss (1943)
Bambi (1941)
Banjo, The Woodpile Cat (1978)
Bartok, The Magnificent (1999)
Basil: The Great Mouse Detective (1986)
Beast from 20,000 Fathoms, The (1952)
Beatles, The (1965)
Beauty and the Beast (1934)
Beauty and the Beast (1991)
Bedknobs and Broomsticks (1971)
Betty Boop's Penthouse (1933)
Black Cauldron, The (1981)
Boomtown (1985)
Boop-Oop-A-Doop (1932)
Brady Bunch, The (1972)
Brotherhood of Man, The (1946)

Bugs Bunny Nips the Nips (1944)
Building the Building (1933)
Bully for Bugs (1953)
Buried Treasure (1928)
Cabinet of Dr Caligari, The (1919)
Cameraman's Revenge, The (1911)
Chess Nuts (1932)
Chicken Run (2000)
Clock Store, The (1931)
Closed Mondays (1975)
Coal Black and De Sebben Dwarfs (1943)
Cockaboody (1972)
Congo Jazz (1930)
Coonskin (1975)
Confidence (1933)
Country Cousin, The (1936)
Creation (1929)
Der Fuehrer's Face (1943)
Dig My Do (1990)
Dinosaur (2000)
Donor Party, The (1996)
Dover Boys, The (1942)
Dragonslayer (1981)
Dukes, The (1982)
Eggs (1971)
Einstein's Theory of Relativity (1923)
Enchanted Drawing, The (1900)
Everybody Rides a Carousel (1976)
Fantasia (1940)
Fantasia 2000 (2000)
Fantastic Four, The (1967)
Fast and Furry-ous (1949)
Felix Dines and Pines (1927)
Felix Gets the Can (1924)
Felix in Hollywood (1923)
Felix Revolts (1924)
Felix Woos Whoopee (1928)
Flintstones, The (1960)
Flowers and Trees (1933)
Fonz, The (1980)
Forrest Gump (1997)
Fox and the Hound, The (1981)

Frames (1978)
Fritz the Cat (1972)
Frog Baseball (1992)
Gallupin' Gaucho (1928)
Gerald McBoing Boing (1951)
Gertie the Dinosaur (1914)
Girl Can't Help It, The (1956)
Glens Fall Sequence (1946)
God, the Devil and Bob (2001)
Godzilla meets Bambi (1969)
Grasshopper and the Ant, The (1953)
Gremlins (1984)
Gremlins 2: The New Batch (1990)
Happy Days Gang (1980)
Haunted Hotel, The (1907)
Heaven and Earth Magic (1960)
Heavy Traffic (1973)
Hell Bent for Election (1944)
Hercules (1997)
Honeymoon Hotel (1934)
How To Kiss (1989)
Humorous Phases of Funny Faces (1906)
Hunchback of Notre Dame, The (1996)
I Dream of Jeannie (1974)
I Like Mountain Music (1933)
I Married a Monster from Outer Space (1958)
I Married a Strange Person (1997)
Idyll (1948)
Inbred Jed's Cartoon (1991)
In Plain Sight (1977)
Interior Designs (1980)
Iron Giant, The (1999)
Jackson 5ive, The (1971)
James and the Giant Peach (1995)
Jason and the Argonauts (1963)
Jonny Quest (1974)
Jungle Book, The (1967)
Jurassic Park (1993)
King Kong (1933)
Land Before Time, The (1988)
Lapis (1963–6)
Le Bijou (1942)

Lineage (1979)
Lion King, The (1994)
Little Mermaid, The (1989)
Little Nemo (1910)
Little Runaway (1952)
Little Rural Riding Hood (1949)
Little Tramp, The (1989)
Lucas the Ear of Corn (1977)
Luxo Jnr (1986)
Magoo's Check Up (1955)
Make Me Psychic (1978)
Mandala (1975)
Mary Poppins (1964)
Mask, The (1994)
Mechanical Cow, The (1927)
Merbabies (1938)
Mighty Mouse: The New Adventures (1987)
Mr Bug Goes To Town (1941)
Modern Times (1936)
Monkey Bone (2000)
More Sex and Violence (1998)
Mother Goose Melodies (1931)
Mouse in Manhattan (1945)
Mulan (1998)
Mummy Returns, The (2001)
Music Box, The (1932)
My Favourite Martian (1973)
New Adventures of Gilligan, The (1973)
Nightmare Before Christmas, The (1992)
Nosehair (1994)
1941 (1942)
Of Stars and Men (1962)
Oliver and Company (1988)
Once Upon a Time (1974)
One Good Turn (1926)
101 Dalmations (1961)
One of those Days (1988)
Orb, The (1973)
Osmonds, The (1972)
Our Lady of the Sphere (1969)
Peace, Love and Understanding (1993)
Pebble and the Penguin, The (1996)

Patten (1970)
Permutations (1968)
Pete's Dragon (1977)
Peter Pan (1953)
Phantom Menace, The (1999)
Pinocchio (1940)
Plane Crazy (1928)
Playful Pluto (1934)
Pocahontas (1995)
Prince of Egypt, The (1998)
Push Comes to Shove (1991)
Puss 'n' Toots (1942)
Quasi at the Quackadero (1975)
Raggedy Ann and Andy (1977)
Red Hot Riding Hood (1943)
Remains to be Seen (1983)
Ren and Stimpy Show, The (1991)
Rescuers, The (1977)
Return to Oz (1985)
Robin Hood (1973)
Rock-a-Doodle (1992)
Rocky and his Friends (1961)
Romantic Melodies (1932)
Ruff and Reddy (1957)
Saving Private Ryan (1999)
Sculptor's Nightmare, The (1908)
Secret of NIMH, The (1982)
Seepage (1979)
Sex and Violence (1997)
Shrek (2001)
Silly Scandals (1931)
Simpsons, The (1990)
Sinking of the Lusitania (1918)
Skeleton Dance, The (1928)
Sleeping Beauty (1959)
Slow Bob in the Lower Dimension (1990)
Small One, The (1978)
Small Soldiers (1998)
Snow White and the Seven Dwarfs (1937)
Solid Serenade (1946)
Song of the South (1946)
Spiderman (1967)

Spook Sport (1939)
Star Wars (1977)
Steamboat Willie (1928)
Story of a Mosquito, The (1912)
Story of Anyburg, USA, The (1957)
Stuart Little (1999)
Sullivan's Travels (1941)
Tell-Tale Heart, The (1953)
Thank You Mask Man (1968)
Thief and the Cobbler, The (1998)
Three Little Pigs (1933)
Three's A Crowd (1933)
Thumbelina (1994)
Tin Toy (1988)
Toot, Whistle, Plunk and Boom (1953)
Tortoise and the Hare, The (1935)
Twilight Zone: The Movie (1983)
Two Little Indians (1953)
Toy Shop (193)
Toy Story (1995)
Toy Story 2 (1999)
Transmutation (1947)
Triumph of the Will (1934)
Tron (1982)
Tune, The (1992)
25 Ways to Quit Smoking (1989)
Unicorn in the Garden (1953)
Valley of Gwangi, The (1968)
Watcher in the Woods (1981)
What's Opera, Doc? (1957)
We're in the Money (1933)
Who Framed Roger Rabbit? (1988)
Will Success Spoil Rock Hunter? (1957)
Windy Day (1968)
Winnie the Pooh, and Tigger Too (1974)
Wiseman, The (1990)
Your Face (1987)

Bibliography

Adams Sitney P. (1979), *Visionary Film: The American Avant-Garde 1943–1978*, New York: OUP.

Allan, R. (1999), *Walt Disney and Europe*, London and Montrouge: John Libbey.

Barker, M. (2000), *From Antz to Titanic: Reinventing Film Analysis*, London and Sterling: Pluto Press.

Barrier, M. (1999), *Hollywood Cartoons: American Animation In Its Golden Age*, New York and Oxford: OUP.

Beck, J. (1994), *The 50 Greatest Cartoons*, Atlanta: Turner Publishing Co.

Bendazzi, G. (1994), *Cartoons: 100 Years of Cartoon Animation*, London and Montrouge: John Libbey.

Bianculli, D. (1994), *Teleliteracy*, New York and London: Simon and Schuster.

Brophy, P. (ed.) (1994), *Kaboom!: Explosive Animation from America and Japan*, Sydney: Museum of Contemporary Art/Power.

Byrne, E. and M. McQuillan (1999), *Deconstructing Disney*, London and Stirling: Pluto Press.

Cabarga, L. (1988), *The Fleischer Story*, New York: Da Capo.

Chambers, S., N. Karet and N. Sampson (Broadcast Research Ltd) and J. Sancho-Aldridge (ITC) (1998), *Cartoon Crazy?: Children's Perception of 'Action' Cartoons*, London: ITC.

Cholodenko, A. (ed) (1991), *The Illusion of Life: Essays on Animation*, Power/AFC: Sydney.

Cohen, K. (2000), *Forbidden Animation*, Jefferson, North Carolina and London: McFarland and Co.

Cotta Vaz, M. (2000), 'Engendered Species', *Cinefex*, No. 82, July 2000, pp. 68–93.

Culhane, J. (1998), *Disney's Aladdin: The Making of an Animated Film*, New York: Hyperion.

Dalton, S. (1980), 'Bugs and Daffy Go To War' in D. Peary and G. Peary (eds), *The American Animated Cartoon*, New York: E. P. Dutton, pp. 158–61.

deCordova, R. (1994), 'The Mickey in Macy's Window: Childhood, Consumerism and Disney Animation' in E. Smoodin (ed), *Disney Discourse: Producing the Magic Kingdom*, London and New York: Routledge, pp 203–13.

Denzin, N. (1995), *The Cinematic Society*, London and Thousand Oaks: Sage.

Dines, G. and J. M. Humez (eds) (1995), *Gender, Race and Class in Media: A Text Reader*, London, New Delhi and Thousand Oaks: Sage.

Dorfman, A. and A. Mattelart (1975), *How to Read Donald Duck*, New York: International General.

Dumm, T. (1997), 'Toy Stories: Downsizing American Masculinity', *Cultural Values*, Vol. 1 No. 1, pp. 81–100.

Dyer, R. (1991), '*A Star is Born* and the construction of authenticity' from C. Gledhill (ed.), *Stardom: Industry of Desire*, London and New York: Routledge, pp. 132–40.

Dyer, R. (1992), *Only Entertainment*, London and New York: Routledge.

Eisner, L. (1983), *The Haunted Screen*, London: Secker & Warburg.

Eisner, M. (1999), *Work in Progress*, London and New York: Penguin.

Eliot, M. (1994), *Walt Disney: Hollywood's Dark Prince*, London: Andre Deutsch.

Ellison, H. (1968), *The Glass Teat*, Manchester: Savoy.

Elsaesser, T. (ed.) (1990), *Early Cinema: Space, Frame, Narrative*, London: BFI.

Featherstone, M. (1991), *Consumer Culture and Postmodernism*, London: Sage.

Frierson, M. (1994), *Clay Animation*, New York: Twayne, p. 122.

Furniss, M. (1998), *Art in Motion*, London: John Libbey, 1998.

Gledhill, C. (ed.) (1991), *Stardom: Industry of Desire*, London and New York: Routledge.

Goldner O. and G. E. Turner (1975), *The Making of King Kong*, New York: Ballantine Books.

Grant, M. (1962), *The Myths of the Greeks and Romans*, New York and Ontario: New American Library.

Graves, R. (1978), *The Greek Myths*, London and New York: Penguin.

Gray, R. (2000), 'Toy Tactics', *Livewire*, Oct–Nov 2000, London: Artisan Press.

Gunning, T. (1990), 'The Cinema of Attractions: Early Film, Its Spectators and the Avant Garde', in T. Elsaesser (ed.), *Early Cinema: Space, Frame, Narrative* London: BFI.

Hames, P. (ed.) (1995), *Dark Alchemy: The Films of Jan Svankmajer*, Trowbridge: Flicks Books.

Hanna, W. (1996), *A Cast of Friends*, Dallas: Taylor Publishing Co.

Harryhausen, R. (1989), *Film Fantasy Scrapbook*, London: Titan Books.

Holliss, R. and B. Sibley (1988), *The Disney Studio Story*, London and New York: Crown.

Hooks, E. (2000), *Acting For Animators*, Portsmouth: Heinemann.

Javna, J. (ed.) (1988), *The Best of Science Fiction TV*, London: Titan.

Kanfer, S. (1997), *Serious Business: The Art and Commerce of Animation in America from Betty Boop to* Toy Story, New York: Scribner.

Kenner, H. (1994), *Chuck Jones: A Flurry of Drawings*, Berkeley and London: University of California Press.

King, B., 'The Burden of Headroom', *Screen*, 1 No. 2, pp. 122–38.

Korkis, J. and J. Cawley (1990), *The Encyclopaedia of Cartoon Superstars*, Las Vegas: Pioneer.

Kracauer, S. (1947), *From Caligari to Hitler: A Psychological History of the German Film*, Princeton University Press.

Langer, M. (1992), 'The Disney-Fleischer Dilemma: Product Differentiation and Technological Innovation', *Screen*, 33 No. 4 (Winter 1992), pp. 343–60.

Lazere, D. (ed.) (1987), *American Media and Mass Culture*, Berkeley and Los Angeles: University of California Press.

McKee, R. (1998), *Story*, London: Methuen.

Maltin, L. (1987), *Of Mice and Magic: A History of Animated Cartoons*, New York: Plume.

Mast, G. and M. Cohen (eds) (1974), *Film Theory and Criticism: Introductory Readings*, London and New York: OUP.

Merritt, R. and J. B. Kaufmann (1993), *Walt in Wonderland*, Baltimore: John Hopkins University Press.

Peary, D. and G. Peary (eds) (1980), *The American Animated Cartoon*, New York: E. P. Dutton.

Pilling, J. (ed.) (1997), *A Reader in Animation Studies*, London: John Libbey.

Rhodes, R. (ed.) (1999), *Visions of Technology*, New York: Simon & Schuster.

Riesman, D. (1969), *The Lonely Crowd*, New Haven and London: Yale University Press.

Robinson, D. (1981), *World Cinema 1895–1980*, London: Eyre Methuen.

Russett, R. and C. Starr (1976), *Experimental Animation: Origins of a New Art*, New York: Da Capo.

Sandler, K. (ed.) (1998), *Reading the Rabbit: Explorations in Warner Bros. Animation*, New Brunswick, New Jersey and London: Rutgers University Press.

Sennett T. (1989), *The Art of Hanna Barbera*, New York and London: Viking Penguin.

Shapiro, M. E. (1992), *Television Network Weekend Programming 1959–1990*, Jefferson, North Carolina and London: McFarland & Company Inc.

Simpson, P. (ed.) (1987), *Parents Talking Television*, London: Comedia.

Smoodin, E. (ed.) (1994), *Disney Discourse*, London and New York: Routledge/AFI.

Snider, B. (1995), 'The Toy Story Story', *Wired* Archive Vol. 3, No. 12, December 1995: http://www. wired. com/wired/archive/3. 12/toy. story_ pr. html

Solman, G. (1996), 'Bringing Things to Life by Hand: an Interview with Henry Selick' in J. Boorman and W. Donohue (eds), *Projections 5*, London and Boston: Faber & Faber.

Solomon, C. (1989), *Enchanted Drawings: The History of Animation*, New York: Alfred K. Knopf.

Stark, S. (1997), *Glued to the Set* , New York: Simon & Schuster.

Steinberg, S. and J. Kincheloe (eds) (1997), *Kinderculture: The Corporate Construction of Childhood*, Boulder and Oxford: Westview Press.

Sypher, W. (ed.) (1956), *Comedy*, Baltimore: John Hopkins University Press.

Tippett, P. (1998), 'Working on the Threshold of Animation', in J. Boorman and W. Donohue (eds), *Projections 8*, London and Boston: Faber & Faber, pp. 327–43.

Warren, C. (ed.) (1996), *Beyond Document: Essays on Non-Fiction Film*, Hanover: Wesleyan University Press.

Wasko, J. (2001), *Understanding Disney*, Cambridge: Polity Press.

Watts, S. (1997), *The Magic Kingdom: Walt Disney and the American Way of Life*, New York: Houghton Mifflin.

Wells, P. (ed.) (1997), *Art and Animation*, Academy Group/John Wiley.

Wells, P. (1998), *Understanding Animation*, London and New York: Routledge.

Wells, P. (2001), '*Roughnecks:* Reality, Recombancy, and Radical Aesthetics', *Point* 11, Spring/Summer, pp. 48–55.

Woods, R. (1999), 'To Infinity ... and Beyond', *Sight and Sound*, Vol. 9, Issue 1 (NS), January, pp. 62–3.

Youngblood, G. (1970), *Expanded Cinema*, New York: E. P. Dutton.

Index

Aaron, Jane, 72
Abstronics, 71
Adams Sitney, P., 70
Adamson, Joe, 11
Aesthetics, 4, 5, 6–12, 19–20, 22, 26, 28,
 29, 31, 33, 35, 42, 51, 143, 159
Aladdin (1992), 1, 109–10, 121, 131, 134–5,
 146, 158
All Dogs Go to Heaven (1990), 130
Allan, Robin, 128
Anastasia (1998), 131–2
Animatophiles, 1, 130
Animé, 4
Anthropomorphism, 22, 119
Antz (1998), 157–8
Appleyard, Brian, 120
Asparagus (1975), 72
Auteurism, 11, 20, 25–6, 31, 50, 53, 62–3,
 71, 75, 84, 113, 126–7, 131, 143, 145
Avery, Tex, 5, 8, 11, 51, 52

Bakshi, Ralph, 6, 73–4, 83, 131
Bambi (1941), 41, 43
Barker, Martin, 107
Barrier, Michael, 21, 25, 30, 52, 55
Battacharya, Sanjiv, 96
Beast Creatures, 4
Beavis and Butthead, 86, 148
Betty Boop, 6, 39, 85, 161–2
Bird, Brad, 116, 156
Blackton, J. Stuart, 28–9
Bloom, Clive, 30
Bluth, Don, 126–31
Brotherhood of Man (1946), 63
Bugs Bunny, 161
Bully for Bugs (1953), 7
Buried Treasure (1928), 6

Bute, Mary Ellen, 71
Butsch, Richard, 89
Byrne, Eleanor, 106, 113, 120, 136, 138,
 159

CAPS (Computer Application Produc-
 tion System), 117, 151
Cardinal, Roger, 5
Carter, Huntley, 35
Cartoon Network, 4, 80
Cartoonal attractions, 98–9, 169
Cavell, Stanley, 6
Cel-animated art, 3
Charney, Leo, 43
Clampett, Bob, 8, 11, 51, 52, 56
Clements, Ron, 132–6, 138, 152
Clokey, Art, 80
Coal Black and de Sebben Dwarfs (1941),
 56–7
Cohl, Émile, 27
Comedy, 5, 15–16, 25, 49, 52, 55, 57, 91,
 98, 147–8, 161
Confidence (1933), 14
Conrad, Peter, 97
Coonskin (1975), 6
Cosby Show, The, 95
Crafton, Donald, 5, 19, 25, 30, 32, 62
Crawford, Ben, 86
Cruikshank, Sally, 72–3

Dante, Joe, 139–41
Davis, Art, 11
de Cordova, Richard, 161
Denzin, Norman, 109
Difference, 1, 9–10, 49, 51, 58, 65, 70, 86,
 89, 92, 94, 103, 107–8, 110, 119,
 127, 136, 148, 155–6, 165

Digilio, Nick, 131
Disney
 aesthetics, 3, 7, 10, 15, 23, 38, 105, 107,
 110, 122
 as *auteur*, 26, 38, 44, 45–6, 103, 128
 and 'Culture', 9, 46
 criticism of, 48, 66–7, 67–9, 102, 107,
 108–9, 111–12, 121
 and Englishness, 66, 128–9
 films as social texts, 118, 123
 ideology, 13–14, 16, 23, 40–1, 47–9,
 51, 54, 74, 102–4, 106, 108, 113–14
 Laugh-O-Grams, 21
 and literature, 66, 129
 as pioneer, 20, 33, 39, 53
 studio, 2, 26, 45, 68–9, 102–3, 113, 127
 technological determinism, 38–9, 42,
 122, 169
 and television, 4, 76–7
Donald Duck, 161
Dumm, Thomas 155, 165
Durgnat, Raymond, 15, 53–4, 55–6
Dwoskin, Stephen, 10
Dyer, Richard, 118–19, 155, 163–4

Effects, 52–3
Eisenstein, Sergei, 13, 21–3, 40–2
Eliot, Marc, 49, 66–7, 121
Ellison, Harlan, 85
Enchanted Drawing, The (1900) 28–9

Featherstone, Michael, 24–6, 168
Fisher, David, 66
Fleischer Brothers
 expressionism, 8, 55
 reflexivity, 33, 55
 technological innovators, 38–9, 50, 54–5
Fantasia (1940), 46, 48
Felix the Cat, 23, 25
Felperin, Leslie, 87, 94
Flintstones, The, 87, 89–97
Freleng, Friz, 11, 21, 78, 82
Fritz the Cat (1972), 6
Furniss, Maureen, 62, 80

Gallupin' Gaucho (1928), 21
Gertie the Dinosaur, 23, 32–3
Gifford, Denis, 78

Gilliam, Terry, 5
Giroux, Henry, 102, 107, 112, 122–3
Gledhill,Christine, 153
Glens Falls Sequence (1946), 69
God, the Devil and Bob
 (2000), 76
Griffin, George, 127
Groening, Matt, 94–8
Grotjahn, Martin, 13
Gumby, 80

Hamilton, James Shelley, 46
Hanna Barbera, 4, 75, 77–80, 87–90
Harryhausen, Ray, 53, 144
Haunted Hotel, The (1907), 29
Heaven and Earth Magic (1960), 70
Hell Bent for Election (1944), 63
Hercules (1997), 109, 114–15, 138–9
Hogan, Phil, 98
How to Read Donald Duck, 108–9
Hubley, John and Faith, 67–9, 104–5
Humorous Phases of Funny Faces (1906), 29

Idyll (1948), 69
Iwerks, Ub, 20–2, 39, 41

Jacobs, Lewis, 38
James and the Giant Peach (1995), 143–4
Jonny Quest (1964), 82
Jones, Chuck, 5, 7, 51, 52, 63, 78–9, 96,
 157
Jordan, Larry, 70, 72
Jungle Book, The (1967), 116

Kanfer, Stefan, 1, 80, 82, 111–12, 116
Karl, Frederick, 24, 26
Kenner, Hugh, 7
King, Barry, 163
King of the Hill, 3, 86
Klein, Norman, 34, 52, 56–7
Kozlenko, William, 12–15
Kricfalusi, John, 6, 75, 83
Kunzle, David, 108

Land Before Time, The (1988), 130, 170
Langer, Mark, 1, 54–5
Lapis (1963–6), 69
Lara Croft, 159–60

Lasseter, John, 149, 151, 165, 169
Le Bijou (1942), 69
Lion King, The (1994), 111–12, 116, 121
Little Mermaid, The (1988), 113, 120
Lee, Francis, 69
Lejeune, C. A., 44, 48
Limited Animation, 64, 78, 88, 90–1, 96
Little Nemo (1910), 31
Little Tramp, The (1989), 84
Lorentz, Pare, 45

Maltin, Leonard, 87, 126
Max Steel, 4
McCay, Winsor, 21, 30–5
McKee, Robert, 9, 104
McKimson, Bob, 11
McQuillan, Martin, 106, 113, 120, 136,
 138, 159
Merbabies (1938), 42
Merrie Melodies, 2
Messmer, Otto, 21, 30
Metamorphosis, 24, 26, 30, 42–3, 143
Mickey Mouse 13, 23, 25, 44, 77, 106, 161–2
Mighty Mouse, 83
Miller, Susan, 104, 111
Modernism, 19–37
 art, 8, 63, 68, 165
 change, 24, 28, 43, 128
 'conservative', 27, 35, 40
 'moderate', 27, 40, 45
 modernity, 8, 22, 24–6, 40, 45, 109–
 10, 122, 123, 128, 130, 163–4, 169
 'radical', 27, 35, 40, 56, 165
 'sentimental', 23, 27, 45
Mr Magoo, 63, 66
Murphy, Patrick D., 23
Musker, John, 132–6, 138, 152

Nightmare Before Christmas (1992), 142
1941 (1942), 69
Nowell-Smith, Geoffrey, 90

Orna, Bernard, 63
Otherness, 1, 30, 34, 57–8, 65, 70, 86, 89,
 92, 103, 119, 155–6
O'Brien, Willis, 53
O'Sullivan, Judith, 31

Panofsky, Erwin, 8
Patterson, John, 121
Pitt, Suzan, 72
Playful Pluto (1934), 16, 41
Plympton, Bill, 6, 16, 145–8
Post-stylisation, 63, 67, 152, 156
Prince of Egypt (1998), 137–8
Putterman, Barry, 78

Real Adventures of Jonny Quest, The, 4
Realism, 8, 12, 15, 20, 22, 30, 33–4, 41, 43,
 63, 66, 92, 134, 154
Reboot, 4
Ren and Stimpy Show, The, 6, 83, 86
Representation, 56–7, 63, 71, 73–4, 84–5,
 105–6, 123
Riesman, David, 64–5, 102
Robinson, David, 48
Rocky and his Friends, 82–3
Rode, Greg, 104, 111

Sandler, Kevin, 53
Sartin, Hank, 56
Schickel, Richard, 20, 23, 65, 74, 103, 106
Schlesinger, Leon, 2
Schwartz, Zack, 15, 63
Seldes, Gilbert, 39
Selick, Henry, 141–4
Sibley, Brian, 106
Simpsons, The, 3, 6, 75, 86–7, 89, 91, 94–7
Sinking of the Lusitania, The (1918), 32–4
Skeleton Dance, The (1928) 21, 71
Sklar, Robert, 15
Smith, Harry, 70, 73
Snow White and the Seven Dwarfs (1937),
 45–8
South Park, 3–4
Sparshott, F. E., 15
Spook Sport (1939), 71
Steamboat Willie (1928), 21
Stalling, Carl, 21
Stephenson, Ralph, 64
Story of a Mosquito, The (1912), 31–2
Svankmajer, Jan, 7
Synaesthetics, 60–3, 67, 70, 73, 92, 95, 99,
 104, 132, 153–5, 157, 161

Tashlin, Frank, 11, 44–5, 51

Television animation, 75–99
Thank You Mask Man (1968), 6, 16
Thompson, Kirsten Moana, 57
Thorson, Charlie, 52
Three Little Pigs (1933), 14
Tom and Jerry, 96
Toot, Whistle, Plunk and Boom (1953), 66–7
Toy Story (1995), 151–67
Toy Story 2 (1999), 166
Tron (1982), 4
Tune, The (1992), 146

Unicorn in the Garden (1953), 64, 65–7
UPA (United Productions of America), 63–7, 128

Vinton, Will, 82
Violence, 87

Waller, Gregory, 2, 8
Walz, Gene, 52
Warner Bros.
 humour, 49–50, 52, 58
 history, 53, 78
 as modernists, 56
 opposition to Disney, 51, 54, 56–7
 reflexivity, 33, 52, 54, 88, 91
 surrealism, 8
 studio, 2
 'Termite Terrace', 5, 11, 52
Watts, Stephen, 24
Whale, Nigel, 19, 22
White, Timothy R., 49–50
Who Framed Roger Rabbit? (1988), 126–7
Williams, Richard, 126–7
Winokur, Mark, 50, 57

Youngblood, Gene, 60–4